A Guide to Medical Photography

A Guide to Medical Photography

Edited by Peter Hansell

Director of Audiovisual Services,
Westminster Hospital School and
Institute of Ophthalmology,
University of London

with contributions from:

Bruno Arnold

Rainer Dammermann

Charles Häberlin

Peter Hansell

Phillip Hendrickson

Dietmar Hund

Per-G. Lundquist

Marcus P. Nester

Patricia M. Turnbull

MTP **PRESS LIMITED**
International Medical Publishers

The Authors

Bruno Arnold, Head of the Photographic Department, Triemli Municipal Hospital, Zürich, Switzerland.

Dr. Rainer Dammermann, Senior Registrar, Barmbeck General Hospital, Hamburg, Federal Republic of Germany.

Charles Häberlin, Photographer, Pathological Institute of the University of Zürich, Switzerland.

Dr. Peter Hansell, Director of Audiovisual Services, Westminster Hospital Medical School and Institute of Ophthalmology, University of London.

Phillip Hendrickson, Department of Physiological Optics, University of Alabama, Birmingham, Alabama, USA.

Dietmar Hund, Head of the Photographic Department, Cantonal Hospital, Basle, Switzerland.

Professor Dr. Per-G. Lundquist, Ear, Nose and Throat Clinic, Karoline Hospital, Stockholm, Sweden.

Marcus P. Nester, Audiovisual Designer, 'ROCOM', F. Hoffmann—La Roche & Co. AG, Basle, Switzerland.

Patricia M. Turnbull, Head of Department of Medical Illustration and Teaching Services, Charing Cross Hospital Medical School, University of London.

Published by
MTP Press Limited
Falcon House
Cable Street
Lancaster, England

Copyright English Language Edition
© 1979 MTP Press Limited

First published 1979

British Library Cataloguing in Publication Data

A guide to medical photography.
1. Photography, Medical
I. Hansell, Peter
610'.28 TR708

ISBN 0–85200–043–X

Printed in Great Britain by W. S. Cowell Limited, Ipswich

Preface

The entire practice of medical photography and medical illustration as we know it today may be said to have been pioneered over the last quarter of a century. During this span much progress has been made in the establishment of standards, qualifications and codes of practice in one country or another, but by virtue of the compact nature of the specialty few authoritative texts on the subject have emerged.

This entirely new collective work, coming in the first instance from Europe in translation, but containing additional contributions from the United Kingdom and the United States of America, must be welcome in these changing times to those embarking on medical photography and illustration as a career. Moreover, it will offer considerable guidance to medical teachers and others who may wish to be informed about what is available and the part they can play in the production of their own material.

The photography of patients is fundamental to the whole process and involves not only adept photographic technique, but the sympathetic management of sick and often bewildered people, which brings in its wake a host of ethical considerations. These two most important aspects open and close the book, and within this framework it has not been the intention to cover the subject comprehensively, but rather to concentrate on those aspects which tend to comprise the daily routine, with more than a passing glance at requirements in some of the specialized fields such as endoscopy and ophthalmology.

The production of immaculate photographs avails nothing if they cannot be utilized to the full and here it is refreshing to find adequate emphasis being placed on the mundane auxiliary tasks of copy work in all its aspects, be it radiographs, text, or graphs. This forms an ever-increasing proportion of the workload of any medical photographic establishment and it seems important that it should be tackled effectively and imaginatively; thus due attention has been paid to the design aspect of the end product.

The text has wisely been shorn of details that are to be found in general photographic textbooks. Instead it leads the reader to consider in broad terms not only the special techniques peculiar to the subject, but also to accept lessons that are available for the taking from other established spheres of photography. It attempts to be an intensely practical book and at all times the would-be practitioner is encouraged to experiment with the object of developing his own techniques and general approach to the subject. All this is reinforced by a wealth of specially prepared diagrams to illustrate set-ups and lighting techniques as well as carefully posed examples of a variety of clinical material, mostly in full colour.

In such a collaborative effort and particularly one involving translation from another tongue in the large part, the task of the editor remains a difficult one; not only in terms of interpretation, but also at those points where it has been deemed necessary to insert or delete material for the sake of continuity or completeness. One has striven not to alter the intent or meaning of the text in any way and in this respect I must praise the translators while at the same time craving the forebearance of the original contributors who have assembled such a useful text.

London, April 1979 Peter Hansell

Contents

The photography
of patients

1. The photography of patients By Dietmar Hund

1.01 Introduction

Patient photography may be of value for a variety of reasons. Such photographs may be used to support a tentative diagnosis, or may serve as a starting point for a whole series of photographs documenting the course of a disease or accident. They can be used for diagnostic purposes, but may also influence the medical decision taken in a departmental conference with respect to further treatment and choice of method. The photographic illustration of the history of the patient's condition can sometimes tell us more than any detailed description. All this serves to underline the significance of patient photography for purposes of instruction and further training.

Nowadays, especially when audiovisual instruction methods are proclaimed as the pinnacle of modern teaching, slide pictures of patients are of the utmost importance. The same is, of course, true for congresses and for lectures. However, the author is of the opinion that even the best slide material cannot always be regarded *a priori* as the best teaching medium. This applies in particular if the condition concerns the movement, speech or psychological condition of the patient; in such cases teaching by demonstration on the patient himself will always be necessary, or alternative media such as film and television will have to be explored.

The photographic documentation of a patient is of obvious interest for clinical purposes; all the more so if such documentation is filed in a logical manner and is readily retrievable by all those who are entitled to access. This is supported by the multiplicity of sophisticated filing systems already available; a discussion of these, however, would be outside the scope of this chapter.

The desire to obtain all-embracing patient documentation without gaps is understandable, but it makes excessive demands on the capacity of photographic departments, especially in large hospitals. It may be helpful to distinguish between those medical conditions which are important enough to document and the multiplicity of control photographs which are carried out on a purely routine basis. It is certainly possible for uncomplicated routine photographs to be taken by hospital staff themselves, using either mounted assemblies or other suitable equipment. This naturally presupposes a photographic situation which can be handled using simple techniques and requiring little instruction of personnel.

1.02 The patient

The patient is sometimes aware that photography is a procedure which is not an essential part of his or her treatment and as long as extremities such as arms and legs are being photographed will accept and understand this. The situation becomes much more delicate if the entire body or the genitals are to be photographed. It is also obvious that patients with physical abnormalities such as obesity, deformities and the like may be embarrassed in front of the camera. Some very obvious procedural rules may be helpful here. A considerable degree of flexibility is demanded on the part of the photographer. Should the photographer be male or female? It is one of the cardinal rules that the photographer should be of the same sex as the patient in critical situations if this is at all possible; otherwise arrangements must be made to have a chaperone present. Discussions with the patient about his condition, or about the prospective consequences of an accident are not uncommon and although such conversations are

easier between members of the same sex they should be entered into guardedly.

A second rule concerns the doctor who asks for the picture to be taken. Every patient should be notified of the intention to photograph him or her. This rule is particularly important when photography places an additional psychological stress upon the patient, or when the person concerned has doubts about the preservation of his anonymity in the picture. The presence of the doctor sometimes helps to calm a patient down. Briefing of the photographer beforehand enables him to prepare the necessary setting, such as illumination and background and to adjust for special situations. It is also important that the photographer should react with caution when confronted with patients who express a desire for further medical information. Such a desire is understandable, but it can only be met by the doctor himself.

A further important rule which must be mentioned is the need for a closed or fully screened area while the patient is being photographed. The presence of people not involved in the work itself, or interruptions by third parties, whether medical staff or other photographic personnel, must be avoided at all costs. From the patient's point of view this interferes with his privacy. In order to avoid any suggestion of alleged negligence on the part of hospital personnel it is necessary for photographic assistants in large and small hospitals alike to remember the fundamental principle that they are working for the good of the patient. Consideration for the patient should take precedence over all else.

1.03 The approach to photography

1.031 *The studio*
Space requirements generally depend upon the type of photography that the photographer is expected to carry out. Photography of the full-length figure determines that a studio for general patient photography should have a *minimum* floor area of *5×7 metres*, with a ceiling height of *at least 3 metres*. A correspondingly wide door opening should be provided to accommodate a hospital bed.

1.032 *Studio equipment*
A sufficient number of electric power points is an absolute necessity in a photographic studio. *For photographing patients 5000 watts* should generally be sufficient. *For large scale photography (or even film sequences) a minimum of 10,000 watts is required.* Apart from the background, colours should be avoided so that undesirable colour reflections are avoided. The walls and ceilings should be painted matt white and flooring should be of a neutral mid-grey colour. The question of backgrounds will be discussed in Section 1.04.

1.033 *Camera equipment*
Should a miniature (35 mm) or a medium format (4 × 4 cm or 6 × 6 cm) be used? It is not the intention to indicate a rigorous preference for one or the other of these formats; firstly because most photographers have already made their own decision (where possible *both* formats should be available) and secondly because of the differing requirements of various hospitals and institutes. These considerations are quite distinct from any financial implications. It is customary to use miniature format for the photography of patients, presumably because the square picture medium format can less frequently be usefully exploited here than, for example, in surgical photography. A comparison of the two formats may be found in the chapter on surgical photography (Figs. 83, 84 and 85).

Although the choice of any particular make of miniature film (35 mm) camera is difficult, close consideration of the wide range of often excellent products on offer in the market reveals that the *quality differences between single lens reflex cameras* are only minimal nowadays. It is no longer possible to keep track of technical developments, particularly with regard to the quality of lenses. There is therefore little point in philosophising about the advantages and disadvantages of individual systems and makes. If the camera is not to be used exclusively for patient photography, attention should be paid to its other possible uses and the versatility of the complete equipment set-up.

1.033.1 Lenses
For most photography of patients it is necessary to use a *long focal length lens (about 105–135 mm)* when work-

ing with a 35 mm camera. This removes distortion due to perspective, especially in the vicinity of the head, the hands or of one arm.

Extreme close-ups, of areas such as the mouth, require a long extension of the lens from the camera, whilst photography of the thorax, for example, requires a shorter extension. In order to enable one to select an extension for any desired subject area (i.e. for normal to short distances from camera to subject) *the lens must be used in conjunction with a bellows extension unit. Macrolenses of 90–105 mm focal length* also fulfil all requirements for the photography of patients. Thanks to the long-focusing mount it is unnecessary to purchase a bellows unit. *Photography of the entire body* requires a *normal focal length of ca. 50 mm*, if studio space is at a premium.

1.033.2 Filters (UV and correction filters)

Every new film should first be checked for suitability and be adjusted with lens filters, if necessary, before placing a firm order for large quantities. In the photography of patients even minor deviations (e.g. of skin colour) can influence colour reproduction. Colour correction filters (e.g. Kodak colour compensating gelatin filters) are placed in the camera filter holder which is usually provided. However, it is better to screw the filter directly on to the lens. This requires a matching filter ring and two pieces of optical glass which have been ground parallel. The compensating gelatin filter is carefully cut out and clamped between the glasses in a dustfree atmosphere taking care to avoid Newton's rings.

1.033.3 The tripod

For most patient photography the camera should be mounted on a rigid but movable tripod. Tripods on castors facilitate work in the studio, particularly so because the distance between camera and subject and the viewing angle may be changed frequently between shots. Apart from this it is exceedingly difficult to achieve sharp focusing in extreme close-ups (e.g. skin surface) without a tripod because of the absence of clearly marked reference points. For comparative purposes some patient photographs have to be repeated at intervals under identical conditions. In such cases the use of a tripod, together

with appropriate floor markings should, among other things, make it easier to keep to an image of constant size.

1.034 *Comparative photography*

It is often very difficult for the photographer to produce an accurate reproduction of asymmetries and differences in size and angle. Suitable marks on the studio floor, measuring the distance from patient to camera, or millimetre marking of the bellows extension, etc. may suffice to some extent, but these are mere improvisations. Even the smallest change in the angle of the shot, due to changes in the position of the camera or of the patient himself, prevents a perfect comparison. Fixed installations consisting of a chair for the patient which can revolve automatically in all directions, tripods and camera assemblies mounted on runners and centrally controlled fixed and movable lamps will sometimes allow one to approach perfection. However, such perfection is countered by the need for perhaps disproportionate expenditure on space, technical and financial resources. For the study of growth processes one often uses calibrated scales marked on walls, or black wires fitted to wooden or metal frames. Both these grid systems are quite laborious and expensive to prepare, require much space and, in the case of painted-on grids, are affected by interfering shadows *produced by the patient who must stand right up against the background.*

In most cases it is much simpler and neater to use a built in graticule. A glass carrying an etched millimetre graticule is glued into the film plane aperture of the camera (Fig. 1) and in this way a grid is sharply reproduced on the film (Fig. 2). The direction in which the camera should be pointed can be conveniently established with a line marked on the floor and a levelling device on the camera. As distinct from the wall grid, the built in graticule is very versatile and subsequent mounting of a millimetre graticule on the slide is not necessary. Possible fields of application include deformities of the spine, shortening of one or other limb, photography for cosmetic surgery, large tumours, and so on.

1.035 *Illumination*

The selection of suitable lighting equipment for photo-

1. Glass with graticule in the film-plane of the camera.

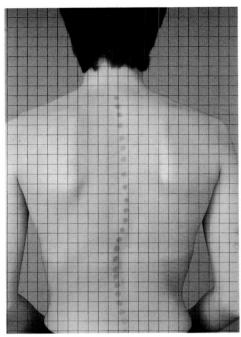

2. Photograph taken with the built in millimetre graticule.

graphing patients is nowadays simplified by the multiplicity of devices on offer. Tungsten lighting is clearly not as convenient as flash. The short duration of flash lighting makes it possible to take pictures of rapidly moving children or patients with tremors. The high efficiency of studio flash units enables one to use a comparatively small aperture and thus achieve greater depth of field, which is undoubtedly an important requirement for any close-up, particularly when photographing a patient. In the case of so-called 'compact flash units' the power supply is incorporated in the unit — in contrast to other studio flash equipment. This eliminates the mains cable as well as the rather cumbersome thick flash cable connection from the power pack. If the individual synchronising cables of the compact flash units are attached to the studio ceiling, the floor of the studio remains clear of the usual spaghetti-like profusion of cables while the mobility of individual lamps is maintained within a certain radius. The flash intensity of each lamp is infinitely variable, and the built in modelling light varies in brightness correspondingly. Suitable variations in the lighting are

achieved by means of differing interchangeable reflectors and screens.

For the photography of patients a total of four such compact flash units will generally suffice. Two of these should be equipped with *soft lighting reflectors* and perhaps additional diffusion screens. Two compact flash units should serve for background illumination, or as contour lights, and must be equipped with *wide angle reflectors.*

1.035.1 Stands for lighting equipment

What has already been said on the subject of camera tripods applies in particular to the mobility of illumination equipment. Permanently and rigidly mounted equipment only makes sense when highly specific series of pictures have to be taken over an extended period of time and in which identical illumination is considered to be important. Normal patient photography, however, often covers a wide range, especially in larger hospitals, and this requires as flexible an illumination system as possible. Movable lamp-stand devices are necessary for this purpose.

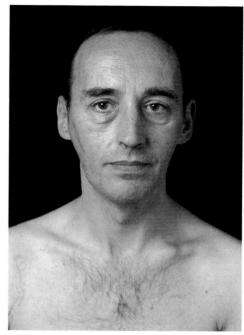

3.—6. Comparison of background colours: influence on skin tones.

5.

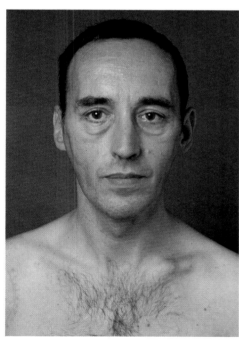

4.

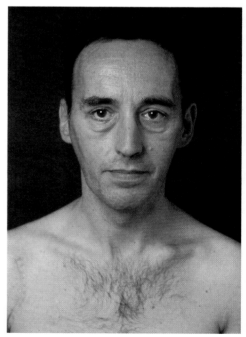

6.

1.036 *Exposure time determination*

The camera lens aperture is determined by using a flash meter. In time, however, personal experience should make preliminary measurements superfluous in any given case. Aperture variations of plus or minus one half-stop produce safe results until confidence is established.

1.04 The background

It is obvious that the background should be unobtrusive and neutral in texture and colour. There is no excuse for parts of cupboards, wash basins, pipes or curtain folds to appear in the picture area. The clothes of the patient or medical staff, as well as bedclothes, tablecloths and the like are liable to produce a similar disturbing effect. Operating theatre drapes can often be used to tidy up an untidy area.

1.041 *Body colour*

Figures 3, 4, 5 and 6 show that the colour of the background is not only a matter of taste or of what happens to be available; the reproduction of the basic colour of the foreground, such as the colour nuances of the skin, also enter into consideration. A neutral mid-grey is best suited to skin tones and softens the severe contrast that would occur with a black background.

The reproduction of skin tones *in black-and-white photography* also constitutes a fundamental problem. The examples show that a black or a white background produces apparent changes in skin tone. A dark background produces a lighter effect, while a white background produces a darker result (Figs. 7, 8). When photographing in black-and-white, a mid-grey suitable for colour reproduction can sometimes suppress the 3-dimensional aspect of the subject because of the similarity with the reproduced grey tone of the skin. Practical and suitable background material may be obtained in the photographic trade in the form of large size rolls of paper about 2·5 to 3 m wide and about 10 m long. Such background rolls are fixed to brackets on the ceiling or on the wall, and they can be rapidly replaced.

7. Dark skin tone with light background.

8. Light skin tone with dark background.

1.042 *Body form*

For recording a patient's movement or the shape of his body, e.g. his gait, posture etc., the reproduction of the colour nuances of the skin is of secondary importance. A relevant example shows that a black background is of advantage in this type of photography (Fig. 9). The reflection factor of black velvet is very low (1%), which causes the material to absorb almost all the incident light. Velvet, as distinct from a black paper surface, produces a deep black background and hence helps to achieve sharp body contours (compare Fig. 126). Photography of the entire body requires the provision of a velvet background of about $2 \cdot 5 \times 6$ m. Individual lengths of material should be stitched to one another with as little longitudinal shrinkage as possible. As with all other background rolls it is suspended from its broad edge and is brought out onto the floor with a slight curve between the wall and the studio floor, thus avoiding a sharp boundary between the two. In this way one makes sure that attention is focused on what really matters, namely the patient, especially in movement studies, and no distractions, however slight,

9. Black background for photographs of the whole body.

arise from horizontal lines and the state of the flooring. In addition, uniform illumination of the background is more easily achieved in this way.

1.05 Rules for illumination

Any attempt to establish fixed rules for illumination is doomed to failure. It is true that photography of patients, in general, is one of the least complicated fields of activity in hospital photography, but the sheer number of completely different medical conditions generally demand different methods of illumination for each individual case. However, it is possible to list basic types of illumination whose effects can be applied to patient photography in general terms and which may be varied in accordance with the job in hand.

1.051 *Frontal and spotlighting*

As shown in the example (Fig. 10) flat illumination may be applied for recording colour changes in the skin where neither the structure nor the shape of the surface is of interest (Fig. 11).

Spotlighting (Fig. 12) is appropriate if the structure and form of the skin surface in the above example are to be recorded (Fig. 13). Fine colour differences tend to disappear with this method of illumination. In order to make the hard incident shadows which arise somewhat lighter, a white cardboard reflector is used. This indirect lighting merely serves to identify the missing contours on the shadow side and must never impede the structural presentation.

A compromise may be achieved by using two lamps with a strong lateral spotlight and an additional weaker frontal light (Fig. 14). Such a type of illumination probably achieves the best results whenever both colour changes and the structure of the skin surface are of importance (Fig. 15).

Observations of this type, however, can often also be made with a single lamp, provided that this achieves uniform illumination of the surface to be photographed. The compromise between colour reproduction and the reproduction of surface structure is based upon the variation of

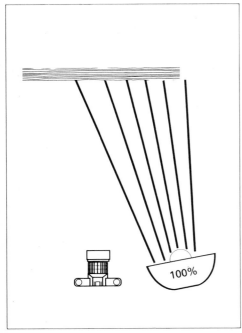

10. Frontal lighting (flat illumination).

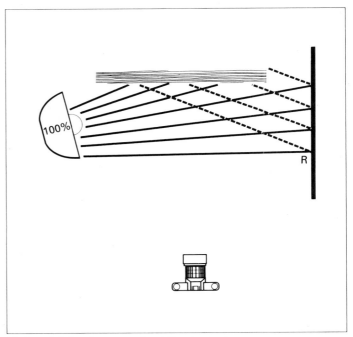

12. Spotlighting (acute angle of illumination).

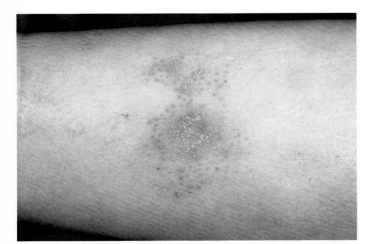

11. Illustration of skin lesion with front lighting: no relief, clear colour differentiation (Photo: A. Kradolfer).

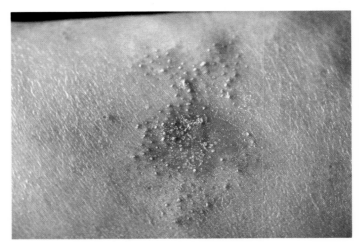

13. Illustration of skin texture with spotlighting: greater three-dimensional effect, reduced colour differentiation (Photo: A. Kradolfer).

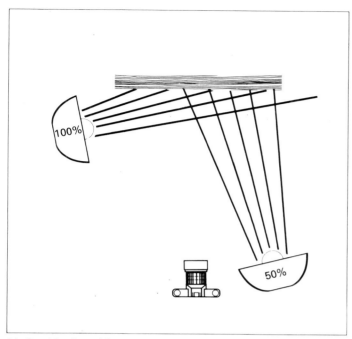

14. Combination of frontal illumination and spotlighting.

the angle between the two extremes of frontal and lateral illumination and the level of illumination (Fig. 16). Using a suitable angle of illumination it was possible, in this particular case, to bring out both the colour and the 3-dimensional characteristics of the condition. An additional lamp would have destroyed the bubble effect and would have produced unnecessary reflections.

1.052 *Controlled illumination*

As is well known, light and shadow are the only means in photography whereby prominences and depressions of a surface can be identified. Lateral illumination (which is approaching back-lighting) produces a longer or shorter shadow, depending upon the angle of illumination; this enables the photographer to emphasize conditions such as those seen in Figs. 17–20. Here too a lightening of the shadow areas is recommended, using either a white reflector or a weaker lamp for fill-in.

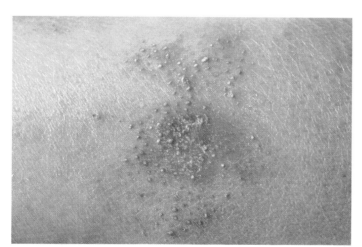

15. Illustration of skin lesion with combined lighting: both structure and colours well differentiated (Photo: A. Kradolfer).

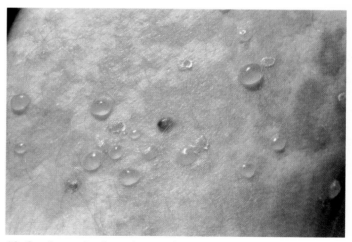

16. Good reproduction using *one* lamp at a suitable angle of illumination (Photo: A. Kradolfer).

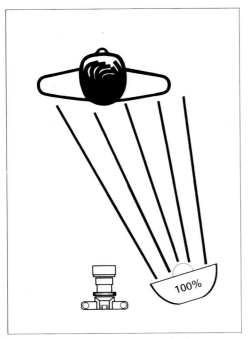

17. Frontal lighting (flat illumination).

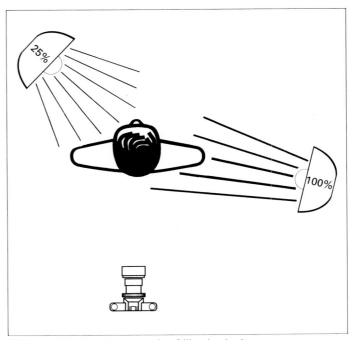

19. Lateral lighting (acute angle of illumination).

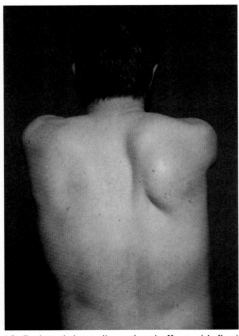

18. Reduced three-dimensional effect with flat illumination.

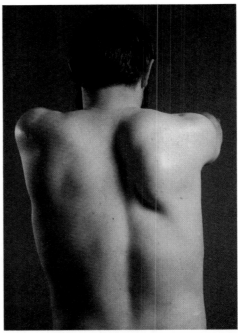

20. Enhanced three-dimensional effect, clear shadows: emphasis on the presenting condition with lateral illumination.

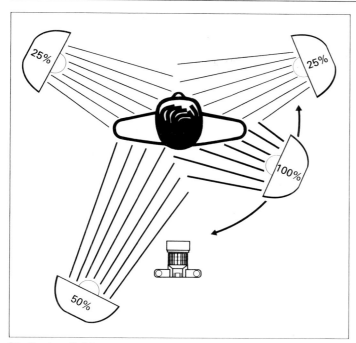

21. Contour lighting.

The real criterion of correct illumination in patient photography is whether it is possible to achieve an exact comparison between the initial and corresponding post-therapeutic appearance of the patient. Illumination can produce such a comparison either in an exaggerated or an attenuated form. There is a particular danger, especially in plastic surgery (e.g. in the recording of scar tissue before and after an operation) of subconsciously influencing an objective record by uncontrolled illumination.

The following rules should therefore be observed in order to achieve objective documentation:

— In order to achieve a fair comparison, the recording of the pre- and post-operative picture should, as far as possible, be based upon identical methods of illumination;

— Extreme lighting effects are generally to be avoided.

The latter may be a matter of degree. Small and almost invisible conditions of the skin surface such as lumps,

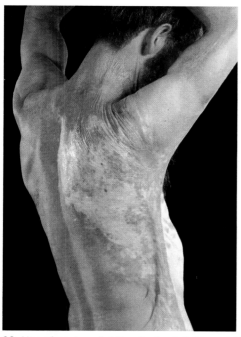

22. Use of contour lighting for back light modelling.

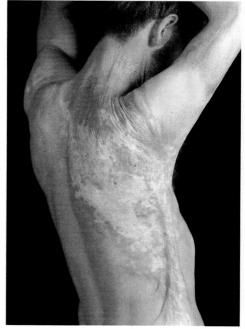

23. Absence of contour lighting.

swellings and the like may be brought out by illumination in the most dramatic manner. Larger features which are quite readily seen by the unaided eye, on the other hand, must be taken without any exaggerated lighting effects.

A unilateral change of the skin surface or of the body shape, e.g. of the left side of the neck, the right leg, shoulder or hand, can often only be appreciated when it is compared with the healthy side. This is why it is important to take a picture or slide of the *whole* neck, *both* legs, shoulders or hands, side by side, and at the same time, especially when the condition shows relatively small changes (compare Figs. 7 and 8).

1.053 *Contour lighting*

Contour lights (Fig. 20) are additional, subordinate side lights and they must not affect the main lighting in any way. A lateral facing light yields sharply defined body contours and, on occasions, even slightly controls back-lighting (Fig. 21).

However, because of the lightening effect the contour light must be used with restraint and it must not dominate in any way. Figure 22 shows a picture taken with contour lighting, while Fig. 23 shows a picture of the same person taken without it. In the latter the outline of some body parts becomes indistinct against the background — for instance, the left arm in the left upper corner.

1.06 Photography of movement

A sequence of movements which must be split up for presentation into a series of separate pictures is, at first sight, inferior to a motion picture sequence. Whilst the methods of film making are capable of documenting the total course of a movement, an individual still photograph can show only one aspect of it. This makes it difficult to demonstrate movement by means of conventional slide projection. Neither can a substantial improvement be achieved by the projection of a series of individual slides. This leaves us with the possibility of confining ourselves to the most important phases of the movement. *The mounting of a number of individual stills on one slide* (Fig. 24) is probably the most effective method of show-

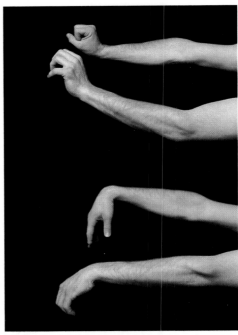

24. Mounting of two slides: beginning and end positions of a movement.

ing several phases of movement. This technique is especially appropriate when recording a cycle of events in which the beginning and the end phase, rather than the course of the movement itself, are generally of interest as the reference points of the event. A black background again facilitates neat mounting.

Another rather more complicated solution is to illustrate the course of the movement by means of multiple flashes (stroboscopic flash) (Fig. 25). The effect of motion is thus obtained more certainly; however, the effect one is trying to record may sometimes be masked by the technique. Movement which is only slightly atypical can often be satisfactorily demonstrated only by means of motion pictures. Functional or comparative photography, on the other hand, when presented in the form of mounted slides, provides useful information about the most important phases of the motion.

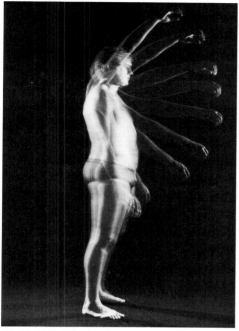

25. Multiple illumination by stroboscopic flash.

26. Impression of a psychiatric condition conveyed by choice of background, position and illumination.

1.07 Photography and psychiatry

With the exception of psychiatric hospitals, the photography of patients whose diagnoses are predominantly characterised by their psychological condition and where this is demonstrable by photographic methods, tends to be rare. The choice of background and the location of the camera therefore both contribute to the actual result; this is demonstrated by the extreme example shown in Fig. 26.

1.08 Summary

The limits of the application of photographic techniques for patient photography are reached when exact values and statements are pictorially refined. It will be readily understood that this chapter on patient photography can convey only the most important basic features. The multiplicity of specialised hospitals with correspondingly different requirements demands that photographic assistants be suitably experienced and equipped and are capable of technical flexibility. The fundamentals given here are intended to provide a basis — certainly for assistants who are as yet inexperienced and possibly even for those who are already more advanced practitioners.

Ophthalmic photography:
a survey

2. Ophthalmic photography: a survey

By Phillip Hendrickson

2.01 Introduction

In any contemporary book on medical photography there must be included at least an introduction to one of its most specialized branches, ophthalmic photography. It should be noted that a professional ophthalmic photographer is often called upon to perform operation photography, specimen photography in ocular pathology, copy photography, as well as general patient photography. Obviously, a great number of considerations concerning the art and the science of medical photography apply also to this specific field; ethical questions involved in medical photography such as the patient's right to privacy, their sensitivity about their physical abnormalities and infirmities, as well as their general psychological condition are certainly of equal concern in ophthalmic photography, where one is often confronted with individuals experiencing an alarming decrease in vision or even the tragic onset of blindness. Furthermore, one faces the same technical problems as in medical photography, such as films, filters, perspective, reproducibility of photographic records, and camera equipment. These problems have been thoroughly discussed in other chapters of this book, so it remains for this section to provide a survey of those techniques unique to ophthalmic photography, including both those that the general medical photographer can perform for the most part with equipment already at his disposal and those more specialized and elaborate methods which he can use to solve a particular problem. For the sake of brevity, many technical details have been left to individual investigation of the literature, for which purpose a bibliography has been provided.

2.02 Photography of the external eye

2.021 *Photographic range*
In general, photographic applications may be arbitrarily divided into large-field photography (from infinity to 1 metre), close-up photography (1 metre to the reproduction ratio of 1:8), macro-photography (from 1:8 to 20:1), and photomicrography (20:1 or greater). The category that encompasses the reproduction ratios most often used in external photography of the eye is that of macro-photography (Hansell).

2.022 *Camera equipment*
If one regards the lowest magnification of most photo-slit-lamps as being 2:1 we can see that all lesser magnifications are readily attainable with a modern single-lens-reflex (SLR) camera body and macro-attachments such as bellows, supplementary lenses, as well as special macro-lenses, all of which are fully discussed in the chapters on specimen-, operation-, and patient photography. An ideal arrangement (Aan de Kerk, Neubauer and Bockelmann) might include an SLR camera body, a bellows with its own focusing rail along which the lens-to-subject distance can be adjusted without changing the overall magnification and a short (90–115 mm) telephoto lens especially constructed for work with a double-cable-

release and bellows, permitting focus between infinity and about 2:1. Alternatively, a commercially-available medical objective lens with its own built-in ring-flash, modelling lights, and colour-coded system of supplementary lenses for magnifications of 1:6 to 3:1 can provide a most useful reproduction range, bearing in mind that ring-flash illumination is not entirely suited to much ophthalmic work.

2.023 *Background, supports, focusing lights*

If at all visible in an external photograph of the eye, the background can play a considerable role in determining the visual impression of the tonal values of the subject. In work involving an evaluation of slight changes in skin tones, a medium-dark background colour should be used, either green, blue, or grey and, above all, should remain the same for all follow-up photography. This may be difficult to achieve.

Highly recommended as a working unit is a frame of normal table height (about 1 metre) with an adjustable chin rest and a table top which can be moved freely on the frame along the axis of photography. Such a set-up avoids readjustment of the patient by allowing the camera to be moved relative to the patient according to the desired magnification. Furthermore, the fixed patient thus remains at the same distance from the background, additionally assuring uniformity of photographs. On such a sliding table top, a stand of adjustable height may be securely mounted and the camera with bellows attached, preferably with a quick-change shoe. Also desirable is the ability to move the entire camera unit from side to side when photographing individual eyes.

For photography in the close-up range, it is often desirable, though not always absolutely necessary, to be able to predict the effect and position of the flash light and the resulting reflexes and shadows depicted in the photograph (Fig. 27). Here, a focusing light which as nearly as possible represents the source of flash light is recommended. Such a focusing light can be located either immediately next to or even in front of the flash tube when the construction of the flash reflector permits. For close-up reproduction ratios up to about 1:8, one could use a ring-flash mounted separately from the lens with the focusing lamp positioned within the ring itself. A flexible

27. Facial tumour with shadow relief (1:3).

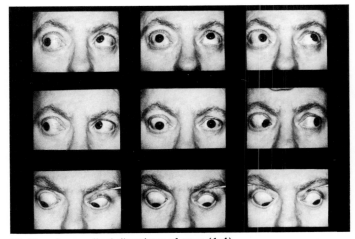

28. The nine cardinal directions of gaze (1:4).

supporting arm allows this lighting unit also to be mounted on the sliding table top. It has to be remembered that such an arrangement will tend to give circular reflexes. The intensity of the focusing lamp should be regulated by a rheostat or variable resistor to provide adjustment of the light level according to the sensitivity of each patient.

2.024 *Recording the nine cardinal directions of gaze*

In ophthalmic photography it is frequently necessary to record the range of eye movements, as in cases of congenital strabismus, orbital tumours, etc. Both eyes are photographed at a magnification ratio of about 1:4 while attempting to gaze at distant fixation points in the following directions: straight ahead, straight/up, right/up, direct/right, right/down, straight/down, left/down, direct/left, and left/up (Fig. 28). Sometimes it is easier for the patient to follow the examiner's finger. To facilitate evaluation of the degree of deviation from normal gaze by observing the variation in the reflexes of the flash upon both corneas, the flash source should be coincident with the axis of photography, for example, directly above the lens barrel.

2.025 *Photography in the macro range*

When photographing at a magnification considerably greater than 1:8, especially between 1:1 and 3:1, the need to predict shadow modelling effects and, often more important the location of the flash source reflex, demands a special solution. Here one must attain total coincidence of the axes of the focusing light and of the flash source. Some commercially available medical flash units utilize a beam-splitter or prism to bring the pathways of both light sources into coincidence. In another solution to this problem, the focusing light may be beamed directly through the transparent flash tube, from which the light is collected not by a concave mirror or reflector but, instead, by an optical condenser. A comparison of the illumination effects obtained by using a ring-flash and a spot flash (about 12 mm diameter) from different angles may be seen in Figs. 29–31. For such photographic effects, it becomes mandatory to be able to predict the results when actually composing the picture through the viewfinder.

2.026 *Slit-lamp photography*

Most camera lenses commercially available today are capable of high resolution at magnifications up to 1:1 or 2:1, but for work at higher magnifications they often prove to be insufficient for the critical user. Here we enter the field of application of the photo-slit-lamp. Since its invention in 1911 by Gullstrand, the slit-lamp has become one of the most important diagnostic instruments available to the ophthalmologist. The development of high performance flash sources and modern high resolution films has led to the adaptation of the slit-lamp to enable photographs to be taken through its optical system, recording serial views as seen by the ophthalmologist during his examination (Meyner). Characteristic of modern photo-slit-lamps are the high resolution and variable magnification of their binocular optics, the adjustability of its observation light source, and the coincidence of the camera/flash pathway with the observation and illumination pathway. These two principal pathways coincide at a point which is simultaneously the plane of focus of the optics and the axis of rotation of the optical and illumination units. This permits total control of all the elements of the entire system, affording observation and photography with four basic types of illumination (Littmann): (a) general or diffuse illumination, which in the lesser magnifications produces results similar to Fig. 30; (b) localized illumination, often at higher powers of magnification, bringing fine structures into isolated view, as seen in Fig. 32; (c) retro-illumination, by which structures behind the point of interest are illuminated to provide a bright background field to display the subject as a silhouette, an effect already seen in Fig. 31; and (d) slit-beam illumination, providing a narrow (often 0·1 mm or less) sectional view through the cornea and the lens (Fig. 33). These various methods of viewing and photography are often used in combination to achieve comprehensive documentation of anterior segment pathology. It is also possible to achieve stereo-photographs with some instruments, three-dimensional information being of great importance in slit-lamp examination.

2.027 *Other special techniques*

From the basic photographic processes mentioned above,

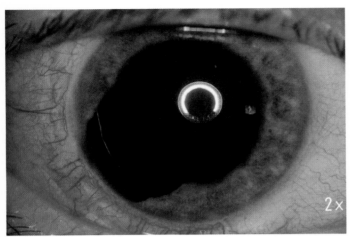

29. Iris resection, photographed with ring-flash (2:1).

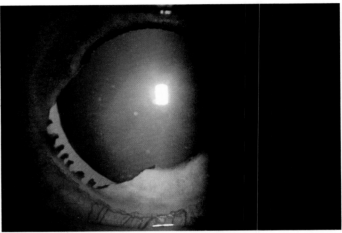

31. Same as Fig. 30, but with the illumination pathway almost coincident with the camera axis: retro-illumination effect (2:1).

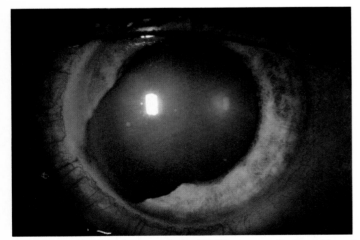

30. Same as Fig. 29, photographed with 12 mm spot flash positioned laterally (2:1).

a number of specialized methods for further documentation of ocular pathology have been developed. Simply listed for brevity, they include: stereo-photography in the macro range (Donaldson); gonioscopic photography (Mikuni), a technique for recording details within the anterior chamber angle especially important in certain forms of glaucoma; an adaptation of the Scheimpflug principle (Scheimpflug) to 35 mm macro-photography for quantitative examination of the process of cataract formation (Niesel, Brown, Dragomiresen); retro-photography with the fundus camera, another method for recording cataracts (Hockwin, Hendrickson); and iris angiography by which the dynamic circulation through the blood vessels of the iris is examined with rapid-sequence photography of an injected tracer dye (Bruu-Jensen, Craandijk, Kottow, Fincham) (see 2.035).

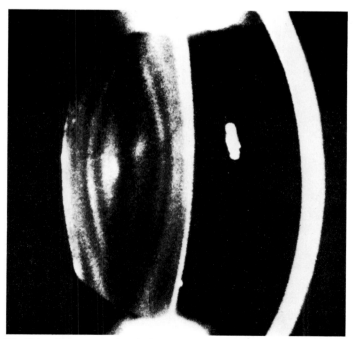

32. Fine pupillary fibres in localized slit illumination and at higher magnification (4:1).

33. Thin slit-beam sectional photograph of the lens and cornea (right) (2·5:1).

Photo-keratography, in which a geometrical target is imaged on the cornea, provides information not only about the lustre of the cornea, but also about its radius of curvature (Fincham).

2.03 Photography of the ocular fundus

2.031 *Introduction*

The development of the fundus camera (von Haugwitz) derives from von Helmholtz's invention of the ophthalmoscope in 1851 and Gerloff's first photograph through a hydrodiascope in 1891. Following the introduction of the reflex-free ophthalmoscope in 1910 by Gullstrand, the carbon-arc device of Nordenson was developed in 1925 in collaboration with Zeiss and this was the first production-line fundus camera. The post-war or modern fundus cameras employ highly efficient electronic flash tubes and provide repeatable records of details of the ocular fundus in natural colour and high resolution. The majority of the most successful models currently available share the characteristic of utilizing a mirror containing an aperture to permit illumination and observation/photography through the same objective lens system (Fig. 34). Some of the various ways in which the fundus camera can be used are mentioned below.

2.032 *Technical considerations*

Most modern pedestal-type fundus cameras employ reflex viewing of an upright image encompassing about 30° of the ocular fundus, thereby allowing the 15° distance between the head of the optic nerve (which itself covers 6° having a diameter of 1·8 mm) and the fovea centralis, plus some of the surrounding area to be photographed on a single film frame (Fig. 35). This implies a magnification of about × 2·5 on the film. The entire optical system is calculated on a basis of the total refracting power of the normal human eye of about 58 diopters, with the employment of an aspherical objective lens to correct for the curvature of the retinal surface. Supplementary lenses can be introduced into the system to make adjustment for gross variations from the normal condition (for example, in cases of myopia or aphakia). Astigmatic corrections

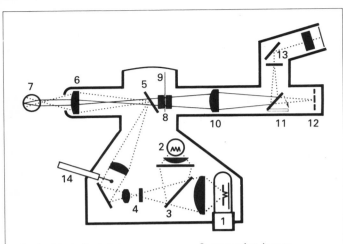

1 electronic flash tube	8 correction lenses
2 focusing lamp	9 astigmatism compensator
3 half-silvered mirror	10 30° objective lens
4 apertures	11 reflex mirror
5 mirror with aperture	12 film plane
6 aspherical ophthalmoscope lens	13 ocular cross-wires
7 patient's eye	14 internal fixation object

34. Sectional view of a fundus camera with its optical pathways. (By kind permission of Carl Zeiss/Oberkochen.)

can also be made when photographing peripheral fields. Interchangeable 35 mm camera bodies provide the possibility of using various film materials.

2.033 *Films and filters*

Generally it is desirable to depict the topography of the fundus in its natural colour and rich details are best reproduced by the use of high resolution reversal colour film of about 18° or 19° DIN (50 to 64 ASA) as seen in Fig. 35. The green pigmented naevus, located between the optic nerve head and the fovea, becomes even more apparent when photographed with infra-red film (Fig. 36). The borders of the naevus are more clearly defined by infra-red recording which penetrates the retinal pigment epithelium and to which infra-red film is sensitive (Matsui; Sautter et al.). As a matter of fact, this technique of selective penetration of the layers of the fundus is also useful in black-and-white fundus photography (Amalric; Best and Reuter; Kajima et al.), as seen in the comparison photographs made of the striations of the nerve fibre layer in red-free light (green filter) in Fig. 37, and of the

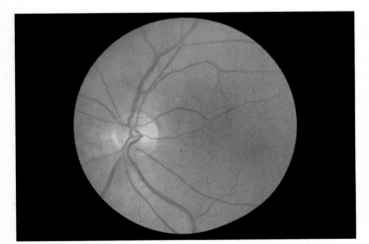

35. Colour fundus photograph of a pigmented choroidal naevus.

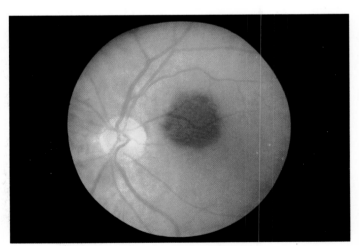

36. Infra-red colour photograph of the same eye as in Fig. 35.

choroidal vessel network made visible in red light (Fig. 38). Both pictures were made with high resolution, fine-grain black-and-white film of 15° DIN (25 ASA) developed in fine-grain developer.

It is worth mentioning the use of Polaroid film materials, to provide photographs for immediate study and comparison, but offering somewhat less contrast and resolution than do 35 mm films (Allen et al.).

2.034 *Handling of camera and patient*

Since critical focusing of the fundus camera is performed by reflex viewing with bright illumination, it is necessary for the patient's pupils to be widely dilated (8–10 mm), often necessitating a wait of half to one hour before the mydriatic drops have taken full effect. A bit of patience here can bring considerable improvement in fundus photography, as a fully dilated pupil permits more uniform illumination of the fundus, eliminates reflexes and can often facilitate focusing to such an extent that the patient need endure a considerably shorter time for examination. While one eye is being photographed, a small fixation point attached to a flexible arm is presented to the other. Proper attention of the patient towards this fixation target can further shorten the photographic session and enhance the precision with which the composition of each photograph is achieved. Generally, it is necessary for the patient to make frequent rests to recover from the rigors of the focusing light as well as from the flash exposure itself. This is especially true when making a so-called fundus panorama or mosaic series of pictures. As the 30° field of view of most fundus cameras is insufficient to record on one picture all the pathological changes associated with diabetic retinopathy or retinal detachment, it is sometimes necessary for the photographer to make a series of slightly overlapping fundus pictures (Lotmar), which can be subsequently joined to present a large field fundus view

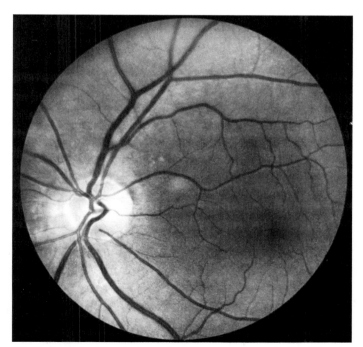

37. Black-and-white photograph of the same eye as in Fig. 35, using a green filter for red-free illumination.

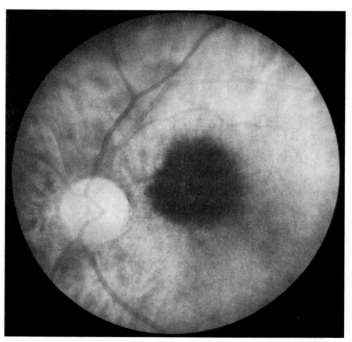

38. Same as Fig. 37, but using a red filter to demonstrate the limits of the naevus within the choroidal vessel network.

(Fig. 39). A recently developed alternative solution to this photographic problem lies in the super-wide-angle fundus cameras which are capable of delivering a 100° to 148° view of the fundus but suffer the disadvantage of using a contact lens (Pomerantzeff; Allen and Frazier). Certain pathological entities are expressed as gross variations in the uniform curvature of the fundus surface, appearing as prominences or depressions. Typical of the former are retinal detachment, certain tumours, and papilloedema, whereas of the latter cupping of the disc is most common (in glaucoma). Such entities are often better recorded in a three-dimensional or stereoscopic view. This can be done by moving the eye under examination, the camera itself, or by an attachment which refracts the image between exposures (Allen).

2.035 *Fluorescein angiography*

As mentioned in Section 2.027, a study of the dynamics of the retinal circulation is facilitated by using a blue exciting light (about 480 nm) to stimulate fluorescence of sodium-fluorescein tracer dye circulating through the retinal vessels, and to photograph such fluorescence on black-and-white film through a yellow barrier filter (Fig. 40a) (Baurmann). By rapid-sequence photography of the circulation of such a dye through the vasculature of the retina, it is possible to record any abnormality in the vascular bed and supportive structures. This technique is particularly useful in determining the location and extent of changes in the continuity of the pigment epithelium, in making the differential diagnosis of malignant melanoma, in observing the results of vascular occlusion and of increased retrobulbar pressure and so on (Shikano and Shimizu; Wessing). The angiographic series presented in Fig. 41a–f demonstrates the arteriovenous phase beginning with 'b' at 13·8 seconds following the start of the dye injection ('a' represents a control picture taken with green light for comparison). In 41b only the arteries have filled with dye, recorded as white in a black-and-white positive picture. Figure 41c shows the returning tracer dye in the veins. This venous filling continues through Figs. 'd', 'e', and 'f' and exhibits typical laminar flow along the inner walls of the veins; 'e' even depicts a thin white line of dye in the middle of the inferior retinal vein resulting

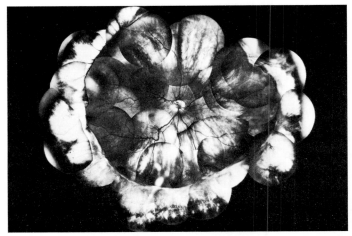

39. Panoramic view of a retinal detachment. The fovea centralis can be seen as a dark spot to the lower left of the optic nerve head in the middle of the picture.

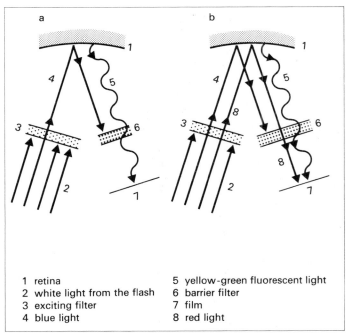

1 retina	5 yellow-green fluorescent light
2 white light from the flash	6 barrier filter
3 exciting filter	7 film
4 blue light	8 red light

40. Schematic representation of the filtration combinations used for (a) black-and-white fluorescein angiography (FAG) and (b) colour fluorescein angiography (CFAG).

from the confluence of the two tributary veins seen at 6 o'clock in the picture. In Fig. 41f (at 21·3 seconds) the abnormal staining of the fundus to the right of the optic nerve-head becomes even more pronounced. A complete series of fluorescein angiograms can cover a total elapsed time of 30 minutes or even an hour.

2.036 *Other special techniques*

The basic technique of black-and-white fluorescein angiography is currently used for the majority of circulation studies of the ocular fundus. Two further, more specialized techniques should be afforded mention: colour fluorescein angiography and infra-red fluorescence and absorption angiography. The former can be of value in distinguishing between true and pseudo-fluorescence in retinal degenerations which may appear white in a black-and-white fluorescein angiogram and, therefore, may be confused with extravascular blood serum containing tracer dye. In this technique (von Rotlicht), the exciting filter transmits not only the dye-exciting blue wavelengths, but also a certain amount of red light to provide illumination of the reddish-orange fundus (Fig. 40b). A comparison of a natural colour fundus photograph and a corresponding colour fluorescein angiogram is presented in Figs. 42 and 43.

This technique offers an additional advantage in that the films may be processed by any commercial colour laboratory, thus eliminating the often prohibitive necessity of specialized darkroom processing associated with black-and-white fluorescein angiography.

The pigmented epithelium layer between the retina and the choroid occludes for the most part the choroidal circulation from fluorescence viewing. To investigate and document pathological changes on the choroidal vasculature, infra-red fluorescence and absorption angiography techniques have been developed (David; Flower). In these cases, the tracer dye used is indocyan-green or 'cardio-green', selected for its particular property of absorbing light at the near infra-red wavelengths (about 800 nm) which passes readily through the pigment epithelium. Its absorption in the choroidal vessels may be recorded through a barrier filter with a transmission threshold of 805 nm.

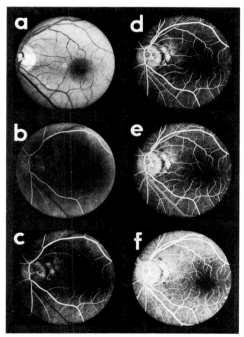

41. Fundus fluorescein angiographic series (see text).

2.04 The future

The emergence of ophthalmic photography as a specialization in itself has depended partly on the creation of the equipment needed for comprehensive examination of the eye and partly on the evolution of highly refined photographic equipment for use with these ophthalmic examination devices. The almost explosive developments in the electronic industry in the last decade promise to enhance greatly the refinement of present methods while offering exciting possibilities in the field of television recording in ophthalmology (Dallow, van Heuren and Schaffer) which could eventually replace the photographic process entirely as processing and electronic data retrieval systems

are relevant to this field. The purpose will, however, remain the same: to provide pertinent, readily available, and consistent documentation of the ocular condition as a supporting and even diagnostic service in the practice of ophthalmology in particular and for medicine in general.

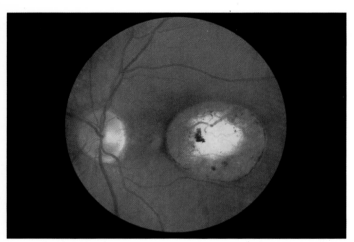

42. Colour fundus photograph of choroiditis in the macular area.

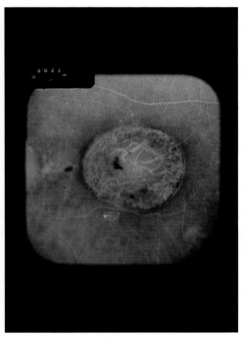

43. Same eye as in Fig. 42, but as a colour fluorescein angiogram.

Photos: Susanne Exinger

Photography in otolaryngology

3. Photography in otolaryngology

By Per-G. Lundquist

3.01 Introduction

Photography in otolaryngology is complicated by the fact that with the exception of the facial surface nearly all the structures to be photographed are hidden within the head and neck. Due to this fact recording of disease or therapy in otolaryngology must often be done with help of endoscopes and/or the surgical microscope. In such instances it is often necessary for the physician himself to do the photography, as knowledge of endoscopical procedure and the related anatomy is necessary for the recognition of features of interest.

The equipment discussed and presented in this chapter is that used by the author and does not necessarily offer the best answer to problems in ENT photography. The equipment used is not so important as the desire to record as much as possible of diseases and results of treatment. Unfortunately this nearly always interferes with treatment procedures, thus it is necessary to develop standard techniques for photography with equipment that is available when it is needed in the clinic or in the surgical theatre.

The following presentation in text and pictures is designed to illustrate how the various parts of the ear, nose and throat can be approached and recorded.

3.02 The face

Photography of the face itself is rarely done in the ENT department, but is usually referred to the hospital photographer. It is only when localized skin tumours, wounds, etc. need to be documented immediately that photography is done in the clinic. This type of photography can seldom be performed under standardised conditions; thus a ring-flash is usually used as the main light source. The usual camera is a Hasselblad 500 with a 120 mm lens and a proxar lens or an extension tube. When 35 mm slides are wanted directly, a Nikon F camera together with a Medical-Nikkor lens has been used for many years with very good results.

When following, for instance, a plastic surgery procedure when many pictures of the same patient will be taken over a long period of time, it is necessary to keep the face to the same scale. With the Hasselblad this usually means a distance of 1·5 m with a 120 mm lens.

3.03 The nose and nasal cavity

In almost any department a good deal of corrective nasal surgery is performed, particularly in cases of congenital deformities or trauma. We feel it necessary to document every patient before and after surgery. This is particularly important for the maintenance of patient morale and as a safeguard in cases of litigation.

3.031 *The external nose*
If possible, photography of the external nose is always done by the hospital photographer under standard conditions. It is important not to photograph the nose too close as that will isolate it from the face and make it difficult to perceive the general appearance of the patient (Figs. 44, 45). In addition to photographs taken from the front and from each side it is advisable to take a close-up

44. Anterior view for corrective nose surgery. Distance approximately 1·5 m. Lens 120 mm with Hasselblad 500 C.

45. Side view of the same patient as in Fig. 44.

photograph of the columella region (Fig. 46). This is easily forgotten but of great help when deformities occur that deform the columella or when the nostrils are asymmetrical. For this type of photography the Hasselblad camera is most suitable.

3.032 *The nasal cavity*

When trying to photograph the nasal cavity we have to resort to very different equipment. The nasal cavity is a narrow space having a depth of about 7 cm and a width of up to 2 cm and a vault rising to about 6 cm. The lateral walls of the nasal cavity include the turbinates and antral ostia. Towards the posterior part of the cavity, above the soft palate, the orifices to the Eustachian tubes are situate.

To record changes in these structures as well as in the nasal septum or nasal mucosa, photography through an endoscope is the only possible solution. Suitable endo-scopes as illustrated are made by several instrument companies. Among those most widely used are instruments from Messrs. Wolf & Storz. For rhinoscopy and nasopharyngeal endoscopy through the mouth we use nasal endoscopes having a diameter of 4 mm and a length of 180 mm.

The endoscopes used in photography of the nasal cavities are fairly thin, which means that the fibre-optic light guide is narrow and thus the light intensity is limited. For this reason electronic flash attachments to the endoscopes are commonly used. These are of two types:

(a) a unit that attaches directly to the endoscope, and

(b) a built-in flash associated with fibre-optic light source. The advantage of a unit attached directly to the endoscope is the higher intensity available without losing light through the light guide. A disadvantage is the bulk, which, as can be seen in Fig. 47, makes it somewhat uncomfortable in use for both doctor and patient.

46. Close-up of the nostrils.

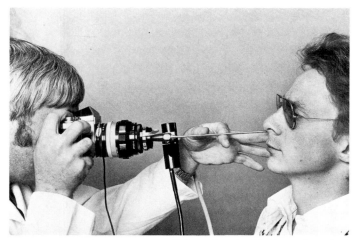

47. Rhinoscope (4 mm diameter, 180 mm long) with 85 mm lens; flash unit mounted directly between the light bundle and endoscope.

A unit built into the light source thus has the advantage of not interfering with the investigation, but some light is lost in transmission through the fibre-optic light guide. With modern light sources flash illumination is usually included in the unit and gives excellent results.

It is advisable to study each manufacturer's instructions on flash units for endoscopy, as very often mechanical movements of prisms or mirrors are required to deviate the light from the normal fibre-optic pathway to that of the flash and vice versa. This may necessitate a shutter speed slower than that normally used for flash synchronization. For instance flash equipment made by Storz cannot be used with shutter speeds above 1/30 sec. in most cameras.

3.032.1 The vestibule and the turbinates
Special endoscopes have been developed for rhinoscopy. Most commonly used are instruments having a 30° or 70° viewing inclination and a diameter of 4 mm. With these instruments it is possible to get a good view of the interior of the nose. If a greater definition of depth is wanted, the 30° optics will give this, as the instrument can penetrate further than the 70° instrument (Fig. 48). The latter instrument will, however, give a more detailed view, as it will usually be closer to the structures studied (Fig. 49). Instruments from 0° to 120° are also available, but they are not often used (Fig. 50).

3.032.2 The ostia of the Eustachian tubes
Photography of the osteum of the Eustachian tube can easily be achieved through a rhinoscope. As illustrated in Figs. 51 and 52, quite different views are produced by 30° and 70° instruments. Both pictures were taken with an Olympus OM-1 camera and a zoom lens (F:140 mm).

3.04 The mouth and oral cavity

Most parts of the mouth, teeth and oral cavity can be photographed with the help of close-up lenses or extension tubes on any camera equipped with a ring-flash. The oral cavity is the largest of all cavities encountered in ENT photography and is the easiest to illuminate. In ENT

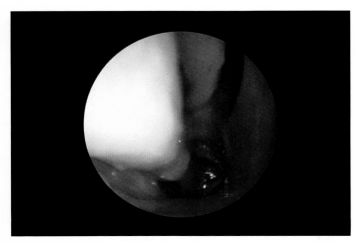

48. Right inferior turbinate, photographed with a Storz–Hopkins 30°
rhinoscope (fitted with an Olympus OM-1 with zoom lens at a focal
length of 140 mm) offering a wide view of good depth.

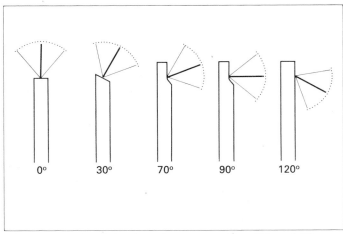

50. Various angles of view in endoscopes used for ENT work. The ones
usually used for the nose are 30° and 70°.

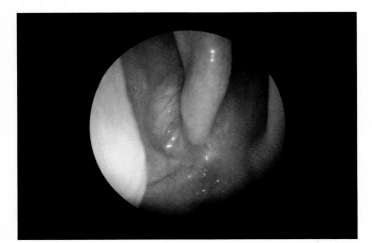

49. As Fig. 48 but with a 70° rhinoscope: less depth of view but better
reproduction of detail due to the closer proximity of the instrument tip.

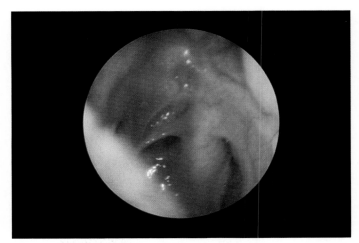

51. Ostium of the Eustachian tube, photographed with the 30° rhino-
scope: the opening can be seen at bottom left, with some mucosal
crypts behind.

work most changes that are photographed occur in the buccal mucosa, in the tongue and in the lips. Tumours and ulcers of the lips are common and are easy to record. No particular skills are required. As indicated in the section on photography of the face a Hasselblad camera or a Medical-Nikkor system are suitable.

3.041 *The lips*
The same equipment is used as for photography of the face and is described in Section 3.02, p. 35.

3.042 *The tongue*
The anterior part of the tongue can be extruded from the mouth and is thus easy to photograph with an external light source (Fig. 53). The posterior third of the tongue must be photographed within the oral cavity and for this purpose ring-flash attachments are the most simple to use. When it comes to depicting malignant tumours it is important to include as much of the floor of the mouth as possible from a lateral point of view as well as the normal anterior view. Due to restricted movement of the tongue because of pain and tumour infiltration it is sometimes necessary to move the tongue to the side with help of a transparent spatula.

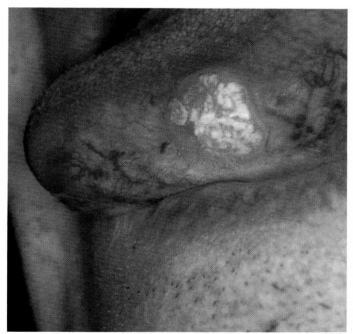

53. Squamous cell carcinoma on the left side of the tongue, photographed with a Hasselblad 500 C, with 120 mm lens, extension ring and supplementary lens. Flash lighting from the right.

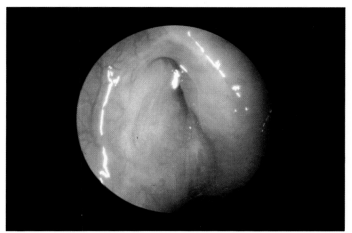

52. As Fig. 51, but photographed with the 70° lens: a clearer picture of the orifice, showing details of the blood vessels in the mucosa.

54. Papilloma of the uvula, photographed with polarised ring flash.

3.043 *Oral cavity*

The buccal mucosa, the tonsils, the uvula and the posterior pharyngeal wall can be easily reached with the help of a medium focal length tele-lens and extension tubes (Fig. 54). If a focal length of about 150 mm is used in the case of 35 mm photography, it is possible to take detailed photographs up to ×2 magnification without any problem. The equipment used in our department is a Hasselblad 500 or Nikon F with Medical-Nikkor.

3.05 The ear

Photography of the ear, that is the external auditory meatus and ear drum, is perhaps the most difficult problem encountered in ENT photography. Due to the anatomical position of the ear drum, approximately 30 mm from the surface and lying within a curved tube about 6 mm diameter, it is very difficult to illuminate the drumhead for photography. The ear drum is also angled in an anterior—posterior as well as in an inferior—superior direction which means that it cannot be parallel to the outer surface of the skull (Fig. 55). Thus, a depth of field of approximately 10 mm is necessary to depict the ear drum sharply at a magnification of ×2 or ×3. This is virtually impossible without the use of an operating microscope and/or endoscope. The advantages and disadvantages of these two approaches are described and discussed below.

3.051 *The external ear*

Photography of the external ear can be carried out with the same equipment as for other external photography. In the case of malformations it must be stressed that photographs should be taken before any surgical procedure to include anterior, posterior and lateral views. The view from behind is very important as this will most clearly demonstrate whether the ears are symmetrical or not. From the normal front and side view the same scale can be used as in photography of the nose.

3.052 *The external auditory meatus*

The outer part of the aural canal can be depicted with close-up lenses or extension tubes when photographs

55. Angular position of the ear drum: top — horizontal section, bottom — vertical section.

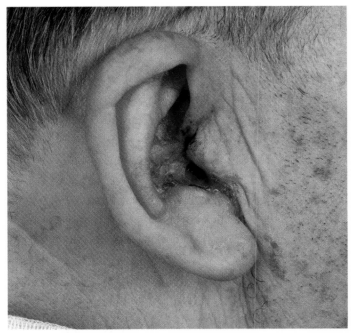

56. Squamous cell carcinoma of the external auditory meatus. Flash lighting from top right.

are required to show foreign bodies protruding from the canal or of infections in these areas (Fig. 56). To visualize the inner aspect of the aural canal it is necessary to use other methods, such as photography through the operating microscope or through an endoscope. These techniques will be described in greater detail in the following section.

3.053 *The ear drum*

Many special cameras have been designed to provide enough light along the narrow ear canal to photograph the ear drum itself. When the surgical microscope was developed it was possible for the first time to work with coaxial light within the ear canal and soon camera attachments were produced which could be fitted on the eyepiece of the microscope. However, the optical quality of such a system is not very high and instead we now use a beam-splitter system and special monocular side-arms for photography. Such systems are available for all commonly used surgical microscopes. Even so the depth of field is insufficient and it is difficult to get enough light into the ear itself. With the development of the halogen lamp, however, there now exist two different light sources for the usual Zeiss surgical microscope providing sufficient intensity for 35 mm photography at a shutter speed of a 1/10 to 1/60 sec. at the normal working distance of 200–300 mm. However, the slightest vibration in the microscope stand or movement of the patient will effectively blur the picture due to the magnification and exposure time involved. Thus, in many cases it is preferable to use a flash source.

For this purpose we have constructed a special flash unit built into the lamp system (Fig. 57). This has the great advantage of being absolutely coaxial with the light used for surgery and thus reflexes in instruments and ear specula can be recognized before photography. The short exposure of the flash also eliminates vibrations completely. Figure 58 shows a photograph taken with this coaxial flash unit; unwanted reflexes on the speculum have been avoided. The photograph was taken with a Nikon F camera with a ×2 converter lens on the lateral adapter of the Zeiss surgical microscope (second largest magnification). One disadvantage with our system is that the light available for surgery is diminished on account of the flash system in the optical pathway.

It is also possible to use a ring-flash around the objective of the surgical microscope to obtain sufficient intensity for photography (Fig. 59). This system has the disadvantage that reflexes cannot be controlled in the same way as with the coaxial light (Fig. 60). However, very intense light can be achieved, up to 1000 Ws. At a distance of 20 cm this will give an enormous amount of light and will give excellent results when used in otological surgery, particularly with open wounds. Even with this intense light, most of it will be wasted when a small aural speculum is used, to say nothing of the fact that a speculum with a diameter of 5 mm or less also considerably reduces the field of view; the concept of using endoscopes for photography of the ear drum is thus logical.

3.053.1 Endoscopic photography via the aural canal

During the last few years special endoscopes have been developed for examination and photography of the aural canal. The first model used a viewing angle of 30° in an attempt to parallel the plane of the ear drum itself. These instruments, however, proved to be very difficult to use. More recently straight viewing instruments have been developed instead. These have diameters of 3–6 mm and have built-in channels for insufflation of air. In the small, almost closed, space between the ear drum and the endoscope there is a tendency for the endoscope to become misted up; the possibility of insufflating air is therefore necessary for obtaining clear pictures. Observation in a straight line enables the remoter parts of the ear canal and ear drum to be examined in depth (Fig. 61).

When comparing the different methods available for ear drum photography it seems likely that the new aural endoscopes with a fibre-optic light source and a built-in flash will give the best results. One disadvantage of these endoscopes is their small size and also the resulting small picture size within the camera. It is thus necessary to use relay-optics of a greater focal length than for other types of endoscope used in ENT work. As will be described later, a zoom relay lens is now made by Storz in Germany. The focal length can be varied from 70 to 140 mm and will almost fill a 35 mm frame vertically.

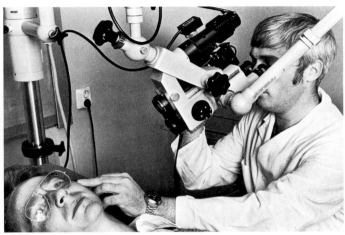

57. Photographing the ear drum using an operating microscope and a coaxial flash unit incorporated in the lamp system (black attachment at the upper border of the picture).

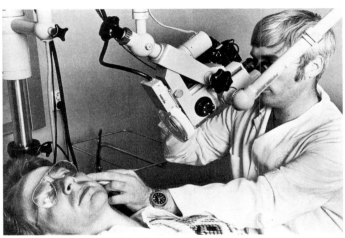

59. As Fig. 57: same equipment, but with ring flash.

58. Ear drum, slightly oedematous due to otosalpingitis. On account of the coaxial flash unit there are no reflections on the speculum. Visualisation is reduced due to the small diameter of the speculum.

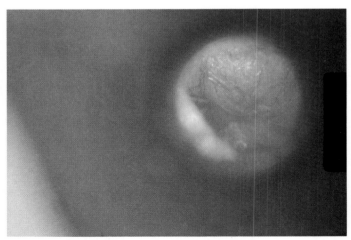

60. As Fig. 58, but taken with ring flash: colour changes and diffused lighting due to ring flash reflections in the speculum.

61. Right ear drum, photographed through a 5 mm Wolf-Lumina lens with flash incorporated in the light source. Olympus OM-1 camera and Storz zoom lens at 100 mm focal length.

3.06 The larynx

Photography of the vocal cords has always been a challenge to the laryngologist and many attacks have been made at it with mirrors and rigid tubes on sedated patients. Due to recent developments in both endoscopic instruments and in laryngoscopic techniques, two methods can now be used with great success.

3.061 *Indirect laryngoscopy*

For indirect laryngoscopy two new laryngo-pharyngoscopes have been introduced, one by Wolf and the other by Storz of Germany. These instruments are different in design and have different pros and cons. Both will give an excellent view of the larynx when introduced into the mouth. They employ a viewing angle of 90°, and provided the patient can put out his tongue it is possible to take beautiful photographs of the posterior part of the tongue, the epiglottis and the vocal cords. This can usually be done without any form of anaesthesia and has simplified the photography of laryngeal disease immensely. The Wolf laryngoscope can be focused at all levels from the vocal cords to the tongue. This is a disadvantage in that it gives pictures of excellent quality at the plane of focus only. The Storz optics on the other hand use a fixed focus system designed to cover the distance from the vocal cords to the epiglottis. Both these instruments can be used with supplementary light sources outside the endoscope. Illumination for photography is thus quite sufficient (Fig. 62).

3.062 *Direct laryngoscopy*

Direct laryngoscopy is usually carried out on a patient under general anaesthesia with the help of a rigid laryngoscope. Through this tube straight endoscopes can be introduced and photographs can be taken. This technique has the disadvantage that it is difficult to control the exact position of the endoscope and the wide angle picture will distort the anatomy. This method has now been superseded by the following:

3.062.1 Photography through the surgical microscope. With the development of microsurgical techniques and so-called microlaryngoscopy when the binocular surgical microscope is used to visualize the larynx in three dimensions, photography can also be carried out through the

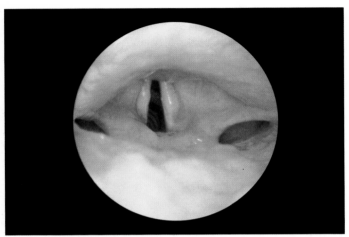

62. Back of the epiglottis, ventricular folds and vocal cords, photographed with a Storz–Hopkins 90° laryngoscope and separate light guide. Olympus OM-1 camera and Storz zoom lens at 100 mm focal length.

63. Extensive juvenile papillomatosis of both vocal cords. Nikon F camera fitted to surgical microscope, coaxial flash and high-speed film.

microscope using the same methods as for ear photography. However, the illumination problem is quite severe in laryngoscopic photography as the working distance has to be increased to 400 mm, and thus the available illumination is reduced to 25% of that available for ear photography. This long working distance also makes the camera very sensitive to vibration. The coaxial flash unit is in our experience most helpful in this respect. The flash intensity used is 800 Ws and even then Ektachrome High Speed film is necessary for good picture quality in the higher magnifications available on the microscope ($\times 2$ on the negative) (Fig. 63).

3.07 Bronchoscopy and oesophagoscopy

Photography through straight bronchoscopes has been used for many years to depict disease of the bronchi.

Many excellent atlases are also available, covering the normal and pathological anatomy of the bronchial tree. For the sake of completeness it is necessary to comment briefly on the endoscopes used and the different results obtained with the rigid compared with the fibre-optic bronchoscope.

For oesophageal photography the fibre endoscope has vastly increased the possibility of exploring and recording oesophageal disease. The same instruments are also used for photography of the stomach.

3.071 *Direct endoscopy with rigid tube*

Photographs are taken with straight 90° or 120° instruments in order to visualize the first divisions of the bronchial tree. The picture quality is often poorer with these endoscopes than with instruments used in rhinoscopy or in laryngoscopy. This is mainly due to the length of the instrument, which introduces an additional element of

optical distortion. Due to the comparatively large diameter of the adult respiratory passages there is usually sufficient light available for all types of photography.

3.072 *Fibre endoscopy*

Due to the development of fibre endoscopes it is now possible to depict branches of the bronchial tree of the 3rd or 4th order, as the instrument can be bent and moved into the smaller bronchi. Excellent light sources are available and automatic camera systems make photography almost foolproof. The most advanced and most widely used systems are manufactured by the Olympus camera company. In this case a special 16 mm still camera is used having automatic film transport and automatic exposure control (Fig. 64). 35 mm cameras can also be adapted,

65. Oesophageal carcinoma, photographed with an Olympus 16 mm camera, GIF-P2 oesophagoscope and CLS-F light source. The small black marker (at the top) facilitates subsequent orientation.

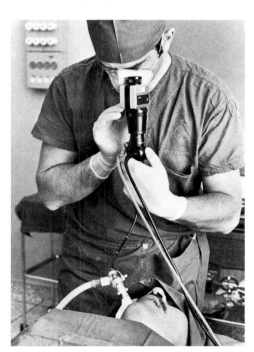

64. Fibre-optic bronchoscopy through a special flap in the endotracheal tube. Photographs are taken with an Olympus 16 mm reflex camera.

but the inherent quality of the fibre-endoscopic picture makes it unnecessary to use a negative size larger than 16 mm (Fig. 65). The resolution of the fibre endoscopes is limited by the size of the single fibres used in the bundle and also by the fact that the same orientation of the fibres has to be maintained at both ends of the bundle, otherwise a distorted picture will result. As a consequence the fibre optic picture will always be seen to be composed of a reticule of small fibre elements. The small fibres in the bundle can break, and in this case dark dots will appear in the picture (Fig. 78, p. 55).

3.08 Cinematography

Excellent systems are available for movie-making with 16 mm cameras in ENT work. The best way to illuminate the narrow cavities is to attach the movie-camera to the operating microscope or to attach endoscopes to the camera direct.

3.081 *Endoscopic cinematography*

The Beaulieu camera company of France has developed special 16 mm cameras for use with endoscopes. In this 16 mm camera a relay lens is built in, and the exposure is automatically adjusted by a rotating wedge of increasing density. As the light sources are mostly mercury or xenon arc lamps, their intensity cannot be varied and thus it is necessary to make adjustments in the camera. Another possibility is to change the number of frames per second to increase or decrease the effective exposure time. This can also be done very neatly on this camera thanks to the through-the-lens exposure measurement system. In order to project the endoscopic picture to a size appropriate to the 16 mm camera, a lens with a focal length of approximately 50 mm should be used.

3.082 *Micro-cinematography*

For use with the surgical microscope two good systems are available at present. One is the House-Urban 16 mm camera, which is attached by a special beam splitter to the Zeiss surgical microscope. This movie-camera is very light in weight and has exchangeable cassettes and is thus very easy to use. This system has no exposure control or any camera adjustments at all, but many surgeons around the world have used it with great success.

The Beaulieu–Zeiss system is more advanced in that a servo-control diaphragm activated by the through-the-lens exposure meter system will automatically adjust the light intensity so that perfect exposures are achieved. As this system is based on standard equipment it is easy to change, and other cameras having a C-mount can be attached to the Zeiss side-arm. The most important drawback is that the Beaulieu–Zeiss system is more clumsy and heavy than the House-Urban system and that changing film is difficult under operating theatre conditions.

3.09 CCTV/videotape recording

Small colour TV cameras of sufficient quality to be used in both endoscopic and microscopic recording now exist. Briefly, it can be stated that endoscopic video recording

is still cumbersome on account of the size of the cameras. The Circon system, however, uses a very small TV camera with an elegant attachment for the endoscopes, but the colour quality is not of the best. Reasonable quality single-tube colour cameras with attachments for endoscopy and for the Zeiss surgical microscopes can now be had from both Sony and Philips. Superb colour quality can be achieved with the Philips 3-tube Video 80 camera system on the Zeiss operating microscope. However, this equipment is still very heavy and must be counterbalanced by external means. In several systems designed, movable optical links have been devised to couple the microscope or endoscope to a professional TV colour camera. For the utmost quality this method is still widely used and with the Wittmoser–Hopkins lens system made by the Storz company excellent results can be achieved.

3.10 General observations

Unfortunately it is not possible to cover the whole field of ENT photography with a single camera system. It is necessary to use different systems for endoscopic photography, for the surgical microscope and for photography of surface structures. As mentioned in the introduction to this chapter, the equipment described and used by the author reflects a personal choice. In order to obtain an ideal system it is necessary to evaluate what instruments are to be used with which cameras and what adaptors for photography exist for such instruments. It should not be necessary to put much effort into making various interconnecting pieces, as manufacturers of both endoscopes and surgical microscopes can give very good advice with regard to camera equipment suitable for their instruments.

3.101 *Camera systems used*

The following camera systems have been used to take the photographs illustrating this chapter:
- Hasselblad 500C for 40 × 40 mm slides;
- Nikon F and Olympus OM-1 for 35 mm slides;
- Storz 70–140 mm intermediate zoom lens to adapt endoscopic pictures of various sizes to the 35 mm format.

3.102 *Film material*

The choice of film is largely a personal one. It is partly a question of the colour rendition that one prefers. It is also a compromise between resolution and speed. When it comes to cinematography, the field narrows as very few negative or reversal films of sufficient speed exist. In our department we use Kodak Ektachrome colour film exclusively because it is available in several speed and colour temperature versions. Ektachrome processing is also available in many professional laboratories and a very rapid service can usually be arranged. This can be of great importance, as sometimes important photographs of tumour spread, etc. can be retaken the same or the next day if the pictures were found to be inadequate. For cinematography we use either Eastmancolor Negative II film, or Kodak Ektachrome Professional reversal film. This material has given consistently excellent results. In most laboratories the Ektachrome Professional film can be force processed up to speeds of 500 ASA, which may be necessary to document microsurgical procedures. The new Video News Film 7240 also gives excellent results with tungsten illumination.

Developments in camera equipment and in medical instruments are always to be expected. It is quite possible that in future more elegant recording devices will be attached to endoscopes or be built into our surgical microscopes. It is a sincere hope that the cumbersome recording techniques we have to use today in the field of otolaryngology will soon become obsolete.

Gastro-intestinal photo-endoscopy

4. Gastro-intestinal photo-endoscopy By Rainer Dammermann

4.01 Introduction

Endoscopic examinations afford an insight into a patient's condition for the examiner alone or, at best, for one other observer who may be looking through a so-called teaching attachment at the same time. Only a photographic record of the endoscopic observation enables all those involved with the case to share in the establishment of the diagnosis. Photography within the framework of gastro-intestinal endoscopy thus assumes a significance which begins to compare with radiology. For everyday clinical purposes one may distinguish between the following specific uses of photography during endoscopy:

1. Diagnostic documentation of the result of the examination in each individual patient on colour negative or Polaroid material;
2. Photographic recording of typical as well as atypical appearances on slides for various teaching purposes, such as at seminars and congresses;
3. Extension of the scope of diagnosis by means of instruments having close-up vision and a high resolution capacity, such as intravital macropathology in the context of laparoscopy. It is necessary to differentiate in principle between endoscopic photography with fixed instruments and conventional optical lenses on the one hand and glass fibre optics on the other, since completely different requirements and results are associated with each system.

4.02 Photography with fixed lens optical systems

Photography with fixed lens optics gives very good results, because it enables one to obtain an exact and sharp reproduction of the image due to the high illumination of the subject field and the very high quality of the lenses.

Within the scope of gastro-enterology, fixed lens instruments are used under sterile conditions in laparoscopy and, with a far simpler set up, under non-sterile conditions during proctoscopic examination.

4.021 *Laparoscopic photography*

Laparoscopy without photography is nowadays primitive and incomplete. Laparoscopic photography aims to record the macroscopic features and reveal decisive diagnostic criteria. This is quite possible with the optical systems which are at present available and with the magnifications associated with them. Thus attention may be drawn to details which may have been overlooked during the examination itself. In difficult cases, or where the position is not quite clear, the less experienced practitioner is able to arrive at the correct diagnosis in consultation with an experienced endoscopist on the basis of the laparoscopic photographs obtained.

4.021.1 Instrument equipment

The provision of a laparoscope, a source of cold light and a photographic camera which may be mounted on the instrument are the basic requirements for laparoscopic photography. The intensity of light which is necessary for photography may be provided by a flash projected via a mirror from the viewing light source (Fig. 66a); a superior system, however, consists of an intra-corporeal flash (Fig. 66b), in which a flash bulb attached to the distal end of the shaft of the laparoscope produces light sufficient even for close-up pictures.

The angle of illumination from a distal flash is about 300°, compared with about 60° for the extra-corporeal flash (Figs. 67 and 68). Satisfactory results with an extra-corporeal flash will only be achieved when the illumination angle can be increased. Such instruments are being developed at the moment.

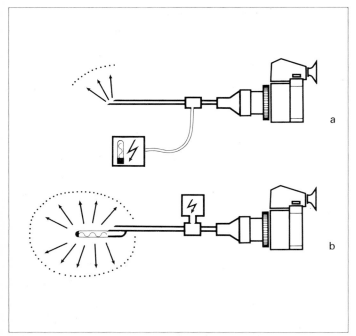

66. a: Extra-corporeal flash; b: intra-corporeal flash.

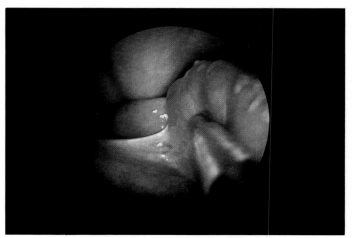

67. Extra-corporeal flash, poor illumination of detail. View through a 180° lens system with a probe in the instrument tube.

The only suitable cameras are single-lens reflex cameras which can be adapted to fit a photo-laparoscope. Apart from the Rolleiflex SL 35 we have also found the Leica with Visoflex adaptor satisfactory, as well as the Zeiss-Ikon and Exakta Varex cameras.

Interchangeable lenses offered are those of 70, 95, 110 and 135 mm focal length. While the lenses with shorter focal lengths enable one to obtain a wide angle of coverage with great depth of field, the 135 mm telephoto lens will produce a picture of only a limited sector of the liver surface at very great magnification and with little depth of field. For routine use the 95 mm lens is preferred because it allows sufficient depth of field for general purposes.

4.021.2 Technical faults

Misting-up of the lens and the unnoticed appearance of specks of dirt during examination are the most common causes of unsatisfactory laparo-photographs (Figs. 69a and b). A warming-up device for the laparoscope should always be available. Alternatively, the instruments may be wiped with 'Ultra-Stop' before use. Before taking the first

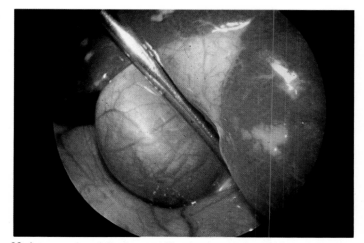

68. Intra-corporeal flash, good illumination of detail. View through a 135° lens system.

direction of illumination and assessment of the light intensity are obtained by firing a trial flash from the flash pack; this enables one to determine the direction of the light, identify reflecting surfaces and assess any special lighting effects. With increasing practice it becomes an easy matter to set the power pack to the correct power.

4.021.4 Photo-documentation procedure

In order to obtain full coverage of a liver examination one should take a general photograph of the right and left lobe with a short focus lens (Figs. 70 and 71), as well as at least one additional close-up of the surface structure (Fig. 72). In close-ups especially, one should attempt to achieve a viewing angle of 90° (Fig. 73), since any attempt to assess the liver structure from a tangential view with forward-view lenses is useless (Fig. 74). For this reason the photo-laparoscope should also, as a rule, have a side-view lens of 130°. If additional abnormalities are encountered in other organs in the remainder of the abdominal cavity while concluding the examination, then these should, of course, be photographed as well (Fig. 75). Only the urge to achieve the 'outstanding photograph' produces a worthwhile and convincing result.

a b

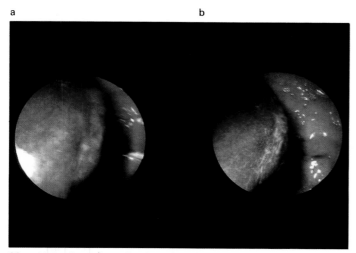

69. a: View through a misted-up lens; b: View through a cleaned lens.

4.021.5 Film material

Every photo-laparoscopic series as described above should as a rule be recorded on negative material, so that the prints can later be fixed to a sheet of paper or card and added to the patient's file. This also makes it possible to assess progress accurately by referring to earlier photographs from previous examinations.

We have found Agfa CMS colour negative film very suitable, but contact and discussion with the processing laboratory is absolutely essential in order to achieve good photographic quality. We recommend the enclosure of examples which are considered perfect with respect to colour and density, so that the processor in the laboratory can select the correct filtration. Only when such co-operation is established will it be possible to depend on consistent results.

If colour photographs have to be provided at short notice, it is possible to make records with a Polaroid camera, which can be attached to the laparoscope in just the same

picture it is recommended that the laparoscope be checked in front of a dark background for the presence of distinct specks of dirt.

4.021.3 Photographic technique

The cameras that are used in laparoscopy have no ground glass screens for sharp focusing; instead they have aerial focusing aids in the form of cross-wires, engraved circles or grids. In order to obtain sharp pictures the laparoscopist must first adjust the focus of the graticule to his own eye and then approach the intended subject from a distance until this also appears sharp. It is important that the subject and the graticule should appear in focus at one and the same time, otherwise a blurred picture will result.

The greatest hazard is visual accommodation on the part of the observer in terms of the depth of the subject which is to be photographed, since very close items may appear very sharp while at the photographic plane they are already unsharp. Only constant and rigid checking of the optical setting ensures good picture quality. The correct

4.021.6 Filing systems

The name of the patient should be photographed through the endoscopy camera before any examination is started in order to ensure subsequent identification of the pictures in question on the strip of 35 mm film which should

4.022 *Photography with proctoscopes and sigmoidoscopes*

This method is only rarely employed in hospitals. Suitable photographic equipment is, however, available both from Messrs. Storz (Tübingen) and from Messrs. Wolf (Knittlingen, West Germany). Since a quick diagnostic record

a b a b

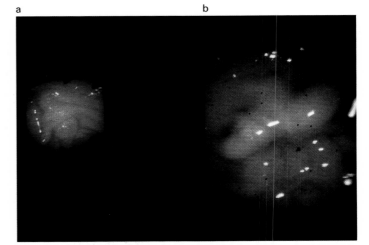

79. a: Good picture quality with an instrument having a regularly assembled glass-fibre bundle; b: Deterioration in picture quality with an irregularly assembled glass-fibre bundle.

80. a: Duodenoscopic photograph of the papilla of Vater without the insertion of a lens; b: as a, but with the insertion of a converter giving better information with a clear grid produced by the glass-fibre bundle.

1. By insertion of a lens between the endoscope adaptor and the camera (e.g. the ACM endoscope and the Contax RTS camera). Here one must put up with a greater weight at the camera end (Fig. 80).
2. Insertion of a converter (Olympus superadaptor SM-4-S). This has the advantage that ease of manipulation is not reduced and the disadvantage of an appreciable loss of light, so that one has to accept a certain degree of unsharpness due to movement (Fig. 80).

Photography with flexible glass-fibre colonoscopes is carried out in exactly the same way as with gastroscopes, the construction of the instrument being much the same.

4.04 Developments

As a result of the progressive miniaturization of photographic and electronic instruments in recent years it has become possible to use colour television cameras with video-recorder connections for the purpose of documenting endoscopic examinations. Although the size of the available cameras had initially been an obstacle to the development of this technique, the picture quality and the colour reproduction were already such as to make it very tempting. Following the development of a handy lightweight camera by Messrs. Siemens it is likely that this method of recording will spread rapidly.

The great advantage of documentation by means of colour television and video tape is that continuous recording of the entire examination becomes feasible, whereas still photography can record merely a few salient features.

Finally, it is necessary to mention briefly the possibility of endoscopic cinematography. Since filming requires a continuous source of light at high intensity, this necessitates the availability and use of specially powerful sources of cold light. In terms of equipment it is usual to employ a 16 mm Beaulieu camera together with Kodak Ektachrome film stock. It should be added that as any endoscopic examination is essentially a kinetic procedure, the projection of selected extracts of film in the form of continuous loops is probably the most valuable form of presentation for teaching purposes.

Photography in
the operating theatre

5. Photography in the operating theatre By Dietmar Hund

5.01 Introduction

Photography in the operating theatre is intended to provide a record of a rare – or possibly typical – condition. A condition which is altered as a result of surgical intervention may lose its teaching value. It is also possible to use photography in order to record a particular surgical technique, which can then be used as an original for a drawing, or as slide material for the lecture theatre. A photographic record is often necessary to illustrate published papers. However, we believe that graphic representations rightly take pride of place in textbooks on surgical technique and that photographs should rather play a subordinate or complementary role in that context. Drawings have certainly not lost their importance; in contrast to photographs they can be used to illustrate principles and to emphasize important points, while omitting less important features (Figs. 81 and 82). In this case photography is merely a drawing aid. Nevertheless, it is important that the photographer should produce pictures of good quality.

Photography in the operating theatre requires neither complex equipment nor special training, despite the protestations of the specialists. On the other hand, some basic principles need to be observed in order that the resulting pictures may be generally useful. We intend to identify these principles, although we are well aware that true excellence is rare and depends upon many factors, as in all other fields of applied and creative photography.

5.02 Briefing and preparation

The photographer who is summoned to the operating theatre must be told where he may set up and for how long he is likely to have to take pictures; it is equally desirable that he be told *what* he is supposed to take.

81. Illustrating intra-vital pH determination at operation as a drawing.

82. As Fig. 81, but as a slide.

An explanation of the arrangements at the operating table must of course be provided. This enables the photographer to understand the situation and to recognize the features which will determine the right area to be selected at the scene of activity as well as the correct illumination. This may appear to be unimportant or superfluous, but such preliminary briefing on the part of the surgeon is essential if useful results are to be obtained. *In actual practice rapport and an appreciation of the task of the photographer are far more important than the use of the most sophisticated equipment.*

It is a great help in enabling the photographer to work quickly if additional sterile drapes are available to prevent contact with the aseptic areas during manipulation of equipment.

If necessary some non-sterile personnel (e.g. porters or attendants) should be available for short periods to assist, for example, with the flash lighting, which can then be kept separate from the camera.

83. Comparison of 4 × 4 cm and 24 × 36 mm slide formats.

5.03 Photographic equipment

5.031 *Film size*
Basically, the advantage of easy handling of a 35 mm camera is balanced by the advantage of a medium-format roll film camera, whose negative size is at least $1\frac{1}{2}$ times greater (Fig. 83). The mobility of the 35 mm camera has proved to be more important in operations where access is difficult (e.g. in surgery of the thorax). In such cases it is far more important to use a handy lightweight camera than to aim for the advantages offered by a larger format camera. The medium format, on the other hand, is to be preferred in cases of readily accessible extremities, because of the considerably larger image area and better resolution and hence better reproduction of detail (Figs. 84 and 85). It is quite conceivable that medium format surgical photography will come to the fore in the future.

5.032 *The 35 mm camera*
Fundamentally, what matters in the case of a 35 mm camera is its *weight*, its *handiness* and its simplicity of *operation*. Simple equipment is often more reliable. Since

84. Crevice in the medial tendon of the knee in the form of a 35 mm slide.

85. As Fig. 84, but in the form of a 4 × 4 cm slide: the advantage of increased area and better resolution can be seen.

we use flash exclusively in the operating theatre, any system of exposure metering is of no great significance.

A ground-glass screen is of particular importance in surgical photography. Focusing with microprisms or split image rangefinders is much too uncertain and is virtually useless in any operation in which organs move. A ground glass screen is therefore recommended.

5.032.1 Lenses

In surgical photography the distance between the lens and the subject lies usually between 30 and 120 cm. Experience has shown that to enable one to cover various subject areas without moving the camera, lenses having the following focal lengths are suitable:

50–65 mm standard lens (for general views),

 90 mm lens, with extension tubes,

 135 mm lens and extension tubes or bellows.

5.032.2 Supplementary lens or extension tubes

When taking close-ups, the use of extension tubes or supplementary lenses is unavoidable. Considering the multiplicity of types of lenses, the use of *supplementary lenses or extension tubes is decisive in determining the quality of the picture*. Depending on the lens used, it may be either the supplementary lens or the extension tube which gives better results. In such a situation it is important *to seek the advice of the manufacturer*. We also draw attention to the corresponding comparative photographs in Chapter 6 on the photography of prepared specimens (Fig. 117, p. 77). Bellows-type cameras limit mobility; here the desire for the largest possible picture size is altogether limited by insufficient depth of field. *The smaller the distance from the subject, the more extension tubes are required and the smaller is the depth of field.* When photographing capillary vessels, and similar features, so that they fill the entire frame, the depth of field is so reduced that the surrounding features (and even certain parts of the subject) make orientation impossible due to extreme lack of definition. Even when the sharpness of the surroundings is of secondary interest, it is still important in most cases to be able to orientate oneself to the 'where, what and how' of the picture.

5.032.3 Macro lenses

Macro lenses with focal lengths of *80 or 100 mm* have the advantage of being corrected for close-ups. The long and continuously adjustable focusing mount and the excellent optical quality of these lenses make it possible to use them from an extreme close-up (39–45 cm) range to infinity, and this makes them eminently suitable for most aspects of surgical photography.

5.033 *The medium format roll film camera*

Compared with the 35 mm camera the range of medium format cameras on offer is much more limited. It is confined to a few top-class instruments. Their greater weight and bulk are disadvantageous in surgical photography. *A pistol-grip with a shutter release trigger* greatly facilitates manipulation. In practice a *45° or 90° pentaprism viewfinder* is essential; as is a *ground-glass focusing screen* and a *4×4 cm negative frame mask*. The quick-change roll film backs are certainly an advantage in the operating theatre. It is a good idea to keep at least one replacement roll of film ready.

5.033.1 Lenses

The lens requirements are similar to those for 35 mm:
 80 mm standard lens.
100–120 mm lens – with extension tubes.
 150 mm lens – with extension tubes.

5.033.2 Supplementary lens or extension tubes

The same considerations as for the 35 mm camera apply here (see 5.032.2)

5.034 *Accessories*

An ultra-violet filter should be used with any lens in order to avoid a blue cast on colour film.

Motor-operated automatic film transport (i.e. motor winders) in the operating theatre depends upon ease of manipulation and weight considerations, but its advantages are obvious. It enables one to work much more quickly, particularly considering that a minimum of 2 or 3 exposures is needed at each stage, with half-stop changes of aperture to make sure that optimum results are reliably obtained.

5.035 *Electronic flash*

A battery powered electronic flash is the most suitable light source for surgical photography. It incorporates the advantage of an independent energy source with relatively light weight and has a high light intensity without heat radiation. The following criteria apply when using electronic flash in an operating theatre:

1. A high guide number = small aperture, therefore
 (at least 60) enhanced depth of field.
2. Rapid re-cycling time = fast succession of exposures.
3. Exchangeable battery = makes replacement possible.
4. Mains operated unit = continuous operation
 (seldom used).
5. 1·5–2 m synchronizing = where lighting is separate
 cable from the camera itself.

Once the aperture has been established a *constant distance between flash and subject* of about 50 cm should be maintained. Small deviations are corrected by an increase or decrease of half a stop. If possible, the flash reflector should be adjusted for wide angle coverage.

The photographer should always consult the anaesthetist before using any form of flash.

86. Parallax between lens and sensor – a potential source of error in close-ups: the sensor measures outside the picture area.

5.036 *Ring flash*

Ring flash is used when a shadow-free picture of a subject is required. It is used in certain instances of surgical photography where difficulty is experienced in illuminating inaccessible parts of the body, such as the buccal cavity or the vagina. We shall return later to the advantages and disadvantages of electronic flash devices which are mounted on the lens. In the case of ring flash the aperture is determined by the exposure distance only. The shorter the distance the higher the light intensity. To compensate for distance changes one sometimes uses neutral density filters, but it is preferable to change aperture according to experimentally determined results.

5.037 *Computer flash*

In the case of computer flash, technological advances are occurring all the time. Extreme close-ups are relatively frequent in surgical photography and the use of the flash sensor device on a flash unit which is mounted on the camera sometimes results in completely wrong values due to the parallax between lens and sensor (Fig. 86).

The writer has not experienced to what extent extremely close proximity of such a flash unit to the subject may affect exposure or colour reproduction as a result of very short exposure reciprocity law failure.

5.04 Colour film materials

Arguing about suitable (or rather, the most suitable) film material for colour photography is a favourite pastime among professional and amateur photographers. It is a fact that the ideal colour reversal film has not yet been invented, despite all the protestations of the manufacturers and despite the steady stream of new products which technological development brings to the market.

It is true that surgical photography does not set the same strict standards of true colour reproduction for film material as would, for instance, be expected in large format photographic reproductions. It is nevertheless advisable continually to test and re-rest *the suitability of the various colour reversal (daylight) film materials for photography in the operating theatre.* This is especially justified by the differences which appear in the reproduction of red colours, which can be a problem in surgical photography. There are colour reversal materials of normally undisputed quality which nevertheless completely lose definition of detail in such circumstances. There are others whose much higher contrast does not show up until a comparative test is carried out.

The variations between batches of individual emulsions are often considerable. This makes it necessary to *set aside a fair quantity of the same batch number of film once it has been selected.* Considering the many facets of work in a hospital there is not much point in restricting oneself to any one particular colour material. The most suitable film material should be used for the particular task in hand.

Figures 87–91 illustrate the differences in the colour reproduction of five commonly used film materials used in photographing the same subject.

5.05 Organisation

Up to this point we have discussed the technical equipment of the photographer in the operating theatre. We now have to turn to the principles involved in securing a useful presentation of the surgical condition (diagnosis). In this context it must again be emphasized that good surgical photography depends far less on the quality of the photographic equipment than on the sympathetic understanding and co-operation of the surgeon. Points 5.051–5.055 listed below apply to the surgeon as much as to the photographer.

5.051 *Positioning*

It is obvious that the surgeon's position must be in the best location and must command the best view of the scene of the operation. *This position is also best for the photographer* (Fig. 92). Any other position, e.g. that of the assistant surgeon, or from above, or from the other side, is a compromise and causes irritation when the picture is subsequently viewed (Fig. 93). Naturally, considerations of maintaining aseptic conditions and of the surgery itself take precedence at all times. However, it is open to argument to what extent these are affected when

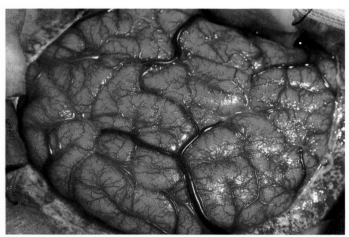

87. Comparative photograph (surface of brain) taken on Kodachrome 25.

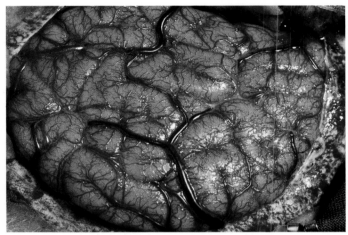

89. As Fig. 87, but on Agfa CT18.

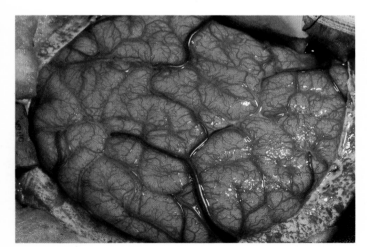

88. As Fig. 87, but on Ektachrome X.

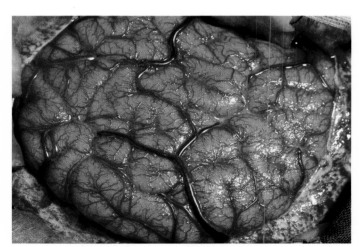

90. As Fig. 87, but on Agfachrome 50 S.

considering the place of the photographer, even in simple surgical operations. There may be ingenious camera mountings on cumbersome scaffolding of a kind which may, in modified form, certainly be used for producing film sequences. Useful results, however, can only be guaranteed if the photographer has mobility and stands in the best place.

It has been proved to be perfectly possible in practice for the surgeon and photographer to *change places for short periods following appropriate shielding of the aseptic areas*. Given well organised teamwork, this can be done without prejudice to the successful conduct of the operation, even in cases of complex surgery. However, in a critical or precarious situation the photographer is best out of the way!

5.052 *The surgical field*

If, in exceptional circumstances, the entire operation area is to be included in the frame, or if the inclusion of some of the drapes in the field of view is unavoidable, then it is generally necessary to re-cover with fresh drapes for

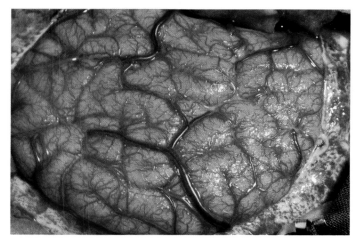

91. As Fig. 87, but on Fujichrome R100.

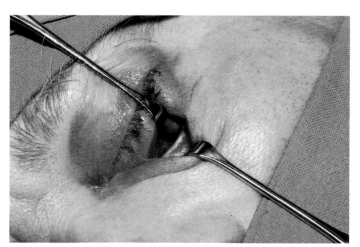

92. Fracture of the floor of the orbit, as seen by the surgeon.

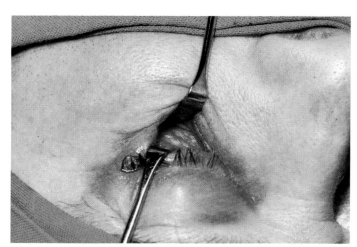

93. As Fig. 92, but from the wrong viewpoint.

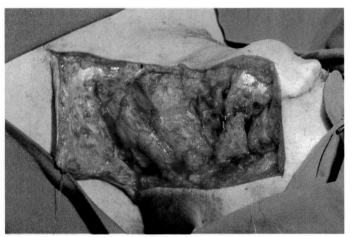

94. Clean draping of the surgical field (cheek resection).

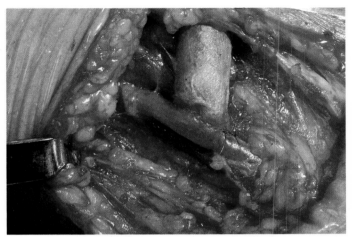

96. Careful preparation of the operative field by dabbing and mopping up of blood (bovine graft anastomosis in the elbow region).

95. Untidy operation area.

97. As Fig. 96, but with inadequate preparation.

98. Tilting of retractors to avoid reflections ('bucket handle' deformity of lateral meniscus).

99. Retractors with moistened fabric sleeves (tumour of adipose tissue in the right cardiophrenic angle).

reasons which are not exclusively aesthetic (Fig. 94). The extreme example shows how an untidy operation area can disturb the orientation of the viewer (Fig. 95).

Unnecessary instruments and other devices distract the attention, while bloody or wet drapes appear dark or black on a slide. White covers are useless. Grey (so-called 'photogenic') masking covers unfortunately often do not rate much better, owing to easily noticeable colour variations in the grey, especially in colour photographs.

5.053 Preparation

A careful preparation of the operation area (using swabs, absorbent cotton or, if necessary, additional staunching of the blood flow from individual vessels) is of enormous importance for photographic presentation (Figs. 96 and 97). It may be necessary to repeat the procedure between exposures.

5.054 Presentation

The presentation of an operation area must be aided by retractors, clamps and other devices in most cases. The rule is: 'as few as possible'. In particular, the size of the instruments used should bear a sensible relationship to the size of the subject. Too many retractors and, more particularly, those of excessive size are particularly out of place in small scale surgery and are most distracting.

5.055 Reflections

There is no way of avoiding the inclusion of instruments necessary for the maintenance of the surgical field, but these can cause problems in terms of reflections, which have a most disturbing effect and can even render the picture altogether worthless. Such reflections do not become apparent in flash photography until after processing and people have tried to remedy this situation by changing the angle of illumination. This is entirely wrong. The correct angle of illumination which is appropriate to a given situation must not be altered, especially when the scope for variation is limited. However, one can take advantage of the law of reflection (angle of incidence = angle of reflection), with which every photographer is familiar, by re-positioning individual retractors which are lying flat

100. Compression fracture of the tibial head, close-up: difficult orientation.

and positioning them slightly on edge (Fig. 98). This requires a little practice, but experience has shown that it presents no problems.

Larger retractors can be provided with white sleeves, but since white retractors present an undesirable contrast, they should be slightly tinted with blood present in the surgical incision (Fig. 99).

5.06 Exposure

Next we shall consider all those points to which the photographer should pay particular attention. *The wide range and diversity of photography in the operating theatre renders any attempt at standardisation futile.* Individual techniques are therefore to be regarded only as propositions and suggestions.

5.061 *The incision*

Close-ups of the operational scene are common in surgical photography. This can lead to disorientation and raise the question 'whereabouts is this?', which then often remains unanswered (Fig. 100). It is therefore a good idea to take a *general picture,* on which the section

101. As Fig. 100: general view with close-up marked.

102. Atypical septum of the knee joint, general view; surroundings diminished by superimposed marker frame and grid.

of the subsequent close-up can be indicated by the addition of a marker frame (Fig. 101). Another teaching aid in less extreme close-ups is the subsequent superimposition of a grid (Fig. 102). The circle directly focuses attention on the important portions of the picture, whilst the surrounding areas are somewhat obscured by the grid.

In normal circumstances *a picture of the principal subject with limited surroundings* is most informative. In contrast, any attempt to isolate the organ concerned from its surroundings by wrapping with covers often results, in effect, in taking merely an 'in vitro' shot in the operating theatre. Appropriate instruments (or, as in our example, a hand) serve to emphasize the major features and give an immediate idea of scale (Fig. 103).

5.062 *Size comparison*

The surgeon sometimes rightly wishes to include size comparisons in the surgical picture. In the absence of reference points, scale comparisons become particularly necessary.

A sterilized metal ruler is not very suitable for this purpose as correct assessment of the reflection – and with it recognition of the calibrations – is rather tricky.

The subsequent mounting of a scale is much less intrusive

in the actual surgical picture (Fig. 104). Thus for example, *the known size of an instrument which is seen in the picture* may be made to serve as *a scale reference.* A lith film negative with a scale which has been prepared beforehand is reduced to that size on to another piece of lith film. Mounting this positive transparency in the proper place presents no problem.

In the event of this technique being inapplicable (e.g. because of a dark background), the inclusion of a hand or a finger may be equally informative for scale comparisons in exceptional circumstances (compare Fig. 103).

5.063 *Illumination*

In surgical photography it is not merely a matter of uniformly illuminating a specified area of a certain size. The area may well have a specific structure, unevennesses, a glossy surface, possibly depressions which need to be better defined. Since a photograph has obviously only two dimensions, namely height and width, it is necessary to generate the third dimension by means of light and shade.

The dimension of depth, that is to say the creation of light and shade by means of an ideal angle of illumination, depends upon the area of operation and is limited by this.

103. Resection of the sigmoid colon in carcinoma; surgeon's hand shown for emphasis and as a scale.

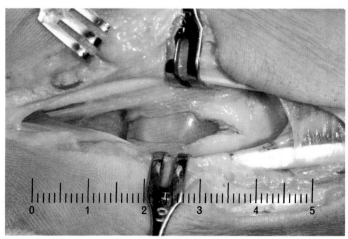

104. Dislocated lunate prosthesis with superimposed scale.

Nevertheless, in most cases there exists some opportunity for individual illumination (Fig. 105).

A flash unit which is mounted directly on, or close to, the camera usually provides the worst imaginable angle of illumination. Although the shadow-free presentation ensures uniformity of illumination without much effort, it is virtually impossible to identify tissue structure (Fig. 106). Frontal illumination is a disadvantage not only for the definition of surface structure, but also because the absence of shadows makes it impossible to note depressions or to identify surface curvatures.

There are two considerations concerning angle of illumination which are of major relevance:

1. The structure, curvature or depressions of an organ or of the entire surgical scene of action (Fig. 107).
2. Reflections – usually in the wrong places – may be avoided by the proper selection of the angle of illumination (Fig. 108).

Surface sheen is desirable in surgical photography, as elsewhere, provided that important parts of the picture are not obscured by this and provided that it does not become overwhelming. The nature of such a highlight is determined by the type of surface being illuminated (e.g. whether it is smooth or porous), and the sheen makes it possible to recognize the material condition of the surface of an organ or tissue. To exclude it altogether by means of polarisation is, therefore, not to be recommended.

Two separate flash sources in the operating theatre reduce mobility, and the overall effect is practically uncontrollable in the absence of modelling lights.

The high light intensity of electronic flash will exceed that of the operating theatre lighting. However, the combination of low-power flash units and cameras with focal plane shutters (synchronization 1/30–1/50 sec.) may cause a distinct yellow colour cast under certain conditions. The main operating lamp should therefore be moved slightly or, if possible, the illumination level should be reduced.

5.064 *Ring flash*

The substantial drawbacks inherent in the use of a ring flash in the operating theatre have already been presented

105. Dupuytren's contracture, three-dimensional effect achieved by careful lateral lighting.

106. As Fig. 105, but with poor frontal lighting: no three-dimensional effect.

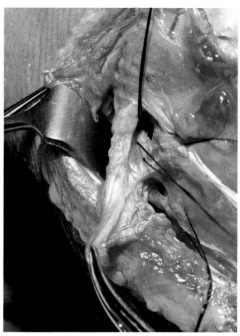

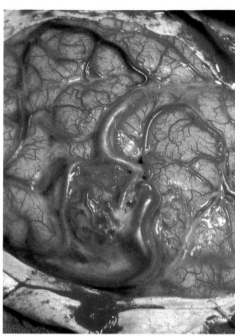

107. Medial tendon of knee: slight lateral illumination (from the top of the picture) creates an impression of depth.

108. Superficial angioreticuloma; avoiding unwanted reflections.

in Section 5.036, p. 63. However, in certain specialized surgical photography it is virtually impossible to avoid using this type of flash, for instance, in extreme close-ups and also for the photography of extremely small openings such as the buccal cavity or the vagina. Nevertheless, one should take note of certain provisos which apply photographic limitations even in these specialized fields. *The parallax between ring flash and lens sets a limit for the minimum close-up*: the relatively large diameter of the ring flash compared with that of the opening renders the depth of illumination of the subject difficult (Fig. 109). In order to reduce the parallax, the photographic distance must be increased with a change to a lens of greater focal length. For 35 mm films *a focal length of about 200 mm* becomes necessary, whilst for *medium format (4×4 cm)* – it becomes *250 mm.* The problems of loss of picture quality associated with the use of supplementary lenses or extension tubes must be appreciated.

If access is extended by the use of a speculum – as in our examples – then one is liable to encounter the problem of undesirable reflections from any device made from chrome

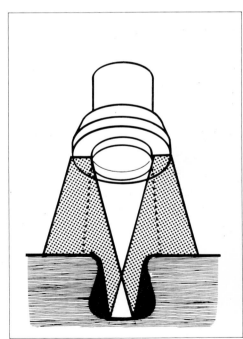

109. Parallax between lens and ring flash in extreme close-ups: insufficient illumination in cavity.

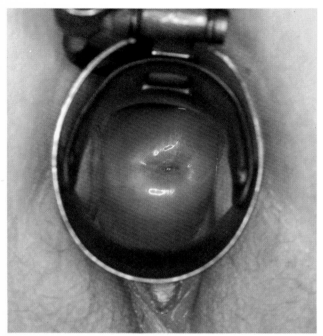

110. Os uteri: undesirable reflections from the speculum (Photo: P. Merkle).

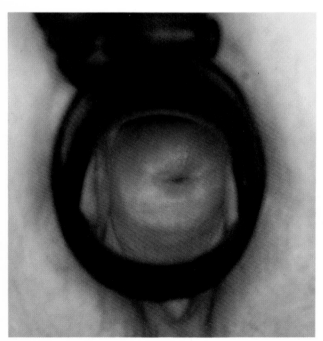

111. As Fig. 110, but with matt black speculum and additional polarisation (Photo: P. Merkle).

steel (Fig. 110). For such purposes one can purchase special *matt black specula*, which prevent halation and direct reflections (Fig. 111).

Excessive reflection of light from a light foreground (skin or chrome steel) on to an object which is important in the picture not only produces unpleasant contrast, it may also impair the quality of the picture by causing flare in the lens.

5.064.1 Standard ring flash

Figure 110 exemplifies the manner in which a standard ring flash unit may be used — the disadvantage of a shadowless, and therefore structureless presentation is clearly discernible. It is also well known that surface reflections enable one to recognize the surface structure, provided that they are used with discretion. On the other hand, if the reflections become overwhelming, colour differences are no longer recognizable; this is illustrated in our example. In practice, it is important not to depend on chance results with possibly unpredicted drawbacks.

5.064.2 Polarized ring flash (Fig. 111)

In order to avoid chance unwanted reflections, exclusion by means of polarized light is recommended. However, polarized ring flash is a much weaker light source than standard ring flash, and polarization tends to give it a touch of colour (yellow) which must be corrected by the use of an appropriate filter.

5.065 *Illumination with a fibre-optic light-guide*

Polarized ring flash may be capable of eliminating interference due to reflections but it does not eliminate any of the other problems such as parallax, structureless presentation or excessive illumination of the foreground. It is therefore suggested that one should take advantage of the well known and commonly available *endoscope* for specialized medical photography, in which a *fibre-optic light-guide* provides an *independent source of light*. The light-guide is small and can therefore be positioned close to the subject. This avoids problems with a foreground which is generally too light in colour or too brightly illuminated.

The combination of (i) a mobile fibre-optic light-guide

and (ii) a modelling light, combined with (iii) an electronic flash tube enables one to keep proper control of the angle of illumination, which may be adjusted as desired. The shutter speed and/or the aperture *must be established experimentally.*

5.07 Adaptation of surgical photographs

The production of teaching slides presents problems in the medical sciences as much as elsewhere. During lectures, or in front of a large audience, the detail of reproduction of a projected slide is limited by the distance from, or by the power of resolution of, the human eye. Although a graphical presentation with tables and diagrams may take account of this, it is virtually impossible to improve on an existing surgical photograph. It should also be borne in mind that a lecture is presented under pressure of time, which gives the lecturer little opportunity to point out salient features with an illuminated pointer. A published paper may be contemplated at leisure, a projected slide, on the other hand, is viewed for a few seconds only.

Surgical photographs with subtle differences in the distinguishing features of vessels and nerves (Fig. 112), or general views with important details (Fig. 113) may be enhanced by the subsequent inclusion of drawings and footnotes. This improves the information which is being conveyed (see also 5.061 and 5.062, pp. 68 and 69).

Simple mounting techniques, where appropriate, may be used with some versatility:

1. A black-and-white enlargement of about 18 × 24 cm is produced from the existing colour slide.
2. An overlay, which should be as transparent as possible, is attached to this enlargement.
3. One can now write or draw on the overlay as necessary in order to provide keys to the surgical photograph.
4. The annotated overlay is reduced using lith film to produce a negative of the same size as the slide.
5. 1:1 positive copy on lith film.
6. The transparent film positive may be mounted over the colour slide with double-sided adhesive tape.

The direct labelling of slides with letters or arrows saves

112. Stomach with antral branch of vagus, emphasised with superimposed dashes.

113. Z-plasty for hare lip, incision superimposed.

114. Tumour of the spinal cord, shown as a slide.

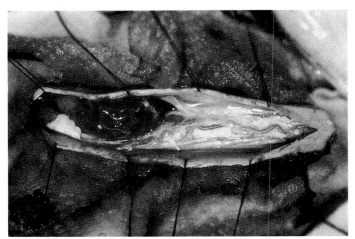

116. As Fig. 115, but copied with a red filter.

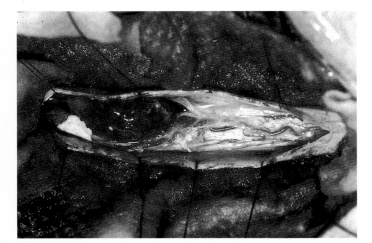

115. As Fig. 114, but printed in black-and-white on paper from a slide via an intermediate negative.

much work in the photographic laboratory if simple. There is, however, a danger of damaging the film surface. With regard to more sophisticated techniques of reproduction, the reader is referred to Chapters 9 and 10 (pp. 117 and 137).

5.08 Black-and-white photography

Colour reproductions in published papers are generally scarce on account of the cost. This means that surgical colour photographs must also be capable of providing black-and-white enlargements ready for the publishers to print. The taking of additional black-and-white exposures in the operating theatre does, of course, involve

more time, which may not be justified considering the poor quality of direct black-and-white photography.

It is virtually impossible to avoid bleeding vessels and tissues in surgical photography, and in black-and-white these usually come out dark grey and without contrast differences. Printing on paper flattens the image contrast further, so that the final result can hardly be compared with those of colour photography (Figs. 114 and 115).

However, the subsequent production of a *4 × 5 inch intermediate negative on panchromatic black-and-white film material* has to be considered if only a colour slide is available. If a surgical colour photograph is printed *using a red filter*, then the red portions appear lighter; this is shown in our example (Fig. 116). Photographs of areas of surgery which are devoid of blood, or where there is only slight bleeding, should be printed without a red filter.

It should be remembered also that some publishers are prepared to make black-and-white reproductions direct from colour transparencies.

5.09 Summary

In our opinion, surgical photography is a task which requires no particular specialist skills to achieve a satisfactory result. Even highly sophisticated equipment does not guarantee superior results unless basic requirements are fulfilled and we have tried to point these out without entering into the fine points of individual experience or into a discussion of particular items of manufacture. Photography in the operating theatre is only a small part of a wide field, but it demands not only solidly based technical competence but also the full commitment of the photographer and good co-operation with the surgical personnel.

Specimen photography

6. Specimen photography

By Charles Häberlin

6.01 The lens

When taking pictures of human or animal organs we generally find ourselves working with reproduction ratios varying between 1:20 and 1:1. Such close range photography may be described as macrophotography. Apart from a few exceptions, scales of more than 1:1 rarely provide more information.

It must be remembered that every type of lens is designed for a particular range of work. Up to a scale of 1:1 we use a normal camera macro lens to advantage, whereas a special objective should be used for scales greater than 1:1.

Standard lenses provided with focusing adjustment from at least one metre to infinity may also be used for close-ups by using extension tubes and a greatly reduced aperture when taking the picture. The use of supplementary lenses is another possibility; these are attached to the existing lens. One should not rely on simple supplementary lenses, but use only a supplementary 'chromatic' attachment, which consists of two lenses. The supplementary chromatic attachment must also be subject to aperture reduction in order to achieve optimum edge definition.

In principle, one should not work with any lens at its smallest aperture. Although a great reduction in aperture achieves more depth of field, overall definition may be affected by diffraction.

The best quality close-up photographs are obtained with lenses which have been made for this purpose, that is to say, with the macro type camera lenses mentioned above. They are designed in such a way as to provide sharp definition from 25 cm to infinity mechanically and without accessories; the optical computations of such lenses make them mainly suitable for close-up photography. Figure 117 shows the same subject three times over, at a scale on the negative of 1:3 and at an aperture of f/8. In each case only a cut-out of the left hand upper corner of the 35 mm negative was enlarged from 4 mm to 12 mm. The pictures were taken:

(a) with the standard lens and extension tube,
(b) with the same lens and supplementary chromatic attachment,
(c) with a macro lens.

The differences in definition are obvious.

Macro lenses are also available in various focal lengths, the most commonly used being 50 mm and 100 mm. For 35 mm cameras a focal length of 100 mm is more suitable, because this enables one to maintain a suitable working distance from the subject. A large lens–subject distance is particularly important in the scale region of 1:1, because it avoids any possible obstruction to the illumination. At the same time this focal length has the advantage that it is close to the angle of vision of the human eye; long focal length lenses do not produce distorted perspective effects.

Many people believe that depth of field is small for a lens

117. a: Histological section, macrophotograph with standard lens and extension tube; b: with standard lens and supplementary chromatic lens attachment; c: with macro lens.

having a long focal length. This is quite wrong; it is the ratio of the size of the subject relative to that of the picture, i.e. the scale of magnification alone, and not the focal length, that determines depth of field. This is illustrated in the practical example shown in Fig. 118: picture 'a' was taken with a lens of 50 mm focal length, picture 'b' with a lens of 100 mm focal length, using the same aperture. For picture 'b' the camera was pulled back far enough to make the distance AB the same, thus producing the same scale in both pictures. Based on scale alone it can be established that the depth of field is the same for both pictures. The only thing that has changed is the perspective. The lines of perspective of the first picture converge more quickly than those of the second. In addition, the depth of field may be calculated using the following formula:

$$\frac{D F^2}{F^2 \pm nk\,(D-F)}$$

where D = the distance from the subject, F = the focal length, n = the aperture, and k = the circle of confusion (which is usually 1/20 mm for the 35 mm format).

A similar problem exists concerning the exposure adjustment for the illumination available. Again, it may be generally stated that the exposure factor at equal scales of magnification remains the same despite differences in focal length. However, close-up lenses are something of an exception because they do not cause a mechanical change of bellows extension.

6.02 The background

In order to determine the question of which type of background should be recommended for the photography of medical specimens, we shall first have to consider carefully and compare individual background materials; we shall be guided in the first place by suitability and in the second by personal taste. Backgrounds fall into four categories: coloured, white, black and grey.

6.021 The coloured background

At first sight a coloured background would appear to be the most suitable since most pictures are in colour. How-

118. a: Depth of field and perspective with lens of 50 mm focal length; b: with lens of 100 mm focal length.

ever, one must bear in mind that the background colour and the specimen colours mutually affect one another. Unattractive and disturbing colour contrasts or optical illusions, such as simultaneous contrasts or successive contrasts, may arise.

Let us, for instance, put two sheets of paper side by side, one luminescent yellow, the other dark blue. We place a piece of paper of the same shade of green on each of the two papers (Fig. 119), and what do we see? The green circle on the yellow background appears darker and more blue than the one on the blue background, while the blue background makes the same green circle appear lighter and more green. This effect is known as 'simultaneous contrast'. If, however, various coloured backgrounds are used in a series of slide projections, this may result in a 'successive contrast', that is to say the successive background colours have a mutual and at times most undesirable effect upon one another.

A further disadvantage of a coloured background should

be mentioned: a proportion of the light which falls on the background is reflected back onto the subject so that the latter may at times assume a tone of colour which relates to that of the background (Fig. 120).

If one always had to choose a single colour, say blue, then a number of purely technical photographic factors would make it difficult to achieve a constant shade of colour. Differences in the intensity of the illumination, the type of illumination (e.g. flat or angled), a change in the batch number of the emulsion or differences in the development of colour film material in the laboratory will all make it impossible to maintain the same background colour over a period of time. Furthermore, we consider it to be our task to make an objective and neutral record of medical specimens, without using advertising techniques such as brilliant colours. We have, therefore, considered for many years that a coloured background is unsuitable for photographing medical specimens.

The two other (achromatic) backgrounds, white and black, do indeed, literally and fittingly, retreat into the background; their colour does not therefore compete with

119. Simultaneous contrast; influence of background colour on the subject resulting in a subjective colour change.

120. Reflection of the background colour onto the subject causing a colour cast.

121. Influence of black-and-white backgrounds on hue and intensity of colour.

(and possibly dominate) the colour of the specimen. Such achromatic backgrounds ensure a certain measure of neutrality, as does grey.

It is instructive to carry out the following simple test: if different colour samples are placed on a white or a black background one tends to prefer the black background in the first instance because the colours appear to be stronger. However, the black background falsifies the objective colour value, because the colours appear brighter (Fig. 121). In addition, a peculiar psychological effect becomes apparent when a black background is used exclusively: such an amount of black tends to produce a mood of boredom and gloom as time goes on. One can further extend this experiment by placing the various colour samples on differently coloured surfaces.

Experience shows that a black background should gener-

ally be used with light coloured specimens and a white background with dark specimens in order to achieve better definition of the contour and outline of the subject.

6.022 *The white background*

When taking pictures against a white background we encounter the problem of shadows cast by the specimen. A single shadow would not necessarily be disturbing — it may even be helpful in giving an impression of the position of the specimen in space. But since we must usually illuminate the subject with several lamps, the multiplicity of shadows detracts from its appearance (Fig. 122a). In addition, it is a fact that specimens appear lighter when they are placed directly against a white background, and this reduces the contrast of the subject; this effect is similar to that of the variation of colour nuances against a

a b

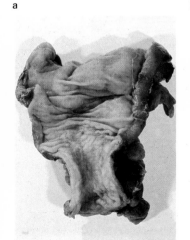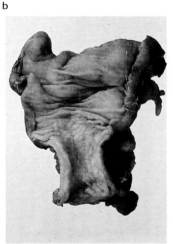

122. a: Subject (preserved piece of intestine) photographed directly on a white background; distracting multiple shadows and lightening of the image; b: subject separated from background.

123. Specimen table, glass plate to hold specimen and screening mask on top, light trough underneath.

124. Specimen table viewed from above (front).

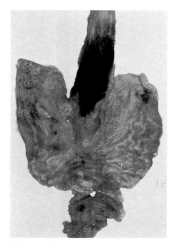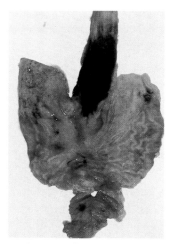

125. a: Background over-exposed by half a stop; b: excessive over-exposure of background: image is flared due to over-illumination (stomach and oesophagus).

coloured background. Both pictures in Fig. 122 were taken with the same exposure time and aperture. We have, therefore, been looking for a solution to the problem of being able to take pictures against a white background without producing any shadows (Fig. 122b); the following solution is based on the construction of a special table.

The table is about 50 cm high and provides two planes, one above the other. The upper one is the photographic plane on which the specimen is placed, the second one, about 35 cm below, is a plane of illumination, a kind of light 'trough' which is intended to provide the white background (Fig. 123). The light trough is equipped with several fluorescent tubes which are in close contact and whose colour temperature is within the colour film range for artificial light. A diffusing opal glass plate lies above the tubes; it obscures them and simultaneously ensures uniformity of light distribution. The illuminated plane is equipped with a system of movable masks in order to screen off any unwanted reflections. The masks are used for screening to an extent which just avoids them from appearing in the field of view. One might be tempted, for the sake of simplicity, to place the specimens directly on the opal glass plate; however, this is not recommended, since we would again have to put up with the same disadvantages that were encountered with a white paper background, namely the contours of the specimen would be obscured by flare, and all that would be gained is that the shadow produced would be somewhat less. The photographic plane consists of a thick sheet of plate glass of about 130×60 cm. Another four movable black masks are positioned directly below this sheet in order to screen off any stray light from the illuminated background. The space separating the photographic and illuminating planes serves the purpose of throwing the shadows more or less out of the picture area and of making them diffuse and weak. When using the illuminated plane shadows should be eliminated altogether (Fig. 124).

If the illumination of the specimen and the background are correctly balanced, shadow-free conditions obtain. In theory, we should illuminate the background and the specimen in such a way that the same exposure meter value is obtained for both. However, it has been shown

126. Effect of various black backgrounds; from left to right: photographic cardboard, poster cardboard, high gloss paper, velvet.

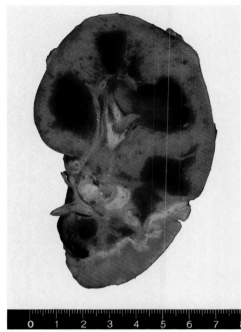

127. Black scale on a light background (kidney).

advantageous in practice to over-expose the background by one half-stop so as to be certain to obtain a neutral white (Fig. 125a). Excessive over-exposure of the background increases the risk of flare (white veil, Fig. 125b). This type of background also possesses technical and hygienic advantages. The glass surface which often supports wet, blood-stained and infected specimens, may be cleaned and disinfected without difficulty.

6.023 *The black background*

This is mainly intended for use with light coloured subjects such as macerated specimens or specimens fixed in formalin. However, it is no simple matter to obtain a background which appears really black on a slide. Several materials appear to be black if one looks at them in isolation, but many appear grey and dirty on a slide. One can readily make out the differences by lining up, side by side, four different black materials such as photographic cardboard, poster cardboard, carbon-blacked high gloss photographic paper, and velvet. It is seen that the velvet is the only material which gives a rich and true black (Fig. 126). Black velvet is a background against which one can take pictures involving several lamps without any problems, and without encountering shadows, since all shadows are lost. Any disadvantage lies in the fact that velvet has to be washed frequently as it comes into contact with moist specimens.

6.03 Proportioning

In order to be able to gain an impression of the size of a specimen it is sensible to include a scale in the picture, especially when any other points of reference for size comparison are absent. If one takes individual pictures of a small and a large kidney in such a way as to fill the field completely, then both appear equal in size. Clearly, the

128. White scale on a dark background (brain).

129. a: Illumination with spotlight: no reflections; b: illumination from a diffuse light source: considerable reflections overall (detail of lung).

scale must not be just casually included in the picture or laid on top of the specimen; it must appear as a narrow band running along the margin of the picture. If the background is white we use a contrasting black scale with transparent figures which can be produced as a negative on 'lith' film. As in the case of the black background, it is difficult to obtain a rich black. This problem can be solved by screening the scale from the nearest light source in such a way that its light illuminates the specimen, but not the scale. Thus we obtain, as it were, underexposure of the scale, resulting in a more intense black (Fig. 127).

Naturally, a white scale is used on a black background. A scale made of white plastic suffices here. In order to avoid affecting the white, the shadow from the specimen should not be allowed to fall on it (Fig. 128). One should take care to place the scale at the level at which the actual size comparison with the specimen will be made; otherwise results might be misleading due to geometric distortion, especially with thick specimens.

6.04 Illumination

6.041 *Lighting equipment*

The use of spotlights and floodlights allows continuous control of illumination. When using tungsten lamps, as distinct from discharge flash tubes, one may vary either the exposure time or the lens aperture as required. Let us consider the advantages and the disadvantages of spotlights and floodlights: the spotlight has the advantage of producing a narrow pencil of light. Focusing enables one to reduce its angle and to obtain increased intensity. In combination with variable apertures (masking flaps), concentrated and controlled illumination of the subject may be assisted by the use of hoods and barn doors. A hard light with dark shadows is obtained, practically devoid of the half-shadows which result when a white background is used. It is also possible to place reasonably sized polarising filters a few centimetres in front of the Fresnel lens without risk of burning.

Using floodlights, the angle of illumination is very great and one tends to illuminate the room as well as the specimen. This produces disturbing reflections and can introduce colour casts. On the other hand, floodlights produce a lighting effect which is softer than that obtained with spotlights. It should also be borne in mind that reflections increase in proportion to the inherent size of the light source and its proximity to the subject. Figure 129 shows the reflections produced (a) when using spotlights and (b) with illumination from a diffuse light source.

6.042 *Electronic flash*

The use of flash units such as those used by press photographers should be avoided even when several lamps are available, because their use makes it difficult to have full control over the illumination. On the other hand, it is reasonable to use studio flash equipment having built-in modelling lights. The choice of daylight types of film emulsion (which are suited to electronic flash) is greater than the choice of emulsions available for artificial light (i.e. spotlights and floodlights). Since the exposure time of the flash is always the same, the actual exposure is controlled by the lens aperture and possibly by additional neutral density filters if the depth of field needs to be modified. Due allowance must be made for the camera extension on the one hand and the potential need for filters on the other. One may visualise an example in the following way: let us assume that a photograph of the whole and part of a specimen are to be taken. The total picture is in the ratio of 1:10; that of the close-up 1:2. With a set of three flash heads of 250 watt-seconds (Joules) each, the flash meter indicates an aperture of $f/22$. The overall photograph requires an aperture of between $f/22$ and $f/16$ after making due allowance for the camera extension (ratio 1:10). For the close-up (which requires a ratio of 1:20) one needs an aperture of $f/11$ (or possibly $f/4$, if polarised light is used). This provides practically no depth of field.

6.043 *Techniques of illumination*

One should always aim to produce a natural type of illumination. In order to achieve the most faithful record, both the format and the structure of the specimen, as well

a b

130. a: Relief illumination, giving a three-dimensional effect and influencing the colour reproduction; b: flat illumination, little effect of depth (transverse section of cerebrum).

as the background employed, are of importance. The character of the specimen can be extensively modified and even falsified by the type of illumination used (Figs. 130a and b). There are no fundamental rules for the location of lamps for illuminating a specimen. What is important is what is observed on the ground glass screen of the camera; only constant and total control results in correct illumination.

A few hints for the less experienced may be in order: the first point to be remembered is that the colours of the subject tend to be more saturated the greater the amount of light that falls upon them. This applies to the colour photography of medical subjects no less than to colour photography in general. It is therefore desirable to have a high lighting capacity at one's disposal, so that the subject can, as it were, be bathed in light. This makes it

131. Soft lighting supplemented with a spotlight (heart with aneurism of the aorta).

132. Intense lateral illumination for clear outlines, with additional soft lighting (artificial femoral head).

advantageous to illuminate specimens by means of several light sources. In general, three light sources are sufficient, because their intensity may be altered by focusing or by a change in the position so as to obtain a modulated effect.

It is recommended that one of the lamps be selected as the principal light. This light should be fairly strong, a spotlight of 500 watts (better still 1000 watts) being ideal. The second lamp is used in order to soften the shadows; in order to achieve this a floodlight or a soft light source of 500 watts is adjusted to a moderately slanted position. A third lamp is positioned very low and close — for instance, a 250 watt lamp in the form of small spotlight; this is used to provide local relief and to illuminate cavities.

When a light coloured background is chosen to show off

133. a: Lightening of shadow areas with extra light sources; b: lightening with white card: falsification of colour and structure (left ventricle).

the specimen to best advantage, it is advisable to work with general top illumination from above, supplemented if necessary by a small spotlight to show up inner structures (Fig. 131). In contrast, intensive lateral illumination coming from various sides is required in order to bring out the contours of the subject when its colour requires a darker background (Fig. 132). However, one should use an additional vertical soft light with not too high an intensity, in order to avoid excessively hard shadow areas in the depths of the specimen.

Secondly, multiple shadows, both on the specimen and on the background, must be avoided at all costs. This problem is solved by the use of a shadowless or black background, as mentioned in Section 6.022, p. 80. The situation is rendered more difficult if the specimens are placed directly on a light coloured background. In order to avoid the production of disturbing shadows one must pay particular attention to the balance between the principal and the complementary illumination. This requires the use of a soft principal light which produces diffuse shadows. Soft beam light sources which are equipped with aperture masks and gauze screens produce very weak shadows. One should also exploit the effect of localised light intensification with some discretion, so as to ensure that the picture is not altogether devoid of character.

In order to lighten shadow areas it is preferable to use an actual light source (Fig. 133a) rather than reflecting surfaces, such as reflecting panels or white board, of the type frequently used in studio photography and portraiture. Such accessories tend to produce a smudging effect due to large mirrored reflections on moist specimens and this leads to a falsification of colours and texture (Fig. 133b).

6.044 *The general problem of reflections*
A new problem arises when several light sources are used. Sometimes there is such a multiplicity of reflections that the specimens disappear behind a sort of sheen. The reduction or total elimination of reflections offers a great difficulty. This is just one reason why one cannot use flash units without a modelling light if reflections are to be controlled.

134. Avoidance of reflections by photographing the specimen (preserved lung tissue) immersed in fluid (a) or with fully polarised light (b).

135. Diaphragmatic hernia photographed under fluid in order to achieve a three-dimensional effect.

136. Biopsy of intestine, also photographed under fluid to separate the villous fronds.

137. a and b: Diagram showing the effect of a polarising filter (see text).

The reflections may be reduced by making do with fewer lamps, or by moving the light sources further away, or by using small reflectors. Reflections can be made to disappear altogether if the specimen is immersed in water. Unfortunately this is not always possible – some specimens may be damaged by immersion, or the fluid becomes rather turbid, while in other cases the original colour becomes modified. Sometimes there may be an additional lighting difficulty if the container edges throw shadows onto the specimen. Another troublesome feature is the appearance of air bubbles on the walls of the container and on the specimen itself. Fully filled containers are difficult to move about and are not conducive to fast operation. Finally, the colour contrast appears reduced in colour photography.

A close-up of a preserved section of lung is shown in Fig. 134, which was taken (a) under fluid and (b) in fully polarised light. It is obvious that photography under fluid is possible in practice, but chiefly for specimens preserved in formalin. Satisfactory results with this method are obtained mainly in the photography of cysts (Fig. 135),

biopsies and the like. The biopsy in Fig. 136 was taken under fluid using a macro lens of 25 mm focal length. Such a lens can give a magnification on the negative of up to ×20. The villous fronds of a gut biopsy are well separated by immersion in fluid, whereas they adhere together in the dry state.

In order to control reflections, or avoid them altogether, one is still left with the possibility of using polarising filters. Polarisation by the double filter method enables one to keep reflections strictly within bounds at the possible expense of definition, duration of exposure and colour degradation.

6.05 Polarisation

The polarising filters with which one is familiar are generally associated with the photography of objects behind plate-glass windows – having a reflection problem – or to remove the sheen when photographing polished furniture. They have the appearance of neutral density filters

and indeed pass no more than half the light available. They have a deleterious effect on detailed resolution if this is critical and have practically no effect on reflections from metallic surfaces. Nonetheless, they are often forgotten in medical photography and have a part to play in the recording of specimens.

6.051 *The principles of polarised light*

Natural light consists of electromagnetic vibrations, which are transverse waves around the axis of a beam of light. Just two planes of such vibrations are diagrammatically shown in Fig. 137. The effect of a polarising filter may be characterised as that of a grid which has the property of permitting the passage of light vibrations in a single plane only. If this grid is in a horizontal position only the horizontal vibrations penetrate; if it is in a vertical position then only the vertical vibrations pass through. If it is in an inclined position only the waves of the corresponding direction of inclination are passed. Because only a portion of the light vibrations pass through the polarising filter, the incident light loses more than half of its original intensity. This is why polarising filters appear grey on inspection.

What happens to a beam of light after it has passed through a first filter, which we will call the polariser? The beam now has direction – it vibrates in one plane only (Fig. 137a). What happens when it meets a second filter, to be known as the analyser? If the rotational position of the analyser coincides with that of the polariser, it permits the passage of the light beam; however, if the analyser is in the crossed position, then no light can penetrate (Fig. 137b).

The function of a pair of filters in the mode mentioned above is shown in a practical example:

Fig. 138a Filters in parallel – light penetrates;

Fig. 138b Filters in the crossed position – no light is allowed to penetrate; the field is therefore black.

138. a: Polarisation filters in parallel; b: polarisation filters crossed.

139. a and b: Reflecting window panes, photographed with different polarisation in each case.

6.052 *The single filter method*

Natural polarised light is mostly generated by reflection. The light which diffuses through the blue sky is more or less polarised following scatter when impinging upon the upper atmosphere. We can therefore reduce or even eliminate certain reflections in outdoor photography by using a single polarising filter. The polarisation effect of sunlight is best exploited when the direction of the camera is at right-angles to the sun's rays. Light rays which impinge on a glossy (but not metallic) surface at an angle of between 25° and 35° are similarly reflected in a completely polarised manner, so that it is also possible to eliminate reflections by means of a single filter.

On looking through a polarising filter when taking pictures out-of-doors it is obvious that not all the reflections can be eliminated simultaneously. Example: two views of the front elevation of a house with reflecting rows of window-panes, taken with a polarising filter (Figs. 139a and b). In (a) the right hand side of the house is polarised,

and not the left; in (b) it is the other way round. The difference was produced by rotating the filter. This is also the case when a medical specimen is illuminated at an angle of 33° with a spotlight whose polarising filter is in the corresponding rotational position. If a specimen is viewed in the reflected angle of the spotlight, it is seen that almost all the reflections are eliminated (Fig. 140a). If one proceeds to view at a different angle the reflections reappear (Fig. 140b).

By eliminating reflections at the surface we achieve an enhancement of colour saturation. The colour characteristics of a subject can be radically changed. It might even be said that the polarising filter, in a sense, has the same effect on colour material as a yellow filter has on black-and-white material.

6.053 *The double filter method*

A single filter in front of the lens produces only a little effect in artificial light, which emits unpolarised light

140. a: View of stomach at an angle of 33°: reflections eliminated; b: view at an angle of 90°: reflections reappear.

141. a: Spotlight reflected from a mirror (filters in parallel); b: spotlight reflections practically eliminated (filters in crossed position).

beams. It filters only those light rays whose angle of incidence is about 33°. We must therefore use primary polarised light to impinge upon the secondary polarising filter in front of the camera. This is achieved by placing a polarising filter in front of the light source, so that the vibrations of the light beam are confined to one plane. We can then proceed without having to bother about the angle of observation. This is an advantage compared with sunlight, because we are now working with fully polarised light. This may be termed the double filter method.

6.054 *The theory of reflections*

A reflection is a reflected beam of natural or polarised light which is generated by metallized surfaces, glossy materials or objects, liquids, mirrors, etc., when the angle of incidence is equal to the angle of reflection in a direct or diffused manner. A reflection thus obeys the laws of optics. It might now be asked why the polarising filter in front of the lens eliminates the reflections only, while leaving the subject visible. Here one must bear in mind the definition of polarised light: it remains polarised after reflection from a polished surface such as a mirror, but it is depolarised when it impinges on a matt surface, when it is again scattered in all directions. Figures 141a and b show the reflection from a mirror of a spotlight which is provided with a polariser. In Fig. 141a polariser and analyser are in parallel; in Fig. 141b they are crossed, so that the light of the spotlight is virtually extinguished, while the image itself remains visible. The remaining blue glimmer, which can still be seen in the mirror, originates from residual non-polarised light. It is there owing to the fact that we are using filters with a permeability of 38%. Such filters have an extinction power of 1:400. Other filters are available which have a much greater extinction power (up to 1:20,000), but their use lengthens exposure times considerably. Such filters are also very sensitive and their potential would not normally be fully exploited. It is pointless to have a polarising filter of low permeability in front of the light source if the filter in front of the camera does not have the same capability. Good results are obtained when a filter foil, such as HN 38–KS/BEL or PW 76 from Messrs. Polaroid and Käsemann, is used in front of the light source, combined with the usual polarising filters marketed by camera manufacturers.

142. a: Part of heart, in polarised light; b: same subject without polarisation: distracting reflections, colour shift.

143. a: Excessive polarisation: subject (carcinoma of the large intestine) appears flat and lacking in contrast; b: additional unpolarised spotlight for relief and structural effect.

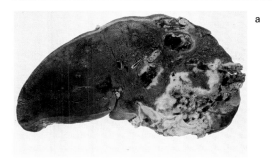

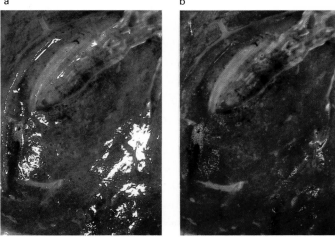

144. a: Liver slice, with total polarisation: true colour; b: same subject without polarisation: water in the tissue acts as a mirror and lightens the colour.

145. a: Detail of lung surface, unpolarised; b: with full polarisation the reflection appears bluish because effect is too strong.

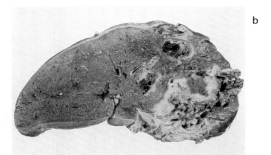

c: incomplete polarisation; d: modified lighting and full polarisation.

Figures 142a and b provide a practical example of specimen photography which illustrates the effect of polarised light. Having extinguished the reflections by crossing the filters it is possible to observe the structure and colour of the subject to better advantage.

6.055 *Experience with polarised light*
The first people to apply the principles of polarised light were those who photographed oil paintings and glass-covered items for catalogues, documents and art publications. The adaptation of the technique to medical macro-photography is a simple step, but it does not follow that total polarisation is always applicable to the photography of medical preparations.

Figure 143a tends to give an impression of flatness, and it also suffers from a loss of definition. A 250 watt spot-

light without a polariser is therefore used as an additional light source to generate a few small reflections; this gives some relief as well as an idea of texture (Fig. 143b). In the case of preserved specimens it has been found that total polarisation is feasible and may even be recommended, depending on the type of subject. An example of this may be seen in the picture of a liver slice (Fig. 144a). Even though the specimen had been dabbed off with filter paper before exposure, it still contained much fluid in the small tissue depressions and these act as mirrors under incident light (Fig. 144b).

6.056 *The practical application of polarised light*

The use of polarised light is not difficult in practice and requires scarcely more time than conventional methods. After attaching the analyser to the lens it should not be touched again, in order to make sure that it always remains in the same rotational position. A polariser is then attached to the lamp and is rotated until the reflections disappear; the same procedure is followed with the other lamps. The filters must not be too close to the light source, because they are liable to be damaged by heat. The disposition of the spotlights has nothing to do with the polarisation effect. It is thus possible to adhere to the fundamentals which have been described in Section 6.04, p. 83, remembering also the recommendation for the use of two spotlights with, and one spotlight without, a polarising filter, the latter being used to create some localised highlights.

Sometimes, however, the intensity of the reflection may be so great that it cannot be totally eliminated (Figs. 145a and b). This difficulty should be avoided by simply not fully polarising the light. This is achieved by stopping the rotation of the polariser before the reflections assume a bluish tint (Fig. 145c). A change in the position of one or more spotlights is another requirement; this produces a reduction of the reflections, which may then be altogether eliminated if required (Fig. 145d). It should be observed that reflections will not only lose intensity but will also become smaller during partial polarisation. This is due to the fact that the centre of the reflection is more luminous than the periphery. Polarising filters can alter the colour characteristics of a specimen in a manner similar to land-

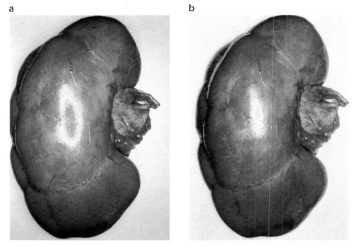

a b

146. a: Circular reflections on a kidney with ring flash at a short working distance; b: reduction of the reflection with a longer focus and greater working distance.

scape photographs, even though the filters do not themselves generate a colour change. This is due to the elimination of all unwanted reflections which may cause desaturation of colours (compare Fig. 144). Thus details obscured by reflections become visible and the correct colour of the subject emerges. The use of polarised light has the advantage that one can work within narrow angles of illumination, even with direct frontal light, without the picture of the specimen becoming virtually unrecognizable on account of reflections.

6.06 Ring flash

Although ring flash is generally used for hand-held photography in the operating theatre or the autopsy room, it

147. Shadows thrown with ring flash at short and long working distances.

148. a: Ring flash with a cut-out plastic polarising foil; b: ring flash with a polarising foil and alternative filter segment.

can also be employed as a simple photographic accessory for the photography of specimens, provided one is willing to put up with a reduction in picture quality. The principal problem with ring flash, however, is once again the matter of reflections, because it depends on head-on illumination and because the circular flash tube tends to generate annular reflections. The location of these reflections cannot be checked prior to exposure because of the absence of a modelling light and they disfigure the picture with bizarre and distorted circular images, depending on the shape and structure of the specimen. The reflexes are the more pronounced the shorter the distance between the ring flash and the specimen (Fig. 146a). For any degree of magnification it is therefore preferable to use a lens with a long focal length (Fig. 146b). Another advantage of a long focus lens when using a ring flash is that only a thin shadow zone is thrown around the subject during exposure. This is illustrated in the two sketches in Fig. 147. The proportions of focal length, ring flash and specimen are deliberately exaggerated in order to demonstrate the the principle. Clearly the half-shadow visible between the light beam and the axis is broader with short focal length lenses than with long focal length lenses.

When taking photographs of pathological preparations the ring flash should be used in combination with a polarising filter. Here, again, we need an analyser and a polariser in the same way as has already been described. As a polariser, we use a foil of plastic polarising filter material which is cut out in the shape of a ring, so that it covers the reflector of the ring flash (Fig. 148a). A glass polarising filter is slotted into the circular opening for the camera optics; this filter is appropriate for the optical field and acts as the analyser. In order to achieve total polarisation one must still ensure that both the concentrically placed filters are in the crossed position. This requires the combination to be viewed through a third polarising filter, and either the cut-out polarising foil or the glass filter must be seen to be dark and the other one light.

An alternative filter design is shown in Fig. 148b. Here a segment is cut out of the filter ring, and the missing piece is replaced with a polarising filter segment lined up in the same direction as the polarising glass filter. This segment is rendered light in the picture and is therefore not

a b

149. a: Intestine, detail of mucosa, partially polarised ring flash: flat, structureless illumination; b: same subject, illuminated with spotlights: three-dimensional effect.

150. Colour charts on light and dark backgrounds, exposed in each case according to the light measurement through the lens.

polarised; this allows partial polarisation of a constant intensity from the reflector surface.

It should be noted that inevitably very flat illumination is produced due to the nature of the design of the ring flash. This may be seen in Fig. 149a which is a photograph of a piece of large intestine taken with a partially polarised ring flash. Figure 149b shows the same specimen, taken with three spotlights, two of which are equipped with polarising filters.

6.07 Exposure determination

Although many cameras have integral light meters these days, it is preferable to carry out independent light measurements, because this enables reproducible results to be obtained more easily. It is obvious that the background influences the measurement of the subject. A black background reflects scarcely any light, and the subject is over-exposed. Using a white background, the subject is under-exposed; this is especially true when the back-

ground receives extra illumination. The differences may be clearly seen in the identical colour charts shown in Fig. 150. The readings from the integral through-the-lens light meter gave an aperture of $f/3\cdot5$ with a black background and of $f/11$ with a white background, the shutter speed being the same. The correct aperture is about $f/8$. Everyone who uses a colour chart can imagine what such a deviation implies.

It is obvious that the exposure adjustments for camera extensions, filters, etc. must be added to the values indicated by the exposure meter. The necessary multiplication factor due to polarisation must be pointed out in particular. A threefold exposure increase for polarised light (which is usually quoted) is insufficient. Four- to sixfold increases in exposure time are more realistic, depending on the degree of polarisation and on the colour of the specimen; this means that one adds 2 to $2\frac{1}{2}$ stops to the calculated value.

It must be borne in mind that the overall tone of the subject plays an important part in the production of a picture. A very light coloured object should be somewhat under-

exposed, even though it might appear slightly grey as a result. In the case of a dark object, on the other hand, slight over-exposure is an advantage in order to distinguish its structure to better effect.

How does one measure the light when using a ring flash? The usual formula 'guide number divided by distance equals aperture value' is incorrect for close-ups. Since the flash is mounted on the lens direct, the lighting intensity is increased, depending on the proximity of the subject that is to be photographed. This intensity is not proportionally compensated for by the required increase in camera extension. It is therefore recommended that the aperture values should be tested for the various distances and a suitable table compiled in order that reproducible results and rapid working may be ensured.

6.08 Some observations on photomicrography

6.081 *Introduction*

In contrast to the photography of patients, specimens or surgical operations, in which the photographer can give his imagination more or less free rein in order to achieve a good picture, photomicrography is largely a technical discipline with constraints at every turn. It is, moreover, a subject which nowadays hardly comes within the purview of the medical photographer in an everyday sense. The optical bench, requiring considerable skill in operation, has given way to the automatic photo-microscope having little or no scope for adjustment. Hence this work now tends to be carried out by pathologists rather than photographers.

However, for the sake of completeness, this brief section is included simply to point out some of the special problems in this field in case the photographer should be confronted with a task involving microscopy. Only the briefest guidelines can be given here, but the reader can refer to a vast fund of literature on this topic and a reasonable selection of titles is to be found in the bibliography at the end of this book (p. 155).

6.082 *Photographic equipment*

It is not a good idea to use a normal 35 mm camera for focusing and exposure. The focal plane shutter provided on these cameras causes vibration due to its lateral momentum and this is mainly responsible for blurred pictures.

The relatively coarse structure of the small ground glass screen makes it difficult to observe details; precise focusing is therefore impossible. In order to obtain satisfactory results the use of a micro-adapter is accordingly recommended. This can be fitted to any microscope and generally allows the camera itself to be used simply as a film magazine.

This system incorporates a focusing eyepiece which — as an actual picture can be seen — permits a very clear view and precise focusing. For exposure, a 'between-lens' shutter is provided in a light lock mount, which avoids any blurring as the vibrations produced by the movement of the shutter leaves are distributed around the optical axis and cancel each other out. Furthermore, this attachment is mounted in such a way as to prevent vibrations being transmitted to the microscope. When measuring the exposure, it is quite possible that values may be arrived at that lie between the standard shutter speeds. In black-and-white photography it is sufficient to adjust the lamp voltage in order to achieve the shutter timings marked on the setting ring. In colour photography such a procedure cannot be followed as explained in Section 6.084. With a grey filter (density: ND 0.1 and ND 0.2, factors: $1\frac{1}{4}$ and $1\frac{1}{2}$ respectively) in front of the light source correct exposure can be achieved. Such problems do not of course arise with automatic equipment, since in addition to the facilities of the micro-adapter an electronic device is provided which on the one hand adjusts the shutter in accordance with the intensity of the light source and on the other transports the film between exposures.

6.083 *The optical system*

In the effort to obtain a sharp picture the objectives of the microscope play just as important a role as the lenses of the camera in general photography. Results that are satisfactory in every respect can be obtained only with flat-field achromatic objectives, as these even out the curvature of the image. Lenses, eyepieces and condensers of different makes should not be used in combination; what

seems acceptable to the naked eye will not always produce the expected result in the finished picture. Chance alone may produce something better.

Very often, too little attention is paid to the optimum combination of objectives and condensers. It is very important in this case to read the manufacturer's instructions carefully in order to find out which condenser should be used, whether its front lens — if there is one — should be inserted, and at what height the condenser should be set. To avoid errors, the illumination should be set to conform to Köhler's arrangement before each exposure. Once the desired illumination has been achieved, the aperture in the condenser must not be reduced too much. It is suggested that the aperture be closed just far enough for a reduction of the light intensity to be noticed (Fig. 151a). Many people think that if the aperture is closed

right down, a better depth of field is obtained, as with a photographic lens. This is a fallacy, however, because in this way double contours are produced by diffraction, i.e. a kind of pseudo-phase contrast, with reduced resolution and a loss of intermediate tones (Fig. 151b).

Despite the most careful setting of Köhler illumination, it may still be found that the light distribution is incorrect. Only a practised eye can tell by looking through the eyepiece if the field is evenly illuminated. One should therefore check from time to time whether the lamp is still in a central position and the collector correctly set; for this purpose the manufacturer's instructions should be followed. This check can be carried out quickly by projecting the image of a sharply focused specimen on to a piece of white card about 25 cm from the eyepiece. When the slide is removed, any unevenness of illumination can be seen at once.

6.084 *The picture*

Apart from technical shortcomings, it is obvious that only a well-stained specimen can yield a satisfactory picture; this applies to colour photographs even more than to black-and-white ones.

In black-and-white photography it is to some extent possible to intensify the contrast by inserting filters, in modifying development or in making copies. The limits to this, however, are not as wide as is generally thought; if one goes too far, detail will be missing in the grey tones, and the result will in consequence be disappointing. Films of low sensitivity offer the best resolution; in other words they yield good contrast. This can be improved still further by using colour filters chosen according to the stains employed; green filters can be particularly recommended.

In colour photography the contrast cannot be intensified with filters and the light source must always be correctly adjusted with regard to colour temperature (Fig. 152a). The lamp voltage should normally be slightly increased; it is very important that the lamp should always be at the

151. a: Limited closure of aperture, giving high resolution; b: full closure of aperture: diffraction, poor resolution, loss of intermediate tones.

152. a: Histological specimen (liver) with correct lamp voltage and colour temperature; b: same subject with lamp voltage reduced by 10%: colour cast.

153. a: Histological specimen (lung), Van Gieson staining; b: similar subject, haematoxylin and eosin staining (same filter as for Fig. 153a); c: subject a, Van Gieson staining and light blue filter.

same voltage, as a reduction of as little as 10%, for example, can adversely affect the colour rendering (Fig. 152b).

If a daylight film is selected, an 80A or CB12 conversion filter should be placed in front of the light source to compensate for the colour temperature of this film. Two preparations (e.g. haematoxylin and eosin and Van Gieson) should be used as a basis for a series of tests. The final adjustments necessary can be made with the aid of these examples. During the test it is advisable to use films of different speed and to vary the lamp voltage until the best result is obtained; it is quite possible that even then one colour will still obtrude. This can be eliminated by the use of additional colour compensating (CC) filters. The staining of the specimen will generally affect the tone of the picture. If a Van Gieson stain (Fig. 153a) is photographed with the same filter as a haematoxylin and eosin stain (Fig. 153b), a tone is obtained that is rather too warm. To correct this colour cast, a type CC5B or CC10B blue filter must be added (Fig. 153c).

High magnification objectives absorb a considerable

amount of light and the exposure may well exceed 1 sec., depending on the light intensity and the sensitivity of the film. If this is the case, reciprocity failure must not be underestimated; this will result in apparent underexposure and some form of colour cast.

The photography of instruments

7. The photography of instruments

By Dietmar Hund

7.01 Introduction

Compared with other photographic activities at a university hospital the photography of instruments and surgical apparatus is fairly infrequent. Such photographs are required, for example, to illustrate the range of instruments needed for a given operation. Also newly developed individual instruments and surgical devices have to be photographed for publication purposes or to provide the basis for instrument catalogues. Photography is used chiefly to demonstrate the shape and function of an instrument as effectively as possible. Particular difficulties, especially the problem of reflections from metallic objects, may suggest that expensive technical photographic equipment is likely to be involved, but this is not the case. This chapter will describe photographic techniques suitable for photographic units in smaller hospitals which have only a modest range of equipment. This is a field in which, surprisingly enough, the cleverest and most skilful photographic techniques require quite modest technical equipment. The chief difficulty lies in devising the most suitable techniques. James Perret of Lucerne, a freelance industrial and advertising photographer has provided valuable data on exposure and technique. This proves, once again, that the wide spectrum of photography undertaken by photographers from industry and advertising is often able to throw light on some of the problems encountered by hospital photographers whose expertise is specialized and often one-sided.

7.02 The camera

The camera equipment depends on the type of work which is likely to arise in the diverse fields of activity of a given institute or hospital. Small specialized photographic departments are rarely expected to take pictures of instruments and other objects, whereas larger sections at university hospitals may be involved with this type of work almost every day. Under the latter circumstances it is worth buying a technical camera (e.g. 4 × 5 inch format), while small units will have to make do with 35 mm or medium format cameras for the occasional pictures of apparatus.

7.021 *The technical camera*
Compared with standard equipment, the technical camera (with movements) has the advantage that with it one is able to control depth of field, which enables flat objects

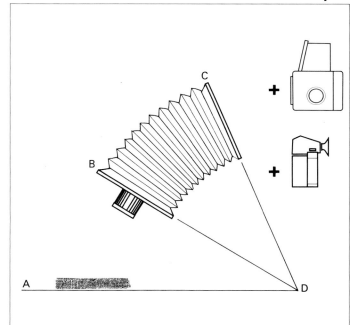

154. Scheimpflug's rule: *A* subject, *B* front lens carrier, *C* rear film carrier, *D* point of intersection of planes.

such as instruments to be sharply defined when photographed from an angle, even with the aperture wide open (Fig. 154). In cases such as extreme close-ups, the necessary depth of field can often not be attained even with the smallest aperture when using the fixed 35 mm or medium format camera.

Since the majority of publications are printed in black-and-white, the larger format of the technical camera is an advantage in recording detail in individual instruments, especially when these are displayed in the context of an entire instrument table.

When colour slides are needed for projection it is possible to mount an appropriate adapter for 35 mm or medium format (6 × 6 cm) film in place of the ground glass screen. This enables one to obtain depth of field control by tilting the front or the back of the camera (depending on the perspective) for these formats as well, while at the same time exploiting the effect of lateral movements as necessary.

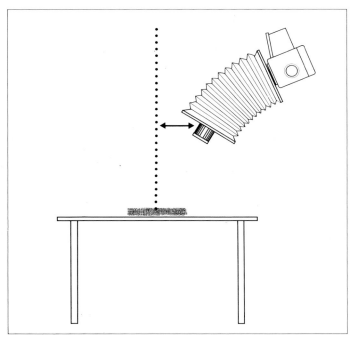

155. Displacement of the camera from the vertical axis.

7.022 *The lens*
In principle, long focal lengths should be used:

35 mm	ca. 135 mm
medium format	ca. 210 mm
4 × 5 inches	ca. 360 mm

Shorter focal lengths cannot only lead to distortion of perspective but also severely limit the use of camera movements due to a restricted covering power.

7.023 *The lens hood*
The lens hood attached to the lens prevents extraneous light rays from reaching the lens and reduces undesirable scattering of light. The definition and the brilliance of a photograph depend to a large extent on the degree to which interference by scattered light and flare can be diminished. The use of a long focal length lens makes it possible to extend a bellows-type lens hood to quite a considerable extent (any possibility of vignetting must be checked) and it is possible even to use a mask within the hood.

7.03 Photographic technique

7.031 *Positioning*
The position of the camera when taking photographs of instruments is not confined to the absolutely vertical plan view. A shift towards the front view direction (Fig. 155) of about 20° produces the all important side view which gives more information about the size, the construction and the possible function of the instrument.

7.032 *Background and illumination*
If we simply use a white cloth as a background, the texture and the folds of the material have a disturbing effect; this is clearly demonstrated by an exaggerated example (Fig. 156). Lateral illumination with two lamps (Fig. 157) results in an ugly double shadow, reflections appear on the instruments, and where the reflections are absent darker areas stand out. All the less attractive features of the instrument surface become apparent (many of the instruments which are to be photographed are often items which have been much used).

The first distinct improvement of the picture is accomplished by the use of a neutral-white background on the one hand, and by diffusion of the light on the other (Fig. 158). Tracing paper or a matt opal plastic sheet is hung above the entire width of the table (ca. 130–150 cm) on both sides; this results in soft illumination (Fig. 159).

The same example on a dark background shows a distinct flattening of the illumination of the instruments (Fig. 160). The side view which is so important for its relief effect (in the example given, especially on the tip of the instrument) is greatly degraded by the reflection of the dark background.

In order to obtain as three-dimensional a presentation as possible and to avoid interference from shadows, it is necessary to present the instruments without background detail (Fig. 161). As is seen in the sketch (Fig. 162), this requires an *additional lamp* (a photoflood lamp), an *opal glass plate*, a *matt glass plate* etched on one side, and four rubber pegs. As regards the size of the glass plates, 50 × 60 cm should generally suffice.

It is important to cover those parts of the background

156. Distracting background, double shadows and reflections.

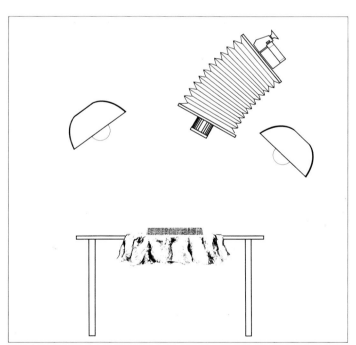
157. Lateral illumination with two lamps, fabric background.

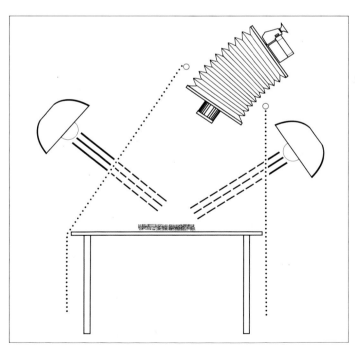
158. Illumination through diffusion screens.

159. As Fig. 156, but with neutral white background and diffused illumination.

161. As Fig. 159, but instruments standing out on a transparent background.

160. As Fig. 159, but with dark background: flattening effect and reflections.

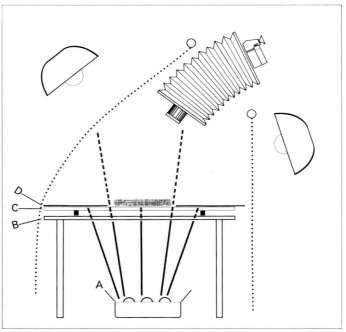

162. Lighting arrangement for maximum relief: *A* flood lamp, *B* opal glass plate, *C* matt glass plate etched on one side (top), *D* masking frame.

which are not used. A *frame* cut out of *black paper or cardboard* prevents serious interference by scattered light which causes flare.

The use of a *semi-matt spray* prevents the mirror effect of sharp edges and hard reflections. The instruments are always carefully sprayed all round from a distance of about 30 cm while lying on a piece of paper. They must be allowed to dry. The effect of the spray begins to disappear after a few hours, and the matt effect vanishes altogether at a temperature of 60–70 °C.

7.033 *Illumination*

Reflected and transmitted light must be balanced to a certain ratio, this ratio being determined by means of a light meter. The *transmitted light* (background) reading should be brighter than the reflected light reading by half to one stop.

The arrangement of the lamps for the illumination of the instruments should not be altered once it has been established, but the illumination of the background may be changed without disadvantage. The brightness of the background depends on the distance between the lamp and the glass plates, and on the light output of the lamp itself. For black-and-white photographs it is possible to alter the light output with a rheostat. For colour photography, on the other hand, it is necessary to keep putting tracing paper or neutral-white fibre-glass sheet between the background lamp and the glass plates until the correct aperture ratio has been established (Fig. 163). Light reduction with a rheostat would affect the colour temperature of the lamp and cause a colour cast on colour film.

7.034 *Filtration*

A slight blueness in the colour of a metal instrument may not be apparent to the human eye. Any resultant blue

163. As Fig. 161, but in the form of a 4 × 4 cm colour slide, neutral white background.

164. Photograph of detail using an exposure cone with diffusion effect.

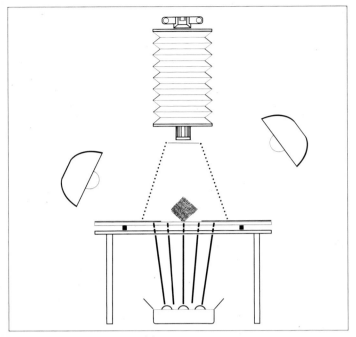

165. Lighting arrangement with exposure cone or tent.

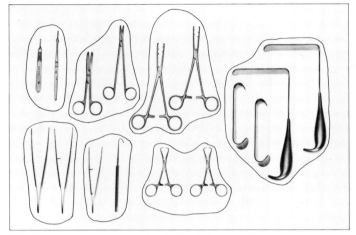

166. Instrument set: mounted individual photographs.

colour cast, when using colour film, may be corrected by using a light blue filter (CC 05 B).

7.035 *The exposure cone*

Details of instruments (close-ups) can also be photographed against the background described using a so-called exposure cone (Fig. 164). The position of the camera is fixed vertically through the opening in the cone (Fig. 165). The required view is simply obtained by rotating the instrument itself. The arrangement of the lamps around the cone must be determined while observing the effect on the ground-glass screen. Larger set-ups may be tackled in a similar manner by employing a 'tent' of muslin or tracing paper affixed to the lens-hood.

7.04 Sets of instruments

Up to this point we have considered the photography of individual instruments. When, on the other hand, it becomes necessary to photograph several instruments simultaneously (e.g. a set of instruments), there are, in principle, two ways of doing this:

1. One alternative is to use a larger background format (opal and matt plate) and to photograph directly all the instruments at the same time. The disadvantage of this (especially for medium, not to mention 35 mm format) lies in the relatively poor reproduction of detail. The more delicate instruments are not readily recognized in the photograph and are scarcely identifiable on publication.

A further disadvantage is the fact that the position of the camera has to be the same for all the instruments. Some instruments require a side aspect, which normally needs substantial *lateral movement of the front or rear elements* of a technical camera. Furthermore, the illumination required is by no means the same for all the instruments. The illumination has to be individually adapted to each instrument, which is of course out of the question in direct photography as described above.

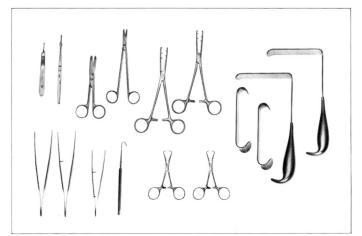

167. As Fig. 166: edges of the cut-outs eliminated by a free-standing mask during preparation of the printing plate.

2. The better alternative is as follows; the set of instruments is assembled in the way in which it is to appear in the publication and an exact sketch is made of the 'composition', noting the position and location of each instrument. A rough overall photograph or even a tracing from the ground-glass screen may prove the easiest way of producing a key.

The instruments, or groups of instruments, are now photographed *individually*, in accordance with the position noted on the sketch. This enables us to move the camera position in a lateral direction between shots and to change the illumination for each as necessary. What must not be altered is the inclination of the camera and the distance from the subject. We first select the instrument which has the largest surface, or the largest group of instruments, so that the scale of the picture can be maintained in the subsequent exposures once this has been established.

After processing we copy, or enlarge, the individual black-and-white negatives to the reproduction scale originally selected. The advantage of the above method lies in the variable enlargement technique which can be adapted to each instrument in turn.

The enlargements or the contact prints of the instruments are cut out and mounted on white cardboard (Fig. 166). Mounting is assisted by reference to the original sketch.

For the final copy for reproduction the production of a *free-standing mask* is no problem; this is intended to ensure that the edges of the cut-out enlargements on paper do not appear on the photo-engraving (Fig. 167). It is also possible for the platemaker to add a slight tint of grey in place of the white background.

The technique just described is especially suitable for producing master copies for publication. It does not require any large-format photographic equipment. Its chief advantage lies in the flexibility of scale and illumination when photographing individual instruments which results in an improvement in the reproduction of detail.

The use of available daylight should not be ignored in instrument photography. There are occasions, especially with large sets of instruments, when the diffuse light of an overcast sky can be used to produce an acceptable result. When one moves on finally to the printing of negatives of instruments, Bullock has described a most useful technique for *outlining* the profiles of instruments by a process of partial reversal or solarization. It is the absence of crisp outlines that often drives instrument manufacturers to use line drawings rather than photographs in their catalogues, but the partial reversal line technique goes a long way towards answering this problem and is certainly less expensive than hand drawn illustrations.

7.05 Colour photography

When placing instruments and surgical equipment directly on a coloured background one obtains coloured reflections from the shiny metal surfaces which greatly detract from the true representation of the subject. Brighter lighting does not help to eliminate this undesirable effect. An effective answer is provided by separating the subject from its background (Fig. 168). As seen in Fig. 169, this technique is relatively simple, but it is limited to

point in the middle of the picture. *Several exposure variations are required in practice.* Starting from a determined average one must use exposure times of at least one half-stop above and one half-stop below. Depending on the character of the radiographic picture (high or low contrast) and on the location of the most important features, it may be necessary to use wider variations of exposure.

When using black-and-white negative film one should over-expose and under-develop. This then allows the production of fine grain enlargements on photographic paper. In special cases larger negative formats of 6×6 cm or 4×5 inches are appropriate. A 1:1 contact copy (radiograph on contact paper) is of little use.

A negative film is also recommended when both slides and paper copies are to be prepared from the same radiograph. It is possible to use slide duplicating equipment for the preparation of 1:1 slide copies from the negative on a high contrast black-and-white film in any desired quantity. In order to produce good work, it is again necessary to allow for variations of exposure times.

The technique which has been described above can hardly ever provide the optimum, in view of the properties of radiographs mentioned initially. No film material can cope with the great differences in contrast. *The reader is therefore advised always to base exposure on those parts of the picture which are the most important.* The photographic print must (if necessary) be rendered more uniform by printing up and shading during enlargement in the darkroom.

8.04 Electronic contrast balance

For hospitals and institutes which depend on the optimum conveyance of information we recommend reproduction or contact copying with an *'electronic contrast balance'* device. This technique is used by some large organizations nowadays and is known by the trade name of 'Log-Etronics'. In this technique a cathode ray tube serves as a light source. Every point on the radiograph is scanned by the cathode ray and analysed by a photomultiplier. The incident quantity of light controls the exposure time

172a

172–176. Conventional copies (series a) and Log-Etronic printing (series b) reproductions of radiographs.

172b

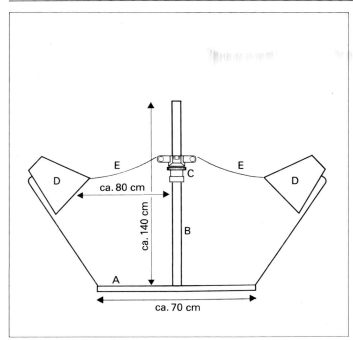

182. Reproduction equipment for 35 mm cameras: *A* base; *B* column with support arm; *C* camera (F=50 mm); *D* lamps; *E* shades to prevent reflections.

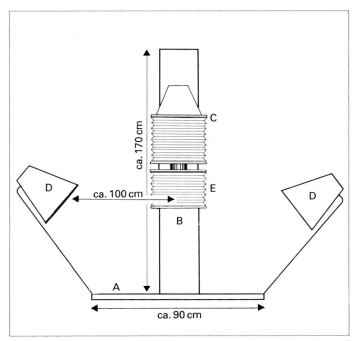

183. Reproduction equipment for medium-format cameras: *A* base; *B* column with supporting arm; *C* camera (F=90–150 mm) with viewfinder lens and bellows; *D* lamps; *E* lens hood.

hand, many suitable film materials are offered by various manufacturers in sheet form. It is, of course, possible to contain both the 35 mm or 4×4 cm format within the 4×5 inch sheet size and this provides an almost unlimited choice of format in the smaller sizes. In addition, the resolution capability of the larger format is superior in certain border line cases compared with the 35 mm format. To this must be added the problem combinations of half-tones with line drawings which can be resolved by means of a register device and enlargers for sheet film formats normally have accessories which make such combinations feasible.

9.04 Lenses

The operating range for all copy work should be thought of in terms of close-up. It is, therefore, important to use high-quality lenses that have been specially corrected for this region. Macro lenses offer one possibility as do the better quality enlarging lenses. If there is a preponderance of this type of work it may be wise to invest in a 'process' type of lens as used in commercial photomechanical reproduction, but short focal lengths are uncommon in this class of lens.

9.05 The original

Drawings, diagrams and other graphic material are generally drawn on tracing paper, ideally on white draughtsman's board, using black Indian ink. The semi-transparent rough tracing paper which is generally used by draughtsmen may, however, offer a problem in reproduction. Liberal application of wet Indian ink unavoidably causes tracing paper to ripple, and this in turn may cause straight or parellel lines to become distorted (Poli-matt paper is an exception). Sandwiching between glass plates is only marginally helpful as a corrective. In addition, reproduction requires the semi-transparent tracing paper to be placed over a white base. The normal 45° illumination required causes scarcely visible shadows which nevertheless reduce the apparent sharpness of the image.

Ortho – Fim

Ortho – Film

Ortho – Film

184. A correction made on the black-and-white original is visible in halftone but disappears on line film.

185. The blue millimetre grid . . .

Corrections to the original can readily be carried out with an opaque white *covering fluid* or by sticking on *paper*, provided that one is working on a pure black-and-white drawing (Fig. 184).

Fine pencil drawings reproduce as slides only with difficulty. If lith film is used the draughtsman's details are lost owing to the very high contrast of the film material; halftone film produces a flattening of the desired contrast due to veiling of the background. The result is inevitably a compromise.

Millimetre graph paper is frequently used as a drawing material, especially for the graphic presentation of numerical results. A *blue* grid (Fig. 185) disappears altogether when an orthochromatic line film is used (Fig. 186). A *red* grid, on the other hand (Fig. 187) remains visible on the slide or on a bromide paper enlargement (Fig. 188).

186. disappears on orthochromatic line film.

187. The red millimetre grid . . .

188. . . . remains visible.

9.06 Colour originals

In contrast to black-and-white drawings, colour reproduction requires a completely neutral white drawing base. Corrections and blemishes become obvious. *Tracing paper is unsuitable* for this purpose. For coloured backgrounds, or for the production of collages (cut-out and mounted coloured surfaces), one should use finely textured, matt-surfaced coloured papers such as 'Letra Color Paper' from Letraset. For the lettering of such an original with white printed letters, or with grease pencils or felt pens, one provides an overlay of completely transparent film (such as clear acetate film) on top of the coloured background. This covering film can then be used for lettering or for drawing lines. Lettering direct on the coloured original may be affected by the colour of the background owing to the transparency of, for example, white printed lettering. In addition, overlays enable one to vary the legend without the need to alter the original itself.

9.07 Variations

9.071 *The negative*
On reproducing a black-and-white original drawing (Fig. 189) one obtains a negative (Fig. 190). In order to obtain very high density backgrounds with completely transparent lines we use so-called lith film material (Kodalith, Ilfolith, Gevalith). Keeping strictly to the precise exposure and processing times in accordance with the instructions for use is far more important for quality and sharpness of projection than is commonly supposed. Only very slight over-exposure makes line intersections distort, grids become irregular and fine lines disappear. Under-exposure, on the other hand, reduces the density, broadens letters and lines, and the centres of closed letters such as e, a and b appear as small black points. Unless the exact exposure is used (having due regard for camera extension and reciprocity law failure) we shall obtain a negative which is unsuitable as a basis for any desired modifications. So-called 'high contrast' half-tone films, or processing in a paper developer, are also useless. Larger

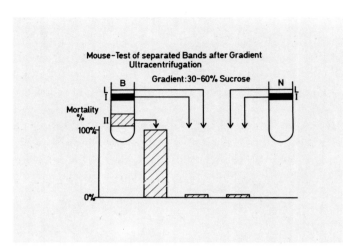

189. Black-and-white original drawing.

sized originals with extremely fine lines which are reduced to 35 mm size directly (Kodalith Ortho Type 3–135) makes excessive demands on the resolution potential of the lens/film combination.

9.072 *The positive*

A positive (Fig. 191) is obtained, again on lith film, by re-copying a lith film negative by contact or through an enlarger. However, more delicate lines (which are only just visible on the negative) demand the use of a *softer working paper developer* during re-copying. The base of the lith film used should have a transparency which is suitable for slide projection (e.g. Agfa 081 p).

As already mentioned, large originals with extremely fine lines place a limit on direct 35 mm photography. A first negative on 4 × 5 inch film, and subsequent reduction to 35 mm in an enlarger certainly extends the latitude of the quality of reproduction. This is especially true for enlargement onto photographic papers. *Line* enlargements do not demand an extremely hard paper, but one of *medium contrast*.

9.073 *The diazo slide*

If a *Lith negative* is copied on to diazo film by contact, we obtain — depending on the choice of colour — a monochromatic transparent negative copy as a projectable

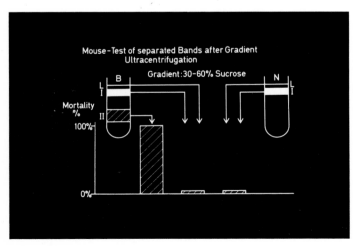

190. Negative on lith film.

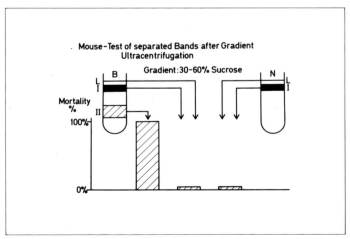

191. Positive on lith film.

slide (Fig. 192). Diazo film material is sensitive to ultra-violet radiation (UV) and is exposed in a UV contact printer. Development is carried out in gaseous ammonia, and both exposure and development can be executed in normal room lighting. Exposure and processing equipment is relatively simple, and various versions are commercially available. The main disadvantage of all diazo materials is their sensitivity to light and heat, which can accelerate the bleaching of diazo slides, especially during extended projection or in the absence of a protective heat filter in the slide projector. To a lesser extent this effect can also be due to the UV radiation of certain projector lamps. This disadvantage is, for the time being at least, unavoidable. Perhaps one should point out that a period of 30 minutes must be allowed to ensure complete drying after development in the ammonia gas before mounting.

The blue-and-white version is very popular because of its colour saturation and because of its pleasing visual effect. The mounting of an unexposed developed film (yellow) with an exposed diazo negative (magenta) amply demonstrates the scope for variation with this material (Fig. 193).

9.074 *Hand-tinted slides* (*Fig. 194*)

It is of course a pre-condition for the hand-colouring of a slide (i.e. the original negative) that the unexposed parts of the lith negative should have sufficient density and the exposed areas should be quite clear. Suitable colouring materials are, basically, *water-soluble* felt pen inks such as an 'Edding Colorpen 1300', or albumen transparent dyes such as 'Colorex'. Not all colours are suitable for slide projection (e.g. dark colours) or can be equally easily applied (owing to poor homogeneity). Water-soluble felt pen inks generally present few problems during application and have a high luminosity, although certain colours from the same manufacturer may fade in time or decompose.

It is recommended that only a few clearly contrasting colours should be used, if only because of the need to give precedence to important information. Individual dense areas, e.g. extended hand-written characters or letters, do not present any problems in hand-colouring; closely adjoining or overlapping outlines such as curves, points, lines, etc., however, are more difficult. In such cases one can have recourse to transparent overlays which facilitates a more precise result.

The first step consists of covering the *area surrounding* the parts which are to be coloured with a transparent pale red stripping lacquer on the reverse (glossy) side of the negative. This water-resistant and somewhat viscous lacquer should be applied accurately, using a paint brush and, if necessary, a magnifying glass. It dries off in a few

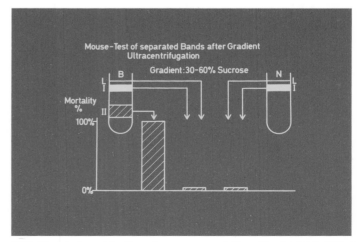

192. Copy on diazo film from negative lith film.

193. Mounted combination of an unexposed diazo film (yellow) with a diazo negative (magenta).

seconds — acetone is used as a thinner and for cleaning the brush (Fig. 195a).

After drying one may start to colour at once, using a blue colour in this case. The stripping lacquer prevents penetration into those parts which are not intended to be coloured (Fig. 195b).

One must now wait until the colour is completely dry. In the case of felt pens this process occurs relatively quickly. The stripping lacquer film is then simply pulled off using adhesive tape (e.g. Scotch Red No. 616). The adhesive tape should not be allowed to leave any adhesive residue on the film (Fig. 195c).

In the case of larger size transparencies it is virtually impossible to avoid unevenness in the application of colour, especially when using felt pens. This is not usually apparent until the slide is projected, when such an untidy coloured area becomes a distraction. This undesirable effect may be suppressed in advance by covering larger areas with a half-tone tint on the original itself. Should this not be possible, then a plastic sheet (e.g. Vangophan foil), which has one matt surface, compensates for any untidy application of colour, without visibly reducing the overall sharpness or transparency. The Vangophan sheet is cut to the size of the slide and is mounted and framed with the matt side facing the emulsion side of the film.

9.08 The combined positive slide

Slides featuring multicoloured lines are always an advantage in enabling one to produce a clear visual separation, e.g. of two values or functions, for diagrammatic representations or in a drawing. The exposure of a multicoloured *line*-original using colour material demands that the drawing paper be spotlessly clean and that the drawing itself be made without any corrections (see Section 9.06, p. 121). On top of this there is the lower transparency due to the thickness of the layers of a colour reversal film, as well as the substantially lower reproduction of contrast in colour film generally. In order to reproduce the coloured detail to an acceptable degree it will be necessary to under-expose the picture slightly. This, in turn, affects the white background, making it appear a more or

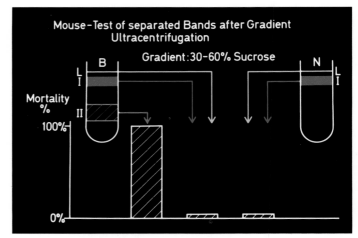

194. Hand-coloured lith negative in slide form.

less grey colour. Such a slide, therefore, is not very suitable for projection over great distances or when using a weak projector. The excellent transparency of lith film in combination with coloured diazo transparency material does, however, open up opportunities which demand little extra of the artist or of photographic technique. The relatively simple procedure is based on a separation system, which means that separate original drawings must be made for the black and for the coloured portions of the picture respectively.

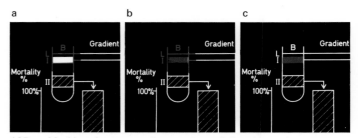

195. a: Masking the surrounding portions of the picture that are not to be coloured. b: Colouring the portion of the picture that has to be coloured. c: Colouring after removal of the masking film.

196. Lith film positive mounted with (red) diazo film (sandwich slide).

9.081 *The original*

The part of the drawing that is to appear black on the slide is drawn on drawing paper with black Indian ink, in the usual way (Fig. 197). A second piece of paper, this time a piece of draughtsman's tracing paper which is as transparent as possible, is then attached to the first drawing. This overlay is attached with adhesive tape to the original along one edge (the lower margin) only. The portions of the slide which are to be given a particular colour on the slide (say, red) are then traced onto the overlay, again using *black Indian ink*, filled in and provided with lettering (Fig. 198).

9.082 *Reproduction*

Register marks: Register marks (Kodak) in the form of a cross are mounted on the bottom original prior to exposure. They must not be covered by the overlay. Particular care is taken to ensure that the register marks remain outside the slide format.

Exposure: The original underneath is first exposed, without the overlay, the latter being carefully folded back at its line of attachment. After exposure, an opaque white sheet is inserted between the original and the overlay, whereupon the second line drawing (the one on the overlay) is exposed. Both exposures are made with the register crosses remaining in position, without any alteration

197. Black-and-white original drawing for lith film positive (black portion of Fig. 196).

198. Black-and-white original drawing for diazo film (red portion of Fig. 196).

in the position of the camera and without readjusting the focus.

Processing: After the usual processing in lith developer the two lith negatives are contact-copied or reduced onto positive film (see Section 9.082, p. 125). In addition, the positive of the overlay is copied on red or blue diazo film, as required.

Mounting: The coloured diazo film is mounted on the black line-positive with the aid of the register crosses, using a light bench. In order that the films should not slip and alter their relative position once they have been registered, a double-sided adhesive strip is placed between them, taking care that the strip will not become visible on the mounted slide.

If a second colour is additionally required (Fig. 199) we simply use a second overlay and another colour for copying the corresponding positive film on to diazo material. Combined slide production presupposes the utmost neatness in mounting.

A light coloured half-tone positive may be used as an alternative to a line drawing (Fig. 200).

199. Lith film positive mounted with two diazo films (blue and red).

9.09 The combined negative slide

A similar technique depends on the mounting of two diazo films of different colour. This time we consider negative instead of positive film mounting. The example illustrates the combination of a purple (magenta) and a blue-green (cyan) diazo negative. This colour combination results in a dark violet background. All the *purple* shades are seen as transparent picture portions on the *cyan* film (Fig. 202), whilst all the *blue-green* shades appear on the *magenta* film (Fig. 203). The white portions of the picture remain transparent on both diazo films. The mounting of two suitable diazo films together thus results in the production of a third colour, as well as transparent white as required.

Whenever possible, individual characters, curves, etc. are covered directly with a covering lacquer, depending on the colours on the black-and-white line negative. If a registration device is available (see Section 9.10, p. 133), advantage is naturally taken of this. Of the blue-green,

200. Half-tone positive combined with diazo film.

purple or white picture portions one separate line nega-
tive is exposed for each. Once these negatives have been
obtained, all the variations must now be directly reduced
to the size of the slide, using the registration device in the
enlarger. Before the exposure of the diazo films it is, how-
ever, necessary once more to re-copy both line positives
so as to produce line negatives from them by means of a
contact colour reversal method.

The scope for variation in this and any other colour com-
bination is wide; the present example (Fig. 204) is a
mere indication.

9.091 *The black-and-white half-tone negative*

To distinguish between orthochromatic and panchro-
matic black-and-white half-tone films, *orthochromatic*
film material is suitable for black-and-white originals
while *panchromatic* material may be used for the repro-
duction of both black-and-white and coloured originals.
Black-and-white originals such as Polaroid pictures or
original graphs are generally combined with lettering and
lines, etc. While the quality of a colour reversal film (see

202. Negative I in cyan, white lines.

201. The mounted combination of two diazo negative films (cyan and
magenta) produces dark violet, cyan, magenta and white.

203. Negative II in magenta, white lines.

Section 9.10, p. 133) may well suffice for slides of *purely* black-and-white half-tone originals, it becomes necessary to expose a black-and-white half-tone film for paper enlargements as well as combined originals.

35 mm reproduction requires the use of film material of low sensitivity (such as Agfapan 25 or Panatomic-X) with a resolving power as great as possible. In the 4 × 5 inch format a whole series of films is available, including orthochromatic film such as 'Kodak Professional Copy', the latter being especially designed for reproduction purposes. The method of processing is given in the 'Instructions for Use'.

9.092 *The black-and-white half-tone positive*

The half-tone negative is printed onto a suitable positive film by contact or by using an enlarger. (Suitable positive film materials are: Kodak Eastman Fine Grain Release Positive 135/36, or Agfa Gevatone N 31 p, with Neutol S paper developer).

The contrast of the half-tone positive varies according to the developer and the processing time. The shorter the

204. Variation of Fig. 201.

exposure and the longer the processing time, the higher the contrast and vice versa.

9.093 *The half-tone/diazo combination* (*Fig. 205*)

Let us look at a slide presentation of a relatively dark radiograph, a scintigram, or a scanner picture cut-out from a larger, very light, picture area. It will be seen that the preponderance of the light coloured areas makes it difficult to focus attention upon the darker, and generally rather more important, parts of the picture (Fig. 206). The combination of a half-tone and a diazo film is, therefore, no aesthetic frivolity, but serves to accommodate to the mode of vision of the human eye through a contrast reduction effect. The technique is illustrated by means of another example (for the end result see Fig. 214).

The original: The half-tone picture (Polaroid, black-and-white copy, original graph) is attached to the drawing paper. The lettering or drawing is executed in relation to the half-tone picture and with due attention to the desired slide format (Fig. 207). To this combined original we attach a sheet of 'Ulanofoil' (Ulano-Amberlith foil) to act as an overlay. This special foil consists of a completely transparent carrier foil layer and a second, and equally transparent, red layer. The latter can be pulled away from the carrier foil. The orthochromatic line film is insensitive to red, so that the red layer prevents exposure. The foil is attached to one side with adhesive tape so that it can be turned over. Using a pen and ruler, the margins of the half-tone image on the side of the red layer are precisely traced on the red layer, whereafter the remainder of the layer is carefully removed from the carrier foil (Fig. 208).

The half-tone negative: A *half-tone negative* is first exposed, using the original *without the Ulanofoil* (Fig. 209). For this purpose the foil is carefully folded back.

The obscuring mask: An opaque sheet of white paper is placed between the original and the mounted Ulanofoil, and a line film is exposed (Fig. 210). This mask is then precisely mounted in register with the half-tone film.

The line negative: A *second line negative* is exposed, needless to say without any alteration to the position of the camera or the focus; this time the exposure is of the original *plus* the Ulanofoil overlay, but *without the white covering mask* (Fig. 211).

Mounting: The masked half-tone negative is printed onto positive film and (Fig. 212), is finally mounted in combination with the line photograph which has been copied on to blue diazo material (Fig. 213 and 214).

If all the negatives are exposed on 4 × 5 inch sheet film, it naturally becomes necessary to reduce the picture to the desired miniature slide format. The line-positive is re-copied 1:1 to give a line-*negative* before final exposure in register with the diazo material.

9.094 *The half-tone/line combination*

A combined half-tone and line original imposes an obvious dilemma. The half-tone picture demands the use of a half-tone film, while the line drawing and the background demand the use of a line film. In other words, the half-tone film is unsuitable for line reproduction, while the line film is unsuitable for half-tone reproduction (Figs. 215 and 216). In spite of time-consuming darkroom techniques, the result of combined printing of a half-tone film and a line film is rarely satisfactory. 4 × 5 inch sheet film, on the other hand, not only yields better detail, but also offers the opportunity to use a registration device, which is usually built into enlargers of this format, or which *should be available as an accessory.* The registration device consists essentially of a special detachable negative holder with register pins and an appropriate punch.

The manner of working with this device is simplicity itself.

The original: Register marks are mounted on the *base sheet supporting* the drawing, one each to the right and left and top and bottom of the drawing.

The half-tone negative: The original is exposed on a half-tone film of the correct dimensions, together with the registration marks. The half-tone negative is developed, and the *line areas* are covered with transparent red adhesive tape (Fig. 217).

The line negative: We now expose a line negative without changing the position either of the original itself or of the camera. All the *half-tone areas* are covered in the line negative (Fig. 218).

Mounting: Using the register marks the two negatives are accurately superimposed and punched.

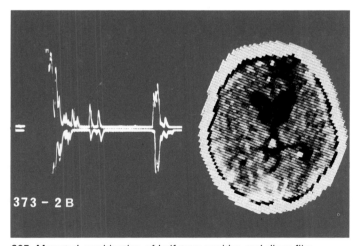

205. Mounted combination of half-tone positive and diazo film.

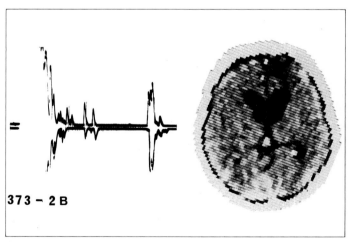

206. As Fig. 205, but without diazo film: the white surrounds cause distraction during projection due to excessive brightness.

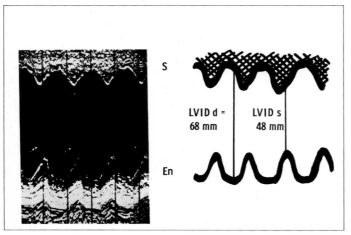

207. Original: half-tone positive (original graph) and lettering.

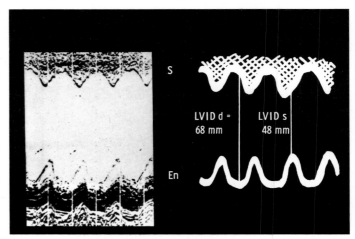

209. Half-tone negative of the complete original.

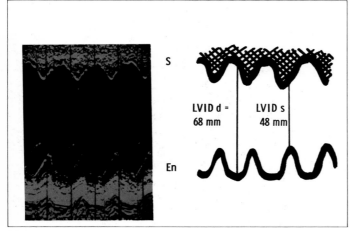

208. Masking the half-tone original with Ulanofoil.

210. Line film covering mask (negative of a white sheet); the half-tone original is covered by the Ulanofoil and is therefore unexposed (white).

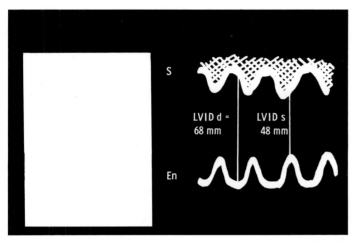

211. Line film negative of the complete original; the half-tone original is once again covered by the Ulanofoil.

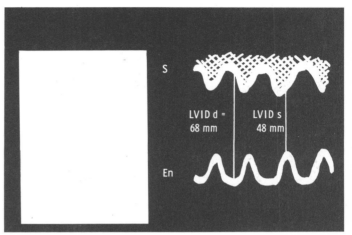

213. Diazo film (from Fig. 211).

212. Masked half-tone positive (from Figs. 209 and 210).

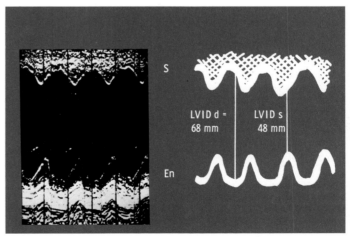

214. Mounted combination of Fig. 212 (half-tone positive) and Fig. 213 (diazo film): the colour values of the half-tone original (graph) are retained, and the line original (lettering) does not stand out too much.

The enlargement: Thanks to the register pins on the enlarger it is possible to expose the punched negatives onto a single sheet of paper *one after the other* and *with perfect registration*. Since the half-tone and the line negatives are separate we have an additional measure of latitude in obtaining the correct exposure time for each negative (Fig. 219).

The slide (*Fig. 220*): Reduction onto positive film requires the same darkroom technique, although in this case the half-tone negative should have a slightly lower contrast than normal. This enables us to make allowance for the harder contrast of the positive film (Gevaton N 41 p, possibly 0 82). The line element of the combination will produce poor copies on positive films of lower contrast.

Naturally, the registration device also enables one to incorporate labelling on the half-tone photograph itself, in addition to the half-tone and line combination which has already been mentioned. In such cases one has to attach a separate overlay to the half-tone picture to act as carrier for the lettering.

If a number of different grey tones have to be included in a line drawing, we require a fresh overlay for each shade of grey. Every grey tone area is covered with black paper or with Indian ink on each overlay in turn, followed by exposure on line film. The exposure time for printing such a line negative onto paper or film in the enlarger is determined by the grey value to be achieved (see Fig. 220).

9.095 *Direct reversal materials*

If some of the methods described seem too complicated or time-consuming, especially for the production of slide material that is to be used only once, it is well to consider that there can be two standards for any job and direct reversal methods may offer a good and quick compromise.

Photographic manufacturers such as Kodak and Agfa offer a range of materials in both 35 mm and sheet form designed to produce a fully reversed image (positive) by simple, direct development. Some are better suited to line originals and others to tone, while at least one or two will

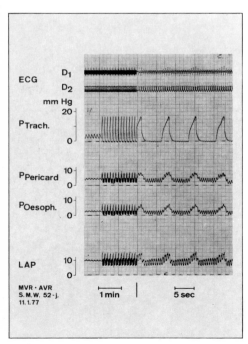

215. Half-tone positive of a combined original: lettering unsatisfactory.

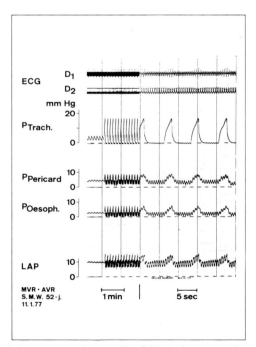

216. Line positive of the same original as Fig. 215: half-tone portion (graphs) unsatisfactory.

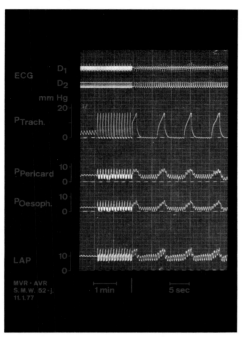

217. Half-tone negative, with line portions masked in red.

produce a fair answer to the difficult combination of line plus tone. The processes are extremely rapid.

Other everyday materials will lend themselves to the usual bleach and redevelopment reversal processing, but this again becomes more time-consuming.

9.10 The combination of colour and line film

For a subsequent legend or labelling of a colour slide one first requires a black-and-white enlargement (via an intermediate negative, or one obtained directly on projection-positive paper) of about 18×24 cm. This enlargement serves only as a drawing master. A transparent overlay is attached, on which one can draw or write, and this is again reduced to the correct slide proportions via a line negative. The re-copied positive line film is mounted in register with the slide (Fig. 221). However, the simple sandwich technique described above permits only the incorporation of black lettering, drawings or labels.

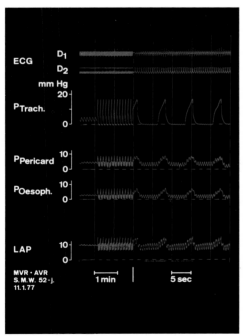

218. Line negative, with half-tone portions masked in red.

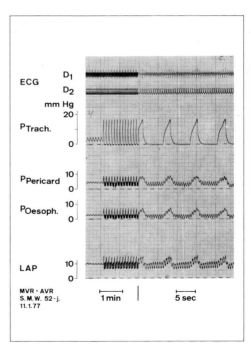

219. Combined positive: the half-tone negative and line negative are exposed separately on the same paper.

220. Combined dual-purpose half-tone and line positive in slide form with the addition of diazo films (red and blue).

221. Mounted combination of a colour slide and a black line film positive (sandwich slide).

When duplicating colour slides white lettering may be included by means of a double exposure technique using previously prepared 35 mm line negatives of the text. One can also obtain a coloured text version, the tint of which depends on the colour of the background in the original slide and on the filtering of the light source during the second exposure of the line negative (Fig. 222).

Background of original slide	Filter colour on line negative	Text on duplicate
red	green	yellow
green	red	orange
grey	optional	filter colour

9.11 Colour reproduction

Perfect colour reproduction is, unfortunately, not just a matter of illumination although new unburnt artificial-light lamps (colour temperature: 3,200 °K) or colour-corrected UV-filtered flash equipment (5,500 °K) become

222. Duplicated colour slide with coloured lettering included.

obligatory in this endeavour. The choice of a given brand of film appears to be determined much more by subjective assessment and therefore one must deliberately refrain from mentioning any given film material as being particularly suitable or unsuitable. In principle, one should test each new emulsion of a colour reversal film and 'filter' it if necessary before a substantial quantity of stock is ordered and stored under appropriate conditions. However, assessment of 'filtering' requires observation of a slide at a colour temperature of 5,000 °K (international standard, e.g. Macbeth luminescence box). The colour correction to be achieved has to be judged by adding colour correction filters of various densities until a suitable result is obtained. *One-half* of the filter value will then be approximately right for actual filtration at the camera lens.

The following colour corrections, relative to the colour tint, should be used:

Colour tint	Filter
blue	yellow
red	cyan
green	magenta
yellow	blue
blue-green (cyan)	red
purple (magenta)	green

9.12 Summary

We believe that the inclusion of data from various exposure tables and developing time charts and other compilations is liable to increase the volume of a book substantially without necessarily adding to its usefulness. Every film and product contains appropriate instructions for use and in any case the committed photographer cannot avoid accumulating his own experience. The present contribution should therefore be regarded as a stimulus to the photographer, as a basis for the unskilled technical assistant, and as a source of reference for the lecturer.

The design of slides
for teaching purposes

10. The design of slides for teaching purposes

By Marcus P. Nester

10.01 Introduction

In the course of lectures and talks, conferences and training sessions one often sees slides, the design and arrangement of which is displeasing. Overcrowded and confusing pictures, illegible lettering, unclear drawings — these are just some of the faults with which such slides are afflicted. The production of well composed slides from both optical and teaching points of view is really no more difficult: at most it calls for a certain amount of thought and the observance of a few simple principles.

10.02 The purpose of the slides

Before starting to plan or indeed to produce a slide, think for a moment about the following requirements: *to whom* do I want to show *what, how* and *why?*

To whom? Who is going to see the slide? What is the extent of his previous knowledge and visual experience (level of education, capacity for abstract thought, etc.)?

What? What information is the slide to contain? What information is required by the person seeing the slide? What information can be conveyed better in other ways (speech, motion picture film, etc.)?

How? In what context will the slide be shown (lecture, teaching session, examination, case study)? What is the relationship of the slide to the accompanying text (to supplement it or to illustrate it)?

Why? What effect should the slide have on the person seeing it (learning effect, motivation, entertainment)?

A visual presentation of the malaria cycle will obviously take a different form according to whether it is to be used for instruction at a college of nursing or for a congress of specialists in parasitology.

A slide to be used in connection with examination questions will obviously not contain the same information as a similar picture used to illustrate a lecture.

The question often arises in this field as to whether one can convey information better with an actual photograph or with a drawing. In these circumstances one must bear in mind not only the didactic purpose but also the psychological effect on the viewer: should and can he identify with the situation illustrated and/or the persons shown? Often an inherently accurate and good quality picture is rejected by the viewer because an unimportant detail does not fit in with his experience — for example, if the insertion of a catheter in a vein is illustrated in connection with a product that is no longer used in the hospital concerned or maybe never has been so used.

If you yourself are quite clear about the purpose of your picture, you will find it easier to decide on such issues as drawing or photograph and to compose the illustration in accordance with the requirements, or to give precise instructions about the work to those carrying it out (graphic artists, draughtsmen, photographers).

10.03 The difference between book illustrations and slides

The distance between your eyes and this book is probably about 30 cm. Now look at Fig. 229 on p. 141 from a distance of about 70 cm. This is how a viewer sees a slide projected at a size of $1 \cdot 2 \times 1 \cdot 8$ m from a distance of 14 m — from the back rows of the hall. How clearly can you still see the details of the drawing? The equating of book illustrations with slide illustrations probably constitutes the most serious misconception which leads to unsatisfactory slides. Both indeed convey information, but the recipients of the information and the way it is conveyed are different. These differences are summarised below:

10.031 *The viewer*

The book illustration is aimed at a *single* reader, while the slide is generally intended to be seen by several people.

10.032 *Duration of viewing*

The reader has an unlimited time at his disposal to examine an illustration, to absorb the information it contains and to process it. In a lecture the duration of viewing is limited by the lecturer — the viewer does not know for how long he can pay attention to the picture.

10.033 *Reading distance*

The reader can vary his distance from the page at will, he can use a magnifying glass, trace lines with his finger, cover up distracting parts of the picture and pick out the parts he considers important — in short, he can make active use of the illustration. The viewer of slides is generally confined to his seat, which is sometimes in an unfavourable position in the back rows of the lecture theatre. He is passively exposed to the projected picture (but see Section 10.036 below).

10.034 *Cross-references*

The reader has the opportunity of making synchronous cross-references: he can turn back to earlier pages in the book and make comparisons with other illustrations and with other works. The viewer sees the slide once: he has limited access to the source of information. Only the complicated technique of simultaneous projection allows two or more slides to be viewed at the same time.

10.035 *Commentary*

The author of a book is obliged to include the complete commentary on his illustration in writing, either in the running text or beneath the figure itself. The lecturer can give a spoken commentary on his slide, i.e. he can pass on aurally all the information that cannot be imparted visually. He can also emphasise important features with a rod or an illuminated pointer.

10.036 *Questions*

In a book it is impossible in practice for the reader to ask the author questions. A complicated illustration must therefore contain all the details necessary. In a 'live' lecture with slides the audience can obtain additional information from the lecturer.

It will be clear from the above observations that the re-

quirements for a slide cannot be the same as those for a printed illustration. The reproduction of illustrations from books and journals will therefore seldom yield satisfactory slides. What then are the consequences to be drawn from this conclusion?

- Do not overcrowd a slide with information.
- Where necessary, distribute the total information over several slides.
- Concentrate the information to be conveyed.
- Omit everything unnecessary and distracting.
- Command the viewer's attention by attractive composition.
- 'Every picture tells a story'; do not spell out the story on a slide.

To some extent these desiderata may appear theoretical, but let us look at them more closely in terms of practical examples. The sub-divisions that follow are more an attempt to be comprehensive than to establish watertight compartments: many of the hints and tips overlap more than one category.

10.04 Hints on layout

10.041 *Actual photographs*

10.041.1 Selected areas of photographs
Choose the specific area of a photograph in such a way that the important features fill the frame. Keep the surroundings to the minimum that will allow some sort of orientation.

10.041.2 Viewpoint
Avoid unusual viewpoints which make it difficult for the viewer to orientate himself. Generally an objective viewpoint towards the subject or a subjective 'over the shoulder' view are to be preferred.

10.041.3 The background
Avoid discordant and distracting backgrounds, e.g. by careful adjustment of the depth of focus or illumination to make any background recessive.

223. Too wide a subject range, unsuitable viewpoint, reflections from racks, confusing background.

224. Same subject as in Fig. 223, photographed in the same location: closer view, stands changed, soft lighting, depth of field adjusted to what is necessary.

10.041.4 Montage

Remember that the technique of superimposition — e.g. the insertion of arrows, letters, symbols, etc. — allows one to emphasize important points in the picture. In this connection see also Section 5.07, p. 73.

Next compare two examples (Figs. 223 and 224, and 225 and 226 respectively). In the first example, types of blood coagulation are to be demonstrated, while in the second the intention is to show that test tubes containing blood samples must not be filled to the brim. Figures 223 and 225 include far too much, the areas covered are too great, the backgrounds are distracting, the subjects are badly placed, etc.

10.042 *Drawings*

10.042.1 Content

Reduce the content to bare essentials, i.e. present the subject in schematic form. Resist the temptation to include items that you do not intend to comment on. Divide up complicated diagrams into their component parts over several slides, having first given an overall view that is not intended to be comprehensible.

10.042.2 Format

Always think first whether you will be able to show square or upright format slides or whether you are restricted to the horizontal 35 mm format. Make full use of the format available to you and always bear in mind that the ratio of the 35 mm film frame is 2:3 when preparing sketches.

10.042.3 Layout

Work in broad areas, in a simple style and boldly; in other words:

— large areas;
— thick lines;
— clear contrasts of brightness and colour;
— simplification;
— no minute detail with thin pencil lines, delicate shading, etc.

Choose the appropriate working materials: felt pens, coloured foils, half-tone foils, rub-down letters and symbols. Those less experienced will find it helpful to prepare

225. Too broad a view, assistant in unsuitable position, distracting surroundings, unnecessarily sharp background.

227. Book illustration. (From Javetz, Melnick, Adelberg: *Medizinische Mikrobiologie*, Berlin, Heidelberg, New York; Springer, 1973.)

226. Same subject as in Fig. 225: procedure shown clearly in close-up, background deliberately blurred.

228. Re-drawing of Fig. 227 for a lecture with slides: stages simplified, no detailed lettering, broad layout.

229. Printed illustration: too many details and too fine a drawing for a slide.

230. Re-drawing of Fig. 229 in a form suitable for a slide.

a drawing in as small a format as possible (e.g. 6 × 9 cm), as this will oblige them to lay out their drawing simply and boldly.

Figure 227 shows the growth of an RNA virus as a book illustration; Fig. 228 is a simplified version restricted to the most important stages to take the form of a slide (the horizontal format was predetermined). The slide contains no detailed lettering; with the aid of the key letters A–F the lecturer can himself explain the process of reproduction of the virus. The information content of this picture is already just about at the upper limit; if more details or smaller stages were to be shown, this would have to be done on more than one slide. Because of the abundance of detail and fine draughtsmanship, the majority of technical drawings are unsuitable for direct use as originals for slides. The cross-section of an atomiser shown in Fig. 229 had to be re-drawn to form a suitable slide (Fig. 230).

10.043 *Diagrams, tables and graphs*

10.043.1 Content
Make sure that the viewer can gain an overall impression at once. Here too the sheer volume of information must be limited and complex tables must be divided up among several slides. Wherever possible, use round numbers (no fractions!).

10.043.2 Conversion
Try to convert figures into graphs, bar-charts or pie-charts wherever possible.

10.043.3 Format
The slide format (upright, square or horizontal) must be taken into account.

10.043.4 Layout
Do not use fine lines — at least $\frac{1}{2}$ mm thick on A4 originals. The curves on graphs should be drawn more boldly than the coordinates. Use large, clear symbols (dots, circles, triangles, crosses, etc.). To show different values use:

	1935 (n = 258)	1960–1970 (n = 262)
Streptococcus viridans	10,0%	19,5%
Enterococcus	0,0%	10,7%
Streptococcus pyogenes	20,6%	1,5%
Pneumococcus	38,4%	8,0%
Staphylococcus aureus	17,0%	16,8%
E. coli	10,5%	28,6%
B. proteus	2,3%	4,2%
Klebsiella	0,8%	5,0%
Pseudomonas	0,4%	5,7%

231. Statistical table from a publication.

— different line symbols (_____ , _____ , , _._._ etc.) for graphs in black-and-white;
— different grids for diagrams in black-and-white;
— or strong, opposing colours.

Do not use a white background, as this will dazzle the viewer when the slide is projected.

Figure 231 compares in tabular form septicaemia pathogens in two periods of time. Although the ratio of the dimensions of the original approximate to those of the slide format, this table should not be used without further processing.

A bar chart, as shown in Fig. 232, is much more informative. A pie chart would make less sense in this instance, as we should have to compress two circles with nine greatly differing segments into one picture.

The table in Fig. 233 (trends in expenditure in hospitals by expenditure categories in percentages) would be quite unreadable if projected as a slide. Here too a reduction of the numerical material is necessary for a slide version. Figure 234 shows such a condensed version, in which

232. Conversion of Fig. 231 to a bar chart.

Table 2. Development of expenditure at the VESKA Hospitals 1950–1973, by category, expressed in percentages.

Year	Personnel	Administration	Catering	Medical Supplies	X-Rays	Other costs, interest, depreciation, etc.	Total
1950	44,3	2,1	21,8	7,3	2,7	21,8	100
1955	50,6	2,0	17,9	8,6	1,3	19,6	100
1960	56,5	1,7	13,4	9,5	1,3	17,6	100
1961	56,8	1,7	12,6	9,6	1,9	17,4	100
1962	59,1	1,6	11,8	9,2	2,1	16,2	100
1963	59,7	1,7	11,3	9,1	2,2	16,0	100
1964	59,8	1,7	10,4	9,0	2,3	16,8	100
1965	61,5	1,6	9,8	9,0	2,4	15,7	100
1966	62,8	1,6	9,1	9,8	2,3	15,4	100
1967	63,2	1,5	8,3	8,8	2,3	15,4	100
1968	63,7	1,5	7,7	9,1	2,5	15,5	100
1969	64,8	1,5	7,2	9,3	2,5	14,7	100
1970	64,9	1,5	6,8	9,3	2,6	14,9	100
1971	66,6	1,5	5,8	9,2	2,8	14,1	100
1972	68,4	s. Tab. 1	5,3	10,0	s. Tab. 1		100
1973	69,4		5,1	9,2			100

Source: VESKA-Statistics 1950–1973

233. Statistical table from a book. (From Gyge, Henni: *Das schweizerische Gesundheitswesen*, Berne; Huber, 1976.)

part of the lettering is replaced by simple pictograms and bold lettering is used for the figures. In Fig. 235 the figures have been converted into graphs. By using colours — although this is more complicated and expensive — even better results can be obtained, particularly where graph lines following a similar course can be distinguished only with difficulty.

10.044 *Lettering*

It has already been stated that a slide should include the minimum of lettering. Some labelling has already been apparent in the examples. When determining the rules set out below for slides with lettering, remember that these apply to all lettering on drawings or tables, since it is here that errors are often committed and slides containing nothing but lettering should be comparatively uncommon.

10.044.1 Content

A maximum of seven lines per slide. A maximum of 25 characters (including spaces) per line.

10.044.2 Size of lettering

On 35 mm slides capital letters should be at least 1·5 mm high. There should be an equidistant space between the lines. Capital (upper case) letters may be used for short texts and titles (Fig. 236). Small (lower case) letters should be used for longer texts (Fig. 237).

10.044.3 Style of lettering

Simple undecorated lettering (e.g. Grotesque, Univers, Helvetica), which should be at least semi-bold, i.e. having thick lines. Typewriting is permissible, but in this event the original must be kept very small (maximum 5 × 7·5 cm). Here, too, use a simple clear typeface (e.g. Courier 10, Letter Gothic, Manifold). The same applies to stencilled and rub-down lettering (Fig. 238). Do not forget also that in an emergency slides can be written by hand (Kodak Ekta-Graphic).

10.044.4 Background

Do not use white backgrounds or substrates with black lettering (Fig. 240). White lettering on a coloured background dazzles and tires the eyes much less (Fig. 239).

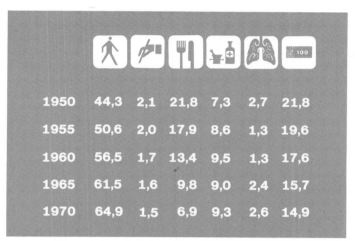

234. Reduction of Fig. 233 in terms of information content: bold lettering, pictograms.

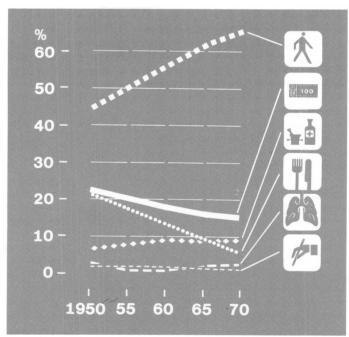

235. Conversion of same numerical values to a graph.

ONLY
SHORT TITLES
IN CAPITALS

236. Upper case letters for short titles.

IBM Composer 11 B

STENCILLING

Rub-down letters

Filmset

238. Various lettering styles.

Längere Texte sind mit
Kleinbuchstaben besser lesbar

longer texts are
easier to read in small letters

237. Lower case letters for longer legends.

Besser weiss auf Farbe...

Better white on colour...

Mieux vaut
blanc sur couleur...

239. Light lettering on a darker background is to be preferred.

The simplest method of doing this is to type through white correcting paper on to a coloured background. Diazo methods (see Section 9.073, p. 122) and the Colour Key process are suitable for the production of colour slides from black-and-white originals.

10.045 *The original*

Try to produce your slide originals in a uniform format wherever possible; this makes the photographer's work easier, and you too can assess the effect of the pictures more quickly.

Leave a large enough margin on the original document (at least 3 cm) so that it can be handled more easily. If necessary define the exact area required for the slide by means of an overlay.

If an original is to be labelled in various languages, it is recommended that these legends be prepared on transparent sheets, which are laid over the original when each photograph is taken. This is also applicable to originals which might be damaged by the application of lettering.

. . . als schwarz auf weiss

. . . than black on white

. . . que noir sur blanc

240. A white background dazzles when a slide is projected.

10.05 Summary

If all these rules and suggestions seem far too complicated and dogmatic, here is a rule of thumb: hold your slide at arm's length against a light background. What you can see and read clearly will still appear clearly to every viewer when it is projected. If you need to assess the slide more precisely follow this check list:

Objective:

☐ Is the slide suitable *a priori* as a source of information?

☐ Is the visual information a genuine aid to understanding?

Content:

☐ Has the information content been kept to essentials?

☐ Have subsidiary, distracting and unnecessary details been left out?

☐ Is the written commentary as concise as possible?

Layout:

☐ Have the viewing habits and educational level of the viewer been taken into account?

☐ Is the resultant simplification understandable?

☐ Has unaccustomed abstraction been avoided?

☐ Has the best use been made of the slide format?

☐ Have important features been visually emphasized?

☐ Is there any distracting background?

☐ Is the layout based on broad areas and a simple style?

☐ Are there clear contrasts between light and dark and between colours?

☐ Is the lettering clearly legible?

☐ Are abbreviations or figures used instead of long words?

☐ Have numerical tables been converted into diagrams?

The matter that cannot be dealt with in a chapter such as this is the academically skilful *use* of the slide — having due regard to the medium — in courses of instruction, at congresses, etc. Even a perfect slide is still no guarantee of efficient communication of knowledge, but it is an important step in that direction.

Ethical considerations

11. Ethical considerations
By Patricia M. Turnbull

11.01 Introduction

Every profession must observe standards of ethical behaviour or it will lack respect and may also lay itself open to legal penalties. Such standards apply to the treatment of patients, the uses to which written or photographic records of them are put, including any research projects in which they form the clinical material. Consent is a vital element in the structure of all ethical relationships in medicine; courtesy and consideration for the patient's interest override everything else.

Since the days of Hippocrates it has always been accepted that a strict ethical code should be observed by the doctor in the treatment of his patients. In medicine as it is practised today not only the doctor but many other people have access to information about a patient's illness. The doctor, as head of the team that cares for the patient, has his own standards of professional conduct, but he is dependent upon the skills and integrity of the other professionals working with him and each member of the team must assume responsibility for his own professional activities.

Among the team working for the benefit of the patient is the medical photographer. For him, the ethical considerations in his job are complicated by the fact that the end-product of his activities is a photographic record, be it a print, slide or ciné film. Such end-products are commonplace in every day life and taking a picture is all too often viewed by staff and patients alike as an unimportant snapshot and not as part of a scientific medical service. The sight of a photographer appearing in the ward with camera and flash equipment is nearly always bound to bring smiles to the faces of the ward inhabitants and helpful hints on technique from the amateur photographers amongst the patients will abound.

Whilst the medical photographer may feel disinclined to claim a particular 'mystique' about his expertise, he must nevertheless ensure that the end-product of his photography of sick people is treated with the same ethical respect as is accorded to the rest of the patient's records.

The ethics of the practice of medical photography can be discussed under the headings of relationships with the medical profession, the patient and the authorities of hospital, medical school or research institute in which the medical photographer works, as well as his relationship with his own colleagues in his own profession.

11.02 Relationship with the medical profession

The ethics of clinical practice are based on 'trust' in the doctor by the patient and by the other members of the health care team. Where there is 'no trust' relationships tend to deteriorate. The doctor is in charge of the patient and must therefore take overall responsibility for his care; because of this he must receive the full support and loyalty of those working with him — including that of the medical photographer. The same is true of members of the nursing staff. If by any mischance disagreement occurs between medical photographer and members of the medical or nursing staff, the discord should never be referred to in front of the patient; difficulties should be quietly and reasonably discussed elsewhere. The medical photographer has no need to feel he must be subservient to the doctor, for the experienced medical photographer has a great deal to contribute in terms of specialized knowledge and technical expertise and can be of the greatest assistance in presenting facts visually for the benefit of both doctor and patient. The skilled photog-

rapher is an expert in visual presentation and, if professional in his attitude, will be appreciated by his colleagues as a member of the medical team. In teaching hospitals or research institutes the medical photographer also has a vital role to play in the production of teaching aids for the numerous professions being trained within the hospital environment. The use of photography as a research and recording tool has long been accepted as of paramount importance.

11.03 Relationship with patients

The same loyalty which applies to the medical profession must also be rendered to the patient. The individual has a fundamental right to privacy and nowhere is this more important than in medicine where the unauthorised publication of personal data may have social or legal repercussions for the patient concerned. For instance the disclosure of a pregnancy, an abortion, plastic surgery or the contraction of a sexually transmitted disease, if it is made known without express permission from the patient could well result in legal proceedings against the hospital.

In the United Kingdom the position with regard to still and ciné photography of patients is contained in a DHSS* document from which the following extract is pertinent —
'— photographic clinical records form part of the medical record of the patient and as such are subject to the same rules of medical confidentiality as any other portion of that record. That is to say they cannot be disclosed to anyone without the consent of the clinician responsible for the patient and at his discretion, the patient himself'. From this extract it is clear that the confidentiality of all visual records is vested in the clinician himself.

Furthermore, the medical photographer has a professional duty both to the patient and to the medical staff to regard all the photographs he takes under the terms of his employment as being confidential. For example, the photographer has no legal or moral right to display or publish photographs without the written permission of the patient and the doctor in charge of treatment or, in the case of research projects, the written permission of the research

*Department of Health and Social Security (U.K.).

worker. Most departments of medical illustration will receive requests from publishers, pharmaceutical firms, television or film companies for illustrations of stated clinical conditions to be made available. These should on no account be provided without written permission from the doctor in charge of the patient and only then if the patient has either given permission or is not recognizable. In no case should the patient's name be divulged.

Disposal of unwanted photographs is another aspect of confidentiality. Any well run department of medical illustration has strict rules concerning this and will employ a shredding machine for disposal of unwanted film and prints. Failing this, all staff should have firm instructions which ensure that confidential photographic records do not fall into unauthorised hands. Tearing or cutting up and burning are the safest methods.

It goes without saying that hospital staff should not speak about their cases in public places, such as lifts and restaurants where they may be overheard by the lay public, or in such a manner that the patient is recognizable. In some hospitals staff are requested to sign a statement that they understand and will obey the confidentiality procedure prevailing in that establishment. Photographic records should always be kept in a properly documented safe filing system and should never be released to unauthorised personnel.

11.04 Permission of the patient

The informed permission of the patient must be obtained before photography is undertaken. The reason for requesting photographs must be carefully explained to the patient in terms that he will understand. Once it is established that the patient is capable of understanding and that he has fully comprehended the situation he should be asked to sign a statement to that effect. In cases of disability or injury preventing the patient from signing he can give verbal permission in front of two witnesses, one of whom will sign on his behalf. Alternatively permission can be given verbally by the patient and recorded on audio or video tape or at the beginning of a ciné film session. Most patients will give permission if the circum-

stances are properly explained to them. In the case of children or those under the age of consent, permission may be given, under similar circumstances to those stated previously, by a parent or guardian. This procedure is only essential if the patient's identity will be recognizable in the final picture. A prerequisite of obtaining the patient's permission is that he is mentally able, mature and knows the nature and effect of his decision. Where this is not the case, and in order to forestall possible objections from relatives or indeed the patient if he regains his senses, a legal representative may be requested to give permission. Although it appears to be the practice in some establishments to offer financial reward to patients for the use of their photographs, because it can be useful as positive proof of the patients' agreement, it is an undesirable practice as it might appear that the co-operation of the patient had not been an entirely free decision.

It is only courteous to give some form of explanation to the patient if he asks why he is being recorded. An uncomplicated reason such as 'The doctor wants a picture as part of your confidential medical records to help him assess your treatment' is usually acceptable and in a teaching hospital the more intelligent patient will understand the value of medical photographs for the teaching of other doctors and for reference in the treatment of similar cases.

Every patient has a right to refuse to be photographed. If for any reason photographs requested by the doctor cannot be obtained, the fact and circumstances should be recorded and the doctor informed.

Photography of internal organs at operation or in the post-mortem room, endoscopic, pathological or microscopic photography do not require the patient's permission as identity is not revealed. Care should be taken in the reproduction of x-rays, ECG or EEG tracings, temperature charts and similar records for publication or use outside the hospital, that the name of the patient is not shown.

Some authorities view the request for medical photography as being part of the patient's treatment and that as the patient has asked for treatment he must, *inter alia*, be giving permission for photography to take place. This is an unsafe presumption and should not be relied upon.

Apart from the natural desire to respect the confidence which the patient places in the doctor and hospital staff, the medical photographer should understand that the breaking of this confidence could be regarded as actionable conduct, resulting in civil action with consequent damages awarded against the hospital authority and members of the staff if the case were proved. The staff are ordinarily regarded as 'servants of the hospital authority' under the legal maxim 'respondeat superior', but cases have occurred in which hospital staff have been summoned.

11.05 Patients' records

The patient should never have the opportunity of reading his records while in the care of the medical photographer. It is the responsibility of the latter to ensure that this does not occur and to return the records separately to ward or clinic in a sealed envelope or by portering services. Likewise, such records should not be accessible to porters.

11.06 Chaperones

This is a subject on which conflicting views are held, but which requires a strict code. It is always advisable to have a chaperone present if a male medical photographer is photographing a female patient whose clothing is to be removed. In these circumstances embarrassment to the patient is lessened by a female assisting in dressing and undressing and it will also prevent the possibility of hysterical accusation of assault against the male photographer. If genitalia have to be photographed then it is advisable to arrange for a photographer of the same sex as the patient.

In small departments, it may sometimes be necessary to use the same studio in which patients are photographed to photograph animals for research record purposes. Care should always be taken to arrange this at times when patients are not expected in the department as the sight of dead or anaesthetised animals can be very upsetting to many people. Similar precautions must of course be taken with gross pathological specimen photography.

11.07 Negligence

A civil action may be brought by the patient against the medical photographer for failure to use reasonable skill or care which results in damage. Fortunately this is a very rare occurrence but it behoves the photographer to take special care to see that his apparatus is in good working order and not likely to damage the patient, i.e. lens hood falling into the operation field; or that he does not burn delicate tissues such as mucous membrane or eyes by the use of hot photographic lamps for too long a time. A patient suffering from epilepsy may have an attack brought on by repeated electronic flash discharges. Although this happens rarely, the medical photographer should be aware of the possibility. Furthermore, he should always be alert to recognize the symptoms of a patient who may be about to faint and take the necessary preventive action. Should any untoward accident occur, medical assistance must always be sought and after the patient has been treated, a written report of the accident must be sent to the appropriate hospital authority.

The medical photographer has a moral responsibility to see that the records he makes do not represent the patient in a tasteless or undignified fashion. Although the care of the patient is legally the responsibility of the doctor the medical photographer has a unique position in relation to his photographs. He is the only member of the team with the specialist skills which enable him to realize the significance of the features being recorded. It is correct to say that although the doctor requests the photographs to be taken to demonstrate a particular facet of disease or treatment and may in fact be present when photography is taking place, the onus is on the photographer to see that the patient is not unwittingly being made to look ridiculous, stupid or undignified. Sometimes in the stress of filming sessions it can be forgotten that it is not an actor but an ill person being photographed and the experienced medical photographer will always endeavour to see that his records represent skilled, courteous and caring treatment of patients.

11.08 Professional relationship with other medical photographers

No doctor considers it ethical practice to see or treat patients who are already being attended by a colleague without the prior agreement of that colleague.

Similarly it is quite unethical for a medical photographer to copy or re-photograph the work of a colleague without his prior knowledge and agreement.

Most professional bodies publish a code of conduct for their members; *extracts* from the code published by the Institute of Incorporated Photographers are very pertinent to the practice of medical photography and are as follows —

'Every member shall at all times present himself, his photography and his photographic services, in such a manner as will uphold and dignify his professional status.

Every member shall exercise all reasonable skill, care and diligence in the discharge of the duties agreed to be performed by him and in so far as any of his duties are discretionary shall act fairly and in the utmost good faith giving full consideration to the requirements of the client.

Any information acquired by a member during the course of his professional duties regarding the confidential policy or processes of a client or employer shall not be divulged by him to any other person, firm or company.

In whatever capacity a member may be engaged he shall act in a just and faithful manner towards clients, employers, employees and towards others with whom his work is connected and towards other members.

Any member being an employee shall not undertake photographic work outside his own organisation without notifying or obtaining permission from his employer.

A member, on being approached or being instructed to proceed with any photographic service upon which he is aware another member is engaged, shall notify the fact to such other member.

A member may use, in conjunction with his own name, only such designatory letters or other descriptions to which he is entitled.

A member shall not offer or accept a photograph for reproduction or accept a reproduction fee in respect of any photograph of which he does not own the copyright, without the authority of the owner of such copyright.'

Finally, the ethical attitude to the profession of medical photography and to colleagues in that profession must be one of loyalty combined with straight dealing.

11.09 Hospital etiquette

The term etiquette can be described as the conventional laws of courtesy observed between members of the same profession. In this instance, in which the profession is concerned with the care of the sick, it is all the more necessary that certain courteous practices be observed. The codes of practice in operating and post-mortem rooms must be learned before the medical photographer enters either area and must then be strictly observed. There are certain rules of etiquette in wards, clinics and treatment areas which may vary slightly from one hospital to another and the wise medical photographer would be well advised to discover what they are and adhere to them, for there are generally extremely good reasons for their institution. Rules such as requesting permission to enter a ward, not disturbing a doctor while he is with a patient, not interrupting a nurse while she is dressing a patient's wound, not allowing a ward patient to be unaccompanied on journeys to and from the ward, besides being mannerly conduct, are based on the need for maximum care of the patient.

11.10 Copyright

The laws of copyright are those which protect the sole rights of reproduction of literary or artistic — in this instance photographic — works. These laws though similar in principle may vary in detail in different countries and the medical photographer would be wise to seek guidance on the legal situation existing in his own country.

Varied though the laws may be, their purpose is to see

that 'fair play' is adhered to in relation to the end-product of a photographer's skill and industry.

In the United Kingdom the law of photographic copyright in force at present is the Copyright Act of 1956. However, the enormous complexity of this Act necessitated the setting up of a committee to consider the present laws (Copyright Act 1956, Design Copyright Laws 1968, Registered Design Act 1949) and to report whether any, and if so what, changes were desirable. The committee reported to the Secretary of State in March 1977 in a lengthy publication that many changes were indeed necessary. These are now under consideration by the various authorities concerned.

Under the 1956 Copyright Act, copyright is vested in the author of the work concerned. In the case of photographers there are exceptions to this ruling. Copyright does *not* belong to the photographer who actually takes the picture *unless* he is also the owner of the negative in the camera at the time the picture was taken. Therefore, when a medical photographer is employed by a hospital, medical school or research institute, the copyright of the photograph he takes in the course of his employment belongs to the employing authority. Similarly, if a photograph is commissioned by someone who pays for it and there is no agreement to the contrary, the copyright belongs to the commissioner and not to the photographer. The period of copyright protection of a photograph is 50 years from the date of *publication* of the photograph, after which time it expires.

The law allows the photographer to retain ownership of negatives even if he has been commissioned to take them. This means that, during the 50 year period, he may dispose of the negatives how he wishes, with the exception that he may not use them to make further prints for use or sale to anyone other than the copyright owner, without the written agreement of the latter.

Besides safeguarding the copyright of his own work, the medical photographer must not infringe the copyright of other illustrators by copying photographs or artwork which are similarly protected.

Circumstances do exist, however, in which it is legal to copy protected work without permission. The commonest case encountered by the medical photographer will be

the use of copyright material for teaching purposes in educational establishments. It is therefore permissible to reproduce copyright illustrations as slides or diapositives for teaching although it is courteous but not at all necessary to quote the source. On the other hand, it is quite illegal to reproduce the *same* illustration for *publication* unless written permission has been obtained from the copyright owner who will, in all probability, require the source to be acknowledged.

11.11 Reproduction rights

It is possible for the owner of the copyright to sell or give away the reproduction rights of a photograph. That is to say, he may agree to allow reproduction of a photograph, for a specified purpose, without giving up the copyright. This action does not prevent the copyright owner from similarly granting reproduction rights of the same picture to other sources, *unless* the original recipient of reproduction rights has been given *sole* reproduction rights.

It is difficult within the limits of this chapter to do other than outline the main points of concern to the medical photographer and to recommend that he should be alert to the avoidance of possible infringements of copyright. He should safeguard his own work by marking it 'copyright' and should never infringe the copyright of others. The detailed law of copyright is a very complicated subject and in case of any difficulty over either copyright or reproduction rights, expert legal advice should always be sought.

Bibliography

12. Bibliography

12.01 Journals containing articles on medical photography

Biomedical Communications (United Business Publ., New York).
Deutsches Ärzteblatt (from Nr. 49, 1977, Serie über Photographie und Kinematographie in der Medizin) (Köln).
Internationale Photo-Technik (München).
Journal of Audiovisual Media in Medicine (Update Publ., London) from 1978.
Journal of the Biological Photographic Association.
Medical and Biological Illustration (Longman, Edinburgh) until 1977.
Medical Radiography and Photography (Rochester, N.Y.).
Moderne Fototechnik (Ludwigsburg).

12.02 General medical photography and photographic techniques

Beer, J.R.: *Medical Photography 1961–1966.* Adelaide: Public Library of South Australia, 1967.
Breitenecker, G.: Einsatzmöglichkeiten der Sofortbild-Fotografie in einem medizinischen Laboratorium. *Öst. Ärzteztg 31,* 26–28 (1976).
Gibson, H.L.: *Medical Photography, Clinical-Ultraviolet-Infrared.* Rochester, N.Y.: Eastman Kodak Co., 1973.
Hearnsberger, P.L.: The Kowa RC-2 Fundus Camera for Biomedical Photography. *J. biol. Photogr. Ass. 44,* 44–46 (1976).
Heiss, W.H.: Photographie im Allgemeinen Krankenhaus. *K.H.A. 1,* 32–35 (1975).
Hill, B.: Low Power Photomicrography and Photomacrography Using the Nikon Multiphot System. *Med. biol. Ill. 24,* 153–159 (1974).
Hyzer, W.G.: Sensitivities of Photographic Materials. *Res. Develop. 26,* 28–31 (1975).
Ierubino, A. (Ed): *Photographic Science and Engineering in Medicine-Equipment and Techniques.* Proceedings Tutorial Seminar, Newton, Mass., 1972.
Jackson, H.R.: Natural Science Photography. Part 1. *J. biol. Photogr. Ass. 40,* 35–50 (1972).
Jackson, H.R.: Natural Science Photography. Part 3. *J. biol. Photogr. Ass. 40,* 124–162 (1972).
Lampertico, P.: Documentazione fotografica ospedaliera con la apparecchiatura Polaroid mp 4. *Minerva med. 64,* 18–23 (1973).
Linssen, E.F. (Ed.): *Medical Photography in Practice.* London: Fountain Press, 1961.
Loechel, W.E., Jacobs, E.G.: The Surgeon who Chooses to Pay Attention. *Surg. Gynec. Obstet. 141,* 261 (1975).
Longmore, T.A.: *Longmore's Medical Photography,* 8th edn. Ed. P. Hansell, R. Ollerenshaw. London: Focal Press, 1969.
Marshall, R.J., Marshall, B.M.: Routine Medical Photography with 35 mm Black-and-White Film. *Med. biol. Ill. 25,* 115–119 (1975).
Martin, T.P., Pongratz, M.B.: Mathematical Correction for Photographic Perspective Error. *Res. Quart. Amer. Ass. Hlth phys. Educ. 45,* 318–323 (1974).

Nakamura, J.V., Nakamura, M.M.; *Your Future in Medical Illustration: Art and Photography.* New York: Rosen Press, 1971.
Nilsson, L.: *Unser Körper – neu gesehen,* 5. Auflage. Freiburg i. Br.: Herder, 1977.
Orbach, H.: *Medizinische Fotografie und Kinematografie.* Stuttgart: Thieme, 1971.
Osterloh, G.: Dokumentation mit der Kleinbildkamera. *Photo-Technik und -Wirtschaft 9,* 278–281; *10,* 316–318 (1971).
Pokorny, V.: A Viewer for Negatives. *Folia Morphol. (Praha) 24,* 117 bis 119 (1976).
Spiro, H.M.: My Kingdom for a Camera: Some Comments on Medical Technology. *New Engl. J. Med. 291,* 1070–1072 (1974).
Spitzing, G.: *Grenzbereiche der Photographie.* Seebruck am Chiemsee: Heering-Verlag.
Biomedical Photography, Rochester, N.Y.: Eastman Kodak Co., 1976.
Medical Photography with New Kodachrome Films. *Med. radiogr. Photogr. 51,* 48 (1975).
Un nouvel appareil photographique particulièrement intéressant pour les médecins. *Pédiatre 10,* 89–90 (1974).

12.03 Specialised photography of patients

Ainsworth, H., Joseph, M.: An Assessment of a Stereophotogrammetric Technique for the Study of Facial Morphology in the Child. *Ann. hum. Biol. 3,* 475–488 (1976).
Bonneau, E., Benoist, M.: Reproduction de clichés céphalométriques avec trace des tissus mous. *Rev. Stomatol. Chir. maxillo-fac. 77,* 613 bis 616 (1976).
Goldstein, N., Wilder, N., Mita, R., Chinn, D.: Ultraviolet Photography of Skin Cancers and Nevi. *Cutis (N.Y.) 16,* 858–865 (1975).
Maehr, C.B.: Surgical Photography through Sterile Bags. *J. biol. photogr. Ass. 43,* 23 (1975).
Marshall, R.J.: Infrared and Ultraviolet Photography in a Study of the Selective Absorption of Radiation by Pigmented Lesions of Skin. *Med. biol. Ill. 26,* 71–84 (1976).
Merriman, J.S.: Stroboscopic Photography as a Research Instrument. *Res. Quart. Amer. Ass. Hlth phys. Educ. 46,* 256–261 (1975).
Raskind, R.: Positive Identification of Operating Room Photographs. Technical Note. *Vasc. Surg. 9,* 24–36 (1975).
Robertson, N.R.: Contour Photography. *Brit. J. Orthod. 3,* 105–109 (1976).
Toy, R.W.: A Macro-System for Paediatric Photography. *Med. biol. Ill. 26,* 43–45 (1976).
Van Gool, A.V., Ten Bosch, J.J., Boering, G.: A Photographic Method of Assessing Swelling Following Third Molar Removal. *Int. J. oral Surg. 4,* 121–129 (1975).

12.04 Ophthalmology

Aan de Kerk, A.L.: Photographic Aids in Ophthalmic Practice. *Docum. Ophthal. Proc. Ser. 3,* 5–42 (1974).

Allen, L.: Ocular Fundus Photography. *Amer. J. Ophthal. 57,* 13–28 (1964).

Allen, L., Frazier, O.: Photography with Corneal Contact Fundus Cameras. *Doc. Ophthal. Proc. Ser. 9,* 1–7 (1976).

Allen, L., Kirkendall, W. M., Snyder, W. B., Frazier, O.: Instant Positive Photographs and Stereograms of Ocular Fundus Fluorescence. *Arch. Ophthal. 75,* 192–198 (1966).

Amalric, P.: Monochromatische Fundusphotographie. *Ber. dtsch. ophthal. Ges. 65,* 549 (1963).

Baurmann, H.: Grundlagen der Fluoreszenzangiographie des Augenhintergrunds. *Advanc. Ophthal. 24,* 204–268 (1971).

Behrendt, T., Slipakoff, E.: Spectral Reflectance Photography. *Int. ophthalmol. Clin. 16,* 95–100 (1976).

Best, W., Reuter, R.: Monochromatisches Licht in der augenärztlichen Diagnostik. *Ber. dtsch. ophthal. Ges. 67,* 236 (1965).

Bockelmann, W. D.: The New Polaroid Positive/Negative Film Type 105 for Ophthalmology. *Klin. Mbl. Augenheilk. 166,* 847–849 (1975).

Boldrey, E. E.: Fundus Photography Without a Fundus Camera. *Amer. J. Cardiol. 38,* 1616–1617 (1976).

Brown, N.: Slit-image Photography and Measurements of the Eye. *Med. biol. Ill. 23,* 192–203 (1973).

Bruun-Jensen, J.: Fluorescein Angiography of the Anterior Segment. *Amer. J. Ophthal. 67,* 842–845 (1969).

Busse, B. J., Mittelman, D.: Use of the Astigmatism Correction Device on the Zeiss Fundus Camera for Peripheral Retinal Photography. *Int. ophthalmol. Clin. 16,* 63–74 (1976).

Ciuffreda, K. J.: Understanding Fluorescein Contact Lens Photography: Equipment and Technique. *J. Amer. optom. Ass. 46,* 706–712 (1975).

Craandijk, A., Aan de Kerk, A. L.: Fluorescence Angiography of the Iris. *Brit. J. Ophthal. 54,* 229–232 (1970).

Crock, G. W.: Fluorescein Stereo Angiography: Melbourne University Technique. *Int. ophthalmol. Clin. 14,* 1–14 (1974).

Cubberly, M. G.: Infrared Photography as a Diagnostic Tool in Ophthalmology. *J. biol. photograph. Ass. 44,* 80–85 (1976).

Dallow, R.: *Television Ophthalmoscopy.* Springfield, Ill.: Charles C Thomas, 1970.

Dallow, R. L.: Color Infrared Photography of the Ocular Fundus. *Arch. Ophthal. 92,* 254–258 (1974).

Dallow, R. L., McMeel, J. W.: Penetration of Retinal and Vitreous Opacities in Diabetic Retinopathy. Use of Infrared Fundus Photography. *Arch. Ophthal. 92,* 531–534 (1974).

David, N. J.: Infrared Absorption Fundus Angiography; in: *Fluorescein Angiography,* pp. 189–192. Ed. P. Amalric. Basel, New York: Karger, 1972.

Donaldson, D. D.: A Stereo-camera for Medical Photography. *Med. biol. Ill. 5,* 209–216 (1955).

Donaldson, D. D.: Stereophotographic Systems. *Int. ophthalmol. Clin. 16,* 109–131 (1976).

Dragomirescu, V., et al.: Development of a New Equipment for Rotating Slit Image Photography According to Scheimpflug's Principle; in: *Proceedings of the Association for Eye Research,* 18th Meeting. Bonn, 1977.

Ferrer, H.: *Photography in Ophthalmology.* Basel: Karger, 1971.

Fincham, E. F.: The Photo-Keratoscope. *Med. biol. Ill. 3,* 87–93 (1953).

Flower, R. W.: Infrared Absorption Angiography of the Choroid and Some Observations on the Effects of High Intraocular Pressures. *Amer. J. Ophthal. 74,* 600–614 (1972).

Flower, R. W., Patz, A.: A Viewer for Correlation of Fluorescein and Color Fundus Photographs. *Invest. Ophthal. 13,* 398–401 (1974).

Flynn, J. T.: Acute Proliferative Retrolental Fibroplasia: Evolution of the Lesion. *Albrecht v. Graefes Arch. klin. exp. Ophthal. 195,* 101–111 (1975).

François, J., Cambie, E., De Laey, J. J.: Photocoagulation in Diabetic Retinopathy: Focal Treatment or Partial Ablation? *Ann. Ophthal. 7,* 183–189 (1975).

Freeman, J. M.: Close-up Ocular Photography with the New Polaroid SX-70 Camera. *Trans. Amer. Acad. Ophthalmol. Otolaryngol. 79,* 410 bis 412 (1975).

Gullstrand, A.: Demonstration der Nernstspaltlampe. *Ber. dtsch. ophthal. Ges. 37,* 374–376 (1911).

Hansell, P.: Ophthalmological Photography; in: *Medical Photography in Practice,* pp. 277–290. Ed. P. Linssen. London: Fountain Press, 1971.

von Haugwitz, T.: Die Geschichte der Fundusfotografie. *Augenspiegel 22,* 478–487 (1976).

Hendrickson, P., Hockwin, O., Koch, H.-R.: Eine Verbesserung der Linsenphotographie im regredienten Licht. *Klin. Mbl. Augenheilk. 170,* 764–767 (1977).

Hendrickson, P., Oniki, S., Elliott, J. H.: The Matsui Color Fluorescein Angiography Technique – Adaptation to the Zeiss Fundus Camera. *Arch. Ophthal. 83,* 580–583 (1970).

van Heuven, W. A. J., Schaffer, C.: Advances in Televised Fluorescein Angiography; in: *Fluorescein Angiography,* pp. 10–14. Tokyo, 1973.

Hilsdorf, C.: Photography of the Macula through the Contact Glass. *Ber. dtsch. ophthalmol. Ges. 73,* 70–71 (1975).

Hockwin, O., Weigelin, E., Hendrickson, P., Koch, H.-R.: Kontrolle des Trübungsverlaufs bei der Cataracta senilis durch Linsenphotographie im regredienten Licht. *Klin. Mbl. Augenheilk. 166,* 498–503 (1975).

Hoover, G., Waltman, S.: Single Frame Stereoscopic Slit-lamp Photography. *Amer. J. Ophthalmol. 78,* 854–856 (1974).

Kojima, K., Watanabe, I., Niimi, K.: Clinical Application of the Monochromatic Fundus Photography. *Acta Soc. ophthal. jap. 72,* 808–821 (1968).

Kottler, M. S., Drance, S. M., Schulzer, M.: Simultaneous Stereophotography. Its Value in Clinical Assessment of the Topography of the Optic Cup. *Canad. J. Ophthalmol. 10,* 453–457 (1975).

Kottow, M., Hendrickson, P.: Iris Angiography in Cystoid Macular Edema after Cataract Extraction. *Arch. Ophthal. 93,* 487–493 (1974).

Laing, R. A., Danisch, L. A.: An Objective Focusing Method for Fundus Photography. *Invest. Ophthal. 14,* 329–333 (1975).

Littmann, G.: Spaltbildphotographie. *Zeiss-Inform. 56,* 43–51 (1965).

Lotmar, W.: Fixationsleuchte für Panorama-Fundusaufnahmen. *Klin. Mbl. Augenheilk. 170,* 767–774 (1977).

Mandell, A. I., Foster, C. W., Luther, J. D.: External Photography of the Eye. *Int. ophthalmol. Clin. 16,* 133–143 (1976).

Matsui, M.: Infrared Color Film in Fundus-photography. *Acta Soc. ophthal. jap. 74,* 146–150 (1970).

Matsui, M., Oka, Y., Matsui, T.: Fluorescein Fundus Angiography in Color. *Acta Soc. ophthal. jap. 73,* 653–658 (1969).

Meyner, E. M.: *Atlas der Spaltlampenphotographie und Einführung in die Aufnahmetechnik.* Stuttgart: Enke, 1976.

Mikuni, M., Iwata, K., Yaoeda, H.: Stereo-gonioscopy by means of Kowa Fundus Camera. *Jap. J. clin. Ophthal. 23,* 765–772 (1969).

Neubauer, H., Bockelmann, W. D.: Photographische Dokumentation in der Augenheilkunde; in: *Die ophthalmologischen Untersuchungsmethoden,* Vol. 2, pp. 754–814. Ed. W. Straub. Stuttgart: Enke, 1976.

Niesel, P.: Spaltlampenphotographie mit der Haag-Streit Spaltlampe 900. *Ophthalmologica (Basel) 151,* 489–504 (1966).

Parry, D. G.: A Technique for High Magnification Photography of Ocular Fundus Detail and for Accurate Fixation. *Med. biol. Ill. 25,* 25 bis 27 (1975).

Pashby, R. C., MacDonald, R. K.: Photographic Assessment of the Optic Disc. *Canad. J. Ophthal. 10,* 286–289 (1975).

Pomerantzeff, O.: Equator-plus Camera. *Invest. Ophthal. 14,* 401–406 (1975).

Pomerantzeff, O.: A Lens System for Wide-angle Fundus Photography. *Int. ophthalmol. Clin. 16,* 101–108 (1976).
Sautter, H., Luellwitz, W., Naumann, G.: Die Infrarot-Photographie in der Differentialdiagnose pigmentierter tumorverdächtiger Fundusveränderungen. *Klin. Mbl. Augenheilk. 164,* 597–602 (1974).
Scheimpflug, T.: Der Photoperspektograph und seine Anwendung. *Photogr. Korresp. 43,* 516–531 (1906).
Schirmer, K. E.: Simplified Photogrammetry of the Optic Disc. *Arch. Ophthalmol. 94,* 1997–2001 (1976).
Schlosshardt, H., Rueger, J.: Die Vorteile der Polaroid-Fundusphotographie bei der Dokumentation augenärztlicher Befunde. *Ber. dtsch. ophthal. Ges. 73,* 482–488 (1975).
Shikano, S., Shimizu, K.: *Atlas of Fluorescence Fundus Angiography,* Tokyo: Igaku Shoin, 1968.
Smith, N. H., Constad, W. H., Farnsworth, P. N., Cinotti, A. A.: Tomographic Measurements of In-vivo Cataracts by Slit-lamp Photography. *Arch. Ophthalmol. 94,* 1989–1994 (1976).
Soper, J. W.: A Camera Adapter for Slit-lamp Photography. *Int. ophthalmol. Clin. 16,* 181–182 (1976).
Suckling, R. D., Donaldson, K. A.: Retinal Nerve Fibre Photography. *Trans. ophthal. Soc. N.Z. 26,* 77–78 (1974).
Vancader, T., Edwards, W. C., Allen, L.: Ophthalmic Photography in Academic Ophthalmology. *Ann. Ophthalmol. 5,* 1165–1178 (1973).
Wessing, A.: *Fluoreszenzangiographie der Retina.* Stuttgart: Thieme, 1968.
Würth, A.: Chamber-angle Photos with the Zeiss Fundus Camera. *Klin. Mbl. Augenheilk. 167,* 128–130 (1975).

12.05 Dentistry

Bazzarin, S.: La fotografia nella prassi ortodontica. *Mondo odontostomat. 15,* 453–458 (1973).
Bergstrom, J.: An Investigation of Gingival Topography in Man by Means of Analytical Stereophotogrammetry. II. Changes Following Periodontal Surgery. *Acta odont. scand. 32,* 221–233 (1974).
Bergstrom, J., Jonason, C. O.: An Investigation of Gingival Topography in Man by Means of Analytical Stereophotogrammetry. I. Methodological Aspects. *Acta odont. scand. 32,* 211–220 (1974).
Dervin, E., Gore, R., Kilshaw, J.: The Photographic Measurement of Dental Models. *Med. biol. Ill. 26,* 219–222 (1976).
Fontenelle, A., Garcon-Calvi, C., Mosse, A.: Occlusogramme: set-up photographique. *Orthodont. franç. 45,* 217–221 (1974).
Gasser, R. J.: Beitrag zur klinischen Photographie in der Zahn-, Mund- und Kieferheilkunde. *Öst. Z. Stomatol. 71,* 382–389 (1974).
Gausch, K., Kulmer, S.: Zahnärztliche Photographie – praxisnah. *ZWR 85,* 330–334 (1976).
Gouedard, D., Migozzi, J.: The Photographic Instruments in Odonto-Stomatology. *Rev. Odont. Stomat. (Paris) 5,* 127–134 (1976).
Kirschner, H., Osterloh, G.: Klinische Photographie in der zahnärztlichen Praxis. *Quintessenz (Berl.) 1972,* Mai/Aug., 1–24.
Klinger, J.: Klinische Photographie in der zahnärztlichen Praxis zur Befund- und Behandlungsdokumentation mit der Kleinbildkamera – Teil II. *ZWR 84,* 239–244 (1975).
Klinger, J.: Klinische Photographie in der zahnärztlichen Praxis zur Befund- und Behandlungsdokumentation mit der Kleinbildkamera – Teil III. *ZWR 84,* 304–314 (1975).
Leopold, D., Gunther, E.: Objektive Röntgenstereophotogrammetrie in der Zahn-, Mund- und Kieferheilkunde. *Dtsch. zahnärztl. Z. 30,* 555 bis 559 (1975).
Lund, D. N.: Dental Photography. *Aust. orthod. J. 4,* 45–52 (1975).
Obreschkow, C.: Variable ATP Lens Extender-Converter of Single

Lens Reflex Cameras for Intraoral Photography. *Dent. radiogr. Photogr. 48,* 36–38 (1975).
Obreschkow, C.: Ein neuer Weg für intraorale Photographie: Der Oral-Zoom-Converter. *Schweiz. Mschr. Zahnheilk. 85,* 548–584 (1975).
Selle, G.: Die präoperative Photographie als Hilfsmittel in der orthopädischen Kieferchirurgie. *Fortschr. Kiefer- u. Gesichtschir. 18,* 106 bis 110 (1974).

12.06 Otolaryngology

Alberti, P. W.: Still Photography of the Larynx – an Overview. *Canad. J. Otolaryngol. 4,* 759–765 (1975).
Alberti, P. W.: Still Photography of the Larynx – an Overview; in: *Workshops from the Centennial Conference on Laryngeal Cancer,* pp. 721–727. Ed. P. W. Alberti, D. P. Bryce. New York: Appleton-Century-Crofts, 1976.
Diot, J., Segal, S.: Œsophagoscopie. *Acta oto-rhino-laryng. belg. 29,* 375–395 (1975).
Draf, W.: Die Endoskopie der Nasennebenhöhlen – Diagnostische und therapeutische Möglichkeiten. *Laryngol. Rhinol. 54,* 209–215 (1975).
Gould, W. J., Jako, G. J., Tanabe, M.: Advances in High Speed Motion Picture Photography of the Larynx. *Trans. Amer. Acad. Ophthal. Otolaryng. 78,* 276–278 (1974).
Hellmich, S., Herberholdt, C.: Technische Verbesserungen der Kieferhöhlenendoskopie. *Arch. klin. exp. Ohr.-, Nas.- u. Kehlk.-Heilk. 199,* 678–682 (1971).
Holinger, P. A., Brubaker, J. D., Brubaker, J. E.: Open-tube, Proximal Illumination Mirror and Direct Laryngeal Photography. *Canad. J. Otolaryngol. 4,* 781–785 (1975).
Holinger, P. A., Brubaker, J. D., Brubaker, J. E.: Open-tube, Proximal Illumination Mirror and Direct Laryngeal Photography; in: *Workshops from the Centennial Conference on Laryngeal Cancer,* pp. 743 bis 747. Ed. P. W. Alberti, D. P. Bryce. New York: Appleton-Century-Crofts, 1976.
Holinger, P. H.: Open-tube Endoscopic Photography in Otorhinolaryngologie and Bronchoesophagology. *Acta oto-rhino-laryng. belg. 29,* 1074–1077 (1975).
Ikeda, S.: *Atlas of Flexible Bronchofiberscopy.* Stuttgart: Thieme; Tokyo: Igaku Shoin, 1974.
Illum, P., Jeppesen, F.: Sinoscopy: Endoscopy of the Maxillary Sinus. *Acta oto-laryng. (Stockholm) 73,* 506–512 (1972).
Jung, H.: Moderne photo-endoskopische Untersuchungsmethoden des Nasen-Rachenraumes. *HNO (Berl.) 23,* 328–330 (1975).
Kitsera, A. E.: Optitscheskaja endoskopija i endofotografija nosa. (Optic Endoscopy and Endophotography of the Nose.) *Vestn. oto-rino-laring. 3,* 71–74 (1974).
Koike, Y.: High-speed Photography of the Larynx and Film Data Processing. *Canad. J. Otolaryngol. 4,* 800–806 (1975).
Koike, Y.: High-speed Photography of the Larynx and Film Data Processing; in: *Workshops from the Centennial Conference on Laryngeal Cancer,* pp. 762–768. Ed. P. W. Alberti, D. P. Bryce. New York: Appleton-Century-Crofts, 1976.
Luchsinger, R.: Zeitdehneraufnahmen der Stimmlippenbewegungen beim offenen und gedeckten Singen. *Folia phoniat. (Basel) 27,* 88–92 (1975).
Messerklinger, W.: Technik und Möglichkeiten der Nasenendoskopie. *HNO (Berl.) 20,* 133–135 (1972).
Moore, G. P.: Ultra High-speed Photography in Laryngeal Research. *Canad. J. Otolaryngol. 4,* 793–799 (1975).
Moore, G. P.: Ultra High-speed Photography in Laryngeal Research;

in: *Workshops from the Centennial Conference on Laryngeal Cancer,* pp. 755–761. Ed. P.W. Alberti, D.P. Bryce. New York: Appleton-Century-Crofts, 1976.

Olofsson, J., Ohlsson, T.: Techniques in Microlaryncoscopic Photography. *Canad. J. Otolaryngol. 4,* 770–780 (1975).

Olofsson, J., Ohlsson, T.: Techniques in Microlaryngoscopic Photography; in: *Workshops from the Centennial Conference on Laryngeal Cancer,* pp. 732–742. Ed. P.W. Alberti, D.P. Bryce. New York: Appleton-Century-Crofts, 1976.

Papangelou, L.: A Simple Technique of Photógraphy with the Operating Microscope. *J. laryngol. otol. 90,* 887–891 (1976).

Pigott, R.W., Makepeace, A.P.W.: The Technique of Recording Nasal Pharyngoscopy. *Brit. J. plast. Surg. 28,* 26–33 (1975).

Prott, W.: Normale und atypische Ausführungsgänge der Nasennebenhöhlen. *Z. Laryng. Rhinol. 52,* 96–109 (1973).

Prott, W.: Endoskopie des Kleinhirnbrückenwinkels auf transpyramidalem-retrolabyrinthärem Zugangsweg. *HNO (Berl.) 22,* 337–341 (1974).

Sommerblad, B.C., Hackett, M.E.J., Watson, J.: A Simplified Method of Recording in Nasal Pharyngoscopy. *Brit. J. plast. Surg. 28,* 34–36 (1975).

Strong, M.S.: Laryngeal Photography. *Canad. J. Otolaryngol. 4,* 766 bis 769 (1975).

Strong, M.S.: Laryngeal Photography; in: *Workshops from the Centennial Conference on Laryngeal Cancer,* pp. 728–731. Ed. P.W. Alberti, D.P. Bryce. New York: Appleton-Century-Crofts, 1976.

Ward, P.H., Berci, G., Calcaterra, T.C.: Advances in Endoscopic Examination of the Respiratory System. *Ann. Otol. Rhinol. Laryngol. 83,* 6 (1974).

12.07 Gastroenterology

De Benedicto, M.J., Nakadaira, A., Pinotti, H.W.: Endo-Rectophotography. *Rev. paul. Med. 81,* 271–274 (1973).

Bergemann, W.: Development, Principle and Progress of Diagnosis Using Gastrophotography. *Med. Welt (N.F.) 27,* 1526–1529 (1976).

Bergemann, W., Roesner, W., Tzekessy, T.: Results of Screening Examinations of the Stomach with Special Endophotographic Procedures. *Med. Welt (N.F.) 25,* 1384–1388 (1974).

Bradfield, G.F.: The Exposure Problem in Laparoscopic Photography. *Acta endosc. radiocinematogr. 6,* 3–4 (1976).

Cohen, M.R.: Routine Endoscopic Photography Simplified. *J. reprod. Med. 12,* 245–247 (1974).

Conn, R.L., Greene, L.F., Miller, E.W.: A Simple Inexpensive Technique for Cystoscopic Photography. *J. Urol. 114,* 927–928 (1975).

Heinkel, K., von Gaisberg, U., Spanknebel, H., Kleen, U.: GT-VAF – A New Instrument for Photoscopy. *Z. Gastroenterol. 12,* 611–612 (1974).

Morton, R., Monro, A.: Photoproctoscopy with the KOWA Fundus Camera. *Med. biol. Ill. 25,* 102–103 (1975).

Olinger, C.P., Ohlhaber, R.L.: Eighteen Gauge Microscopic Telescopic Needle Endoscope with Electrode Channel: Potential Clinical and Research Application. *Surg. Neurol. 2,* 151–160 (1974).

Oshima, H.: Modell GTF-B: Kombination von endogastraler Fotografie, Fiberskopie, Biopsie und cytologischer Untersuchung. *Akt. Gastrol. 3,* 27–30 (1974).

Polak, M.: Laparoscopic Photography on Infra-red Sensitive Film. *Z. Gastroenterol. 13,* 679–680 (1975).

Tavernier, J., Renard, J.S.: Qualité d'image en ampliphotographie avec le foyer 0,3 mm, avec et sans agrandissement géométrique. Application à la radiopédiatrie. *J. Radiol. Electrol. 55,* 642–644 (1974).

12.08 Specimen photography

Burgess, C.A.: Gross Specimen Photography – A Survey of Lighting and Background Techniques. *Med. biol. Ill. 25,* 159–166 (1975).

Chaplin, G.: Photomacrography of Fluorescent and Non-fluorescent Histological Sections. *Med. biol. Ill. 25,* 63–66 (1975).

Hopkins, W.: Illuminating Plastic Appliances for Photography. *Med. biol. Ill. 25,* 170–171 (1975).

Kennedy, M.C., Rubinson, K.: Microscope-enlarger for Macrophotography of Histological Sections. *Brain Res. Bull. 1,* 155–157 (1976).

Lebeau, L.J.: Effective Lighting Systems for Photography of Microbial Colonies. *J. biol. photogr. Ass. 44,* 4–14 (1976).

Levett, A.: Ultraphotomacrography of Whole Histological Sections. A Simple Inexpensive Method. *S. Afr. med. J. 49,* 258–260 (1975).

Lunnon, R.J.: Reflected Ultraviolet Photography of Human Tissues. *Med. biol. Ill. 26,* 139–144 (1976).

Potter, A.R., Evans, T.E.M.: A Simple Unit for Specimen Photography. *Forens. Photogr. 3,* 2–3 (1974).

Ralis, Z.A., Blake, P.D.: The Use of Ultraviolet Light and Fluorescence Macrophotography in Orthopedic Morphology and Pathology. *Clin. Orthop. 113,* 237–243 (1975).

Ralis, Z.A., Blake, P.D.: The Use of Histophotography in Bone Histology and Morphometry. *Med. Lab. Sci. 33,* 63–66 (1976).

Robertson, R.T.: A Simple Procedure for Photomacrography of Stained Histological Sections. *J. biol. photogr. Ass. 43,* 194–195 (1975).

Smith, P., Walker, G.: On Techniques for Stabilising and Photographing Skulls. *Amer. J. phys. Anthropol. 46,* 167–169 (1977).

Photomacrography. Rochester N.Y.: Kodak Technical Publication, 1969.

12.09 Photomicrography

Bode, F.: *Mikrophotographie für jedermann.* Stuttgart: Franckh.

Casida, L.E., Jr.: Infrared Color Photomicrography of Soil Microorganisms. *Canad. J. Microbiol. 21,* 1892–1893 (1975).

Casida, L.E., Jr., Balkwill, D.L.: Color IR Photomicrography of Soil Microorganisms. *Abstr. ann. Meet. Amer. Soc. Microbiol. 75,* 190 (1975).

Castenholz, A.: Stripe Photomicrography – a New Exposure Technique for Continuous Registrations on Fixed and on Moving Objects of Microscopy. *Microsc. Acta 75,* 309–320 (1974).

Del Cerro, M., Walker J.: A Simple Photographic Image Intensification Process for EM. *Med. biol. Ill. 25,* 172–173 (1975).

Chernukh, A.M., Shtykhno Yu, M.: A Simple Method of Objective Evaluation of the State of the Blood Flow in Small Blood Vessels. *Bull. exp. biol. Med. 79,* 594–597 (1975).

Chikh, V.I., Shpynova, L.G., Sanitski, M.A.: Determination of the Photographic Parameters for Electron Stereo Microscopy. *Sov. J. opt. Technol. 42,* 171–173 (1975).

Eaton, E.W.: High Acutance with Improved Contrast in Black-and-White Photomicrography at Low Magnifications. *J. biol. photogr. Ass. 44,* 94–97 (1976).

Elliot, J.G., Carpenter, J.A., Hamdy, M.K.: Technique for Preparing High-quality Microphotographs by Fluorescence Microscopy. *Appl. Microbiol. 28,* 1063–1065 (1974).

Fahrenbach, W.H.: Stereo Photomicrography of Golgi Preparations. *J. Microsc. (Oxf.) 106,* 101–102 (1976).

Gander, R.: *Rezepte zur Mikrophotographie für Mediziner und Biologen,* 2. Auflage. München, 1974.

Greenberg, S.R.: Kodagraph Photomicrography. *J. biol. photograph. Ass. 41,* 18–20 (1973).

Greenberg, S.R.: Darkfield Histophotography. *Med. biol. Ill. 24,* 212–214 (1974).

Hyzer, W.G.: Photography: Macro or Micro? *Res. Develop. 26,* 22–25 (1975).

James, J.: Proceedings: A Simple Device for Spot Counting in Photomicrographs or Electron Micrographs. *Acta morph. neerl.-scand. 14,* 93 (1976).

Klosevych, S.: Microscopy and Photomicrography. Part 1. *J. biol. photogr. Ass. 42,* 123–131 (1974).

Klosevych, S.: Microscopy and Photomicrography. Part 2. *J. biol. photogr. Ass. 42,* 147–160 (1974).

Klosevych, S.: Microscopy and Photomicrography. Part 3. *J. biol. photogr. Ass. 43,* 30–38 (1975).

Klosevych, S.: Microscopy and Photomicrography. Part 4. *J. biol. photogr. Ass. 43,* 51–69 (1975).

Klosevych, S.: Microscopy and Photomicrography. Part 5. *J. biol. photogr. Ass. 43,* 119–139 (1975).

Klosevych, S.: Microscopy and Photomicrography. *J. biol. photogr. Ass. 43,* 187–189 (1975).

Knierim, S.L.: Instant Photomicrography. *Carol Tips 33,* Nr.4, 13–16 (1976).

Laufer, E.E., Milliken, K.S.: Note on Stereophotography with the Electron Microscope. *J. phys. e. sci. Instrum. 6,* 966–968 (1973).

Levett, A.: Ultraphotomacrography of Whole Histological Sections. A Simple Inexpensive Method. *S. Afr. med. J. 49,* 258–260 (1975).

Lundsteen, C.: Microphotometry of Banded Human Chromosomes. II. Technique for Micrography of Banding Patterns. *Clin. Genet. 9,* 156 bis 162 (1976).

Malin, D.F.: Photographic Aspects of Scanning Electron Microscopy. *J. Microsc. (Oxf.) 103,* 79–87 (1975).

Maser, M.D.: Letter: Scale-markers for Microscopical Illustrations. *New Engl. J. Med. 292,* 113–114 (1975).

Milne J.A.: The Choice and Use of Equipment for Photomicrography. *Brit. J. Dermatol. 93,* 231–235 (1975).

Nairn, R.C.: Fluorescence Microscopy and Photomicrography; in *Fluorescent Protein Tracing,* pp. 61–94. Ed. R.C. Nairn. Baltimore: Williams Wilkins, 1969.

Poppa, H.J.: Photomicrography with the 24 mm × 36 mm MF. Matic Camera Attachment. *Jena Rev. 19,* 94 (1974).

Quesnel, L.B.: Photomicrography and Macrophotography; in: *Methods in Microbiology,* Vol. 7B. Ed. J.R. Norris, D.W. Ribbons. London, New York: Academic Press.

Schenk, R., Kistler, G.: *Mikrophotographie.* Basel, New York: Karger, 1960.

Schippel, K.: The Application of Special Photographic Technics in Electron Microscopy. *Z. mikr.-anat. Forsch. 89,* 27–40 (1975).

Secker, P.E., Rees, A., Sanger, C.C.: Simple Light Pipes for the Stereoscan. *J. phys. e. scient. Instrum. 6,* 1090–1091 (1973).

Sen Gupta, P.: A Simplified Camera Attachment for Photomicrography. *J. anat. Soc. India 21,* 97 (1972).

Shatillo, V.P.: Device Combining the MBS-2 Microscope with Attachments for Microphotography. *Sud.-med. Ekspert. 19,* 45–46 (1976).

Thurston, E.L., Sowers, A.E., Scott, J.R.: A Low Cost Technique for Producing High Quality Positive Images from a SEM. *J. Microsc. (Oxf.) 103,* 407–408 (1975).

Van Maaren, P.W.: A New Universal and Variable Flash Steering Device for Visual Examination and Photomicrography: Visuflas. *Mikroskopie 30,* 296–305 (1974).

Vetter, J.P.: A Systematic Approach to Colour Photomicrography. 1. The Microscope: Its Optics and Alignment. *Med. biol. Ill. 24,* 74–85 (1974).

Vetter, J.P.: A Systematic Approach to Colour Photomicrography. 2. Cameras and Photographic Techniques. *Med. biol. Ill. 24,* 140–152 (1974).

Weiss, C.H.: Optical Staining of Colorless Specimens with Infrared Color Film – A New Photomicrography Technique. *J. biol. photogr. Ass. 44,* 86–87 (1976).

Wilson, L.S.: A Template Guide for Electron Microscopy Photography. *Med. lab. Sci. 33,* 179–180 (1976).

12.10 Reproduction, publication and storage

Brown, R.A.G., Fawkes, R.S., Beck, J.S.: Indexing and Filing of Pathological Illustrations. *J. clin. Path. 28,* 77–79 (1975).

Craig, J.F., Moreland, E.F.: Photosketching. A Simple Method to Produce Line Drawings. *Dent. radiogr. Photogr. 49,* 18–20 (1976).

Cunninghamme, M.E.: Photography for Reproduction in Magazines and Periodicals. *N.Z. Sch. dent. Serv. Gaz. 37,* 10–11 (1976).

Jabs, C.M., Robb, H.J.: Polaroid Prints and Ektachrome Enlargements from 16 mm Film. *J. biol. photogr. Ass. 44,* 18–20 (1976).

Kishimoto, Y.: Photographic Technic in Preparation of Research Reports. Methods in Medical Photography. *Kango 26,* 111–118 (1974).

Munday, P.J., Radford, H.T.: Illustration Preparation and Reproduction Techniques – The Publishers' Needs. *Med. biol. Ill. 26,* 111–114 (1976).

von Prosch, H.: Enlargement of Photographic Pictures with Feedback Contrast Control. *Mikroskopie 30,* 321–326 (1974).

Revon, J.: Le service iconographique du centre hospitalier. *Cah. méd. Lyon 51,* 105–110 (1975).

Schneider, P.J.: How to Make Good Black and White Enlarged Pictures from Colour Transparencies. *Plast. reconstr. Surg. 56,* 218–220 (1975).

Strohlein, A.: *The Management of 35 mm Medical Slides.* New York: United Business Publications, 1975.

Thomas, P.E.L.: *A Guide for Authors: Manuscript, Proof and Illustration.* Springfield, Ill.: Charles C Thomas, 1975.

Wolfe, P.: Special Problems of Medical Colour Photography Intended for Reproduction. *Med. biol. Ill. 25,* 235–238 (1975).

12.11 Ethical considerations

Cardew, P.N., Lunnon, R.J., Tredinnick, W.D., Turnbull, P.M.: *Study Guide – Medical Photography.* London School of Medical Photography, London, 1975.

Committee to Consider the Law on Copyright and Designs: Copyright and Designs Law. Her Majesty's Stationery Office, London, 1977.

Copyright Act: Her Majesty's Stationery Office, London, 1956.

Council for Educational Technology for the United Kingdom: *Copyright and Education: a Guide to the Use of Copyright Material in Educational Institutions.* 2nd ed., London, 1974.

Duncan, A.S., Dunstan, G.R., Welbourn, R.D.: *A Dictionary of Medical Ethics.* Darton, Longman & Todd, London, 1977.

Institute of Incorporated Photographers: *Code of Professional Conduct.* Institute of Incorporated Photographers, Ware, 1969.

Skone-James, E.P., ed.: *Copinger and Skone-James on Copyright.* 11th ed. Sweet and Maxwell, London, 1971.

Writer's and Artist's Yearbook. Adam & Charles Black, London, 1978.

Index

Index